Understanding Virtual R~~l'~

GW00455395

This book provides critical commentary on key issues around virtual reality, using media technology as a tool to challenge perspectives for learning and understanding cultural diversities.

With a focus on empathy, embodiment and ethics, the book interrogates the use of immersive technologies for formal and informal educational contexts. Taking a critical approach to discourses around emerging technology and learning, the book presents the idea that a new literacy is emerging and an emphasis on media and technology is needed in the context of education to explore and experience cultural diversities. Employing a personal reflexive narrative, the chapters highlight key issues through research and interviews with leading practitioners in the field.

Understanding Virtual Reality will be of great interest to academics and students interested in the effects of immersive realities on the education experience, and to anyone keen on exploring the paradigm shift from entertainment to education.

Sarah Jones is continually excited about new technologies and how they can help us think about future media, future education and different ways of understanding. She holds a PhD in Immersive Storytelling and has published extensively on virtual and augmented reality, whilst continuing to make and create immersive experiences. She has advised the UK Government on Immersive Technologies, contributing to evidence around the ethics of being in virtual spaces.

Steve Dawkins is an educator with a background in media education. He has worked at Coventry University in the UK for 20+ years teaching around a range of media, primarily time-based but, increasingly, the production and distribution of content for immersive experiences and those experiences. He is completing a PhD by Publication on experiences of immersive media using a portfolio of outputs that includes original 360-degree documentaries, book chapters and journal articles.

Julian McDougall is a professor in Media and Education, Head of the Centre for Excellence in Media Practice and Principal Fellow of Advance HE. He runs the Professional Doctorate (Ed D) in Creative and Media Education at Bournemouth University, UK, and convenes the annual Global Media Education Summit. He is co-editor of the Routledge Research in Media Literacy and Education book series.

Routledge Research in Media Literacy and Education
Series Editors: Pete Bennett and Julian McDougall

Media literacy is now established by UNESCO as a human right, and the field of media literacy education is both growing and diverse. The series speaks to two recurring concerns in this field: What difference does media make to literacy and how should education respond to this? Research and practice have aimed to protect against negative media messages and deconstruct ideology through critical thinking, developing media literacy through creative production and a social participatory approach which focuses on developing active citizens to play a constructive role in media democracy.

This series is dedicated to a more extensive exploration of the known territories of media literacy and education, while also seeking out 'other' cartographies. As such, it encompasses a diverse, international range of contexts that share a conceptual framework at the intersection of Cultural Studies/Critical Theories, (New) Social Literacies and Critical Pedagogy. The series is especially interested in how media literacy and education relate to feminism, critical race theory, social class, post-colonial and intersectional approaches and how these perspectives, political objectives and international contexts can 'decenter' the field of media literacy education.

Ecomedia Literacy
Integrating Ecology into Media Education
Antonio López

Critical Race Media Literacy
Themes and Strategies for Media Education
Edited by Jayne Cubbage

The Routledge Handbook of Media Education Futures Post-Pandemic
Edited by Yonty Friesem, Usha Raman, Igor Kanižaj and Grace Y. Choi

Understanding Virtual Reality
Challenging Perspectives for Media Literacy and Education
Sarah Jones, Steve Dawkins and Julian McDougall

For more information about this series, please visit: https://www.routledge.com/Routledge-Research-in-Media-Literacy-and-Education/book-series/RRMLE

Understanding Virtual Reality

Challenging Perspectives for Media Literacy and Education

Sarah Jones, Steve Dawkins and Julian McDougall

Routledge
Taylor & Francis Group

LONDON AND NEW YORK

Designed cover image: © Getty Images

First published 2023
by Routledge
4 Park Square, Milton Park, Abingdon, Oxon OX14 4RN

and by Routledge
605 Third Avenue, New York, NY 10158

Routledge is an imprint of the Taylor & Francis Group, an informa business

British Library Cataloguing-in-Publication Data
A catalogue record for this book is available from the British Library

ISBN: 978-0-367-33702-5 (hbk)
ISBN: 978-1-032-06103-0 (pbk)
ISBN: 978-0-367-33703-2 (ebk)

DOI: 10.4324/9780367337032

Typeset in Sabon
by MPS Limited, Dehradun

Contents

Contributors

Verity McIntosh is a Senior Lecturer, researcher and creative producer. She leads the University of the West of England's pioneering master's course in Virtual and Extended Realities which is an industry-led, practice-based programme offering students the opportunity to spend a year developing their craft as immersive storytellers. She is part of the Digital Cultures Research Centre (DCRC) and a resident at Watershed's Pervasive Media Studio. Verity works with talented teams and individuals to develop and realise their ideas on a global stage. She is an advocate for interdisciplinary storytelling that bridges physical and virtual worlds and argues for a more considered and inclusive approach to user experience design in XR. Current research interests include the ethics of presence, multi-person virtual experiences and the simulation of unsafe spaces in VR.

Dr. Jenny Kidd teaches immersive media and digital culture in the School of Journalism, Media and Culture at Cardiff University, UK. Jenny's research is situated at the nexis of museum studies, digital humanities and media/communication studies. She has worked in close collaboration with partners in the cultural sector, including on a number of immersive projects. Jenny is a Co-Director of the School's Digital Media and Society research group and a Co-Investigator on the AHRC Policy and Evidence Centre (PEC). She has published widely on immersive media and digital culture and is a Series Editor of Bloomsbury Studies in Digital Cultures. Jenny was elected to the Royal Society of Arts in 2016.

James Taylor teaches and researches at the School of Journalism, Media and Culture, Cardiff University. He specialises in media production, including audio, video, photography, social media content and new emerging formats such as virtual and augmented reality. He has significant practical experience in web design and development, software development (including VR and AR), project management, marketing and communications, research and teaching. As a Creative Technologist, understanding the technology but also the creative processes involved, the artistry in its use, and the impact to the end user/audience, James brings this thinking to his own teaching and research.

Mikko Hiljanen, PhD, works as a university teacher at the Department of Teacher Education at the University of Jyväskylä, Finland. His fields of study contain teacher education, democratic education, pedagogy of history and pedagogy of sustainability. His recently co-edited book, Rautiainen, M., Hiljanen, M. & Männistö, P (eds.) (2022), *Lupaus paremmasta. Demokratia ja koulu Suomessa*. Into. (*The Promise of Better: Democracy and School in Finland*) deals with democracy as a way of life in schools.

Merja Juntunen, MA (Ed.), PhD candidate, works as a project researcher at the Department of Teacher Education at the University of Jyväskylä, Finland. She has specialised in educational technology, especially VR learning. Her personal ambition is to help learners realise their personal "Why?" and ignite their passion to learn. Currently she is working on a project that aims at creating an innovative XR ecosystem in Central Finland.

Matti Rautiainen, PhD, title of docent, works as a Senior University Lecturer at the Department of Teacher Education at the University of Jyväskylä, Finland. His key areas of expertise are teacher education, educational change, education for democracy and pedagogy of history. His latest co-edited book combines all these themes (Trumpa, S., Kostiainen, E., Rehm, I., & Rautiainen, M. (Eds.). (2020). *Innovative schools and learning environments in Germany and Finland: Research and findings of comparative approaches*).

Riitta Tallavaara, PhD candidate, is currently working as a University Teacher at the Department of Teacher Education at the University of Jyväskylä. Her research interests are teacher education, pedagogy of history and education for democracy.

Turo Uskali, PhD, Associate Professor, heads the Journalism Studies program at the Department of Language and Communication Studies at the University of Jyväskylä, Finland. His recent scholarly work focuses on innovations in journalism, new forms of storytelling and journalism education. His latest publications cover topics from innovation journalism, immersive journalism and satellite journalism. Uskali has authored, edited and co-edited seven books about the new forms and practices of journalism. The latest edited book is called *Immersive Journalism as Storytelling: Ethics, Production, and Design*. It was co-edited with Astrid Gynnild, Sarah Jones and Esa Sirkkunen in 2020, and published by Routledge. Uskali has also been affiliated with University of Bergen, Norway as an Associate Professor II (20%) 2016–2020. In addition, he has worked as a Visiting Researcher, and an Associate Fellow at the University of Oxford, Saïd Business School, UK (2007–2008), and as a Visiting Scholar at the Innovation Journalism Program at Stanford University, USA (2006–2007). Before his academic career Uskali worked for five years as a foreign affairs, business, and law and crime reporter for the leading Finnish news media companies.

Professor Andy Miah, PhD, is Chair of Science Communication & Future Media, at the University of Salford, UK, where he directs the Science Communication Space in the School of Science, Engineering and Environment. Professor Miah's research investigates the ethical, legal, social and cultural questions concerning technological change and his publications draw on ideas from science, technology, art and media culture. Professor Miah's publications are renowned for their interrogation of the good life and the ways in which humanity is moving beyond conventional evolutionary through technology where recent works have focused on drones, artificial intelligence, esports, digital health and social media. Prof Miah has published over 150 academic articles in refereed journals and 10 books, along with writing for magazines and newspapers such as the Washington Post, The Guardian, the Independent and the Conversation. Professor Miah has given over 300 major invited conference presentations over the last decade, at which he is often invited to speak about philosophical and ethical issues concerning technology in society. He regularly interviews for a range of major media companies and has appeared in over 300 outlets, including Fortune, Vogue, BBC, The Guardian and the Washington Post.

Dr Vicki Williams is a Researcher of Virtual Reality (VR), immersion and embodiment. She completed her PhD at the University of Birmingham in 2021; her thesis is entitled 'Frameless Fictions: Embodiment, Affect and Unruly Encounters in VR and Virtual Environments'. She has delivered presentations and seminars on topics including digital cultures research, digital ethics, VR and video games at a number of national and international institutions. She also co-founded the seminar series PLAY/PAUSE at the University of Birmingham.

Preface

This is a critical moment for immersive technology.

Probably for the first time ever, Christmas 2021 saw a huge number of people put VR headsets on their Christmas wish list. Many then perhaps spent the day escaping the festivities and immersing themselves in far-off lands or participating in VR games. Who knows where many of those headsets are now? Maybe in the back of a cupboard or, we would imagine, now being used for different purposes like education or engaging with the arts.

VR is a technology that many people want to experience as it has a somewhat mystical aura around it. In many important respects, it is not like any technologies that have gone before: technologies that almost come with a manual of ideas and behaviours that we are already used to. It is a technology that is full of opportunities, which will be explored throughout this book as we explore the key areas of access, awareness, engagement, creativity and action.

Our aim in this book is to explore the ways in which the technology is used, ask provocative questions about it and provide some ideas that will enable people of all demographics to critically engage with it and, ultimately, to avoid having a huge number of headsets lying in a pile of unwanted gifts.

This isn't a purely theoretical approach to the technology but is situated in the lived experiences of users, content creators and educators who use and experience the technology in their work. The authors provide the first and third sections of the book and the second section brings together a number of single-authored chapters.

Acknowledgements

The VR community is strong and supportive and this book would not have been possible without the support, thoughts and wisdom from so many.

The authors are grateful to our chapter contributors, drawing on their own expertise and experiences. Verity McIntosh, Jenny Kidd, James Taylor, Turo Uskali, Matti Rautiainen, Merja Juntunen, Riitta Tallavaara, Mikko Hiljanen, Andy Miah and Vicki Williams.

The experienced professionals and educators who gave up their time and contributed their thoughts and experiences in VR: Catherine Allen, Steve Bambury, Jamie Cohen, Dr Angelina Dayton, Melanie Hague, Shauna Heller, Michael Loizou, Bertie Millis, Nick Peres, Michelle Salvant, David Smith, Sam Watts.

An additional special thanks to the 'Godfather' of VR, Jaron Lanier, who spoke to us on two occasions to relive the defining thoughts of the initial phase of the technology and looked ahead to understand how best we can understand immersive.

We thank you all for your participation and contribution to the work.

We must also take the time as authors to acknowledge those in our lives who have helped us define this work, particularly through the challenging pandemic.

Sarah would like to thank the VR community for constant inspiration and support, especially with this book. A special thanks to her partner Lee for being the ultimate rock and she dedicates this book, as always, to Clara-May and Ditty.

Steve would like to thank his partner, Jo, and son Jimmy for all the times when he couldn't do something because he was "doing the book". He would like to dedicate this book to them and to his children: Martha and Laurence.

Julian wishes to thank the first person account contributors and Sarah and Steve for including him in this project, albeit a serious learning curve! And, as always, for Lyd and Ned.

Introduction

People come to the OASIS for all the things they can do, but they stay because of all the things they can be ... Tall, beautiful, scary, a different sex, a different species, live action, cartoon ... it's all your call.

Ready Player One (2018)

The opening scenes of the film adaptation of *Ready Player One* introduce the viewer to a dystopian 2045, complete with huge social problems, a stark class divide, monolithic tech giants and an energy crisis. The escape for people is the OASIS, a cyberspace experienced through Virtual Reality, with infinite worlds where 'players' can do and be anything they want, where they can travel between worlds experiencing different forms of life, and where education about anything takes place anywhere.

Even if the OASIS does not currently exist in the form represented in the film, Virtual Reality (hereafter, VR) is already a technology with potentially profound effects. There is no doubt that, like in the OASIS, it has a transportive nature that can challenge ideas and perspectives, enable new relations and social norms, whilst enhancing entertainment practices and deepening educational experiences. VR is, above all, an experiential technology which makes those experiences intensely subjective, despite being shaped culturally. The dreams of people working in VR are that it reaches its potential in terms of the way that it, and other immersive technologies, can transform how we think, how we live, how we learn, how we exist.

But, although VR is not a new technology anymore, we still need to understand it better. We need to know how we can become engaged users of the technology, immersed in an environment but maintaining a critical awareness of how it has been produced and how it is being consumed and experienced. That is the question at the heart of this book: *how can all users best understand immersive media so we can all become engaged users of the technology and utilise it to its full potential?* In answering this question, we will develop a framework of core literacies and competencies that can be

DOI: 10.4324/9780367337032-1

applied not just to VR but to other emerging immersive technologies such as augmented or extended realities.

The issues that we seek to explore in the book have long been at the forefront of conversations about VR technology. There were calls for this book as far back as 1995 when, during the second wave of VR, Nintendo was advertising the Virtual Boy as a console that allowed you to jump *"inside the third dimension"*. In the same year as the Nintendo Virtual Boy launch, Sherman and Craig (1995) called for a new literacy to support this *"new and rapidly developing technology"*:

> As a new medium, the *"language"* of VR is still in its infancy, therefore, the study of VR literacy must look both at the content receiver and the content creator.
>
> (1995: 37)

It could be argued that as a visual and auditory medium based on experience, we have already established literacies to enable us to critically engage with it. However, what Sherman and Craig argued for was a *specific* literacy to ensure that the underlying messages and cues in the content were not being ignored. This need is still current more than two decades on.

One difficulty in producing such a literacy is that the emerging technological spaces, practices, content and user experiences of VR and other immersive media forms are not homogeneous but diverse: from the digital divide in relation to the accessibility of creative tools, to the range of production practices, the different forms of content and the different audiences and how and where they experience that content. For example, in terms of content creation, the immersive media industry draws on practice and traditions from game design to theatre and, as a result, attracts people with a diverse skill set: a team creating an immersive experience is likely to be made up of a complex team of designers, coders, programmers, developers, storytellers, musicians and more. VR content creation happens at the intersections of these different disciplines and the technologies of production and consumption. The journey we want to take in this book is designed to make sense of this interplay and to more fully explore these intersections, not to provide a description of them but to acknowledge the recent, ongoing developments in immersive technology and its increased reach. It comes with a renewed sense of urgency to ensure that we build our understanding of the technology and adequately address areas of ethics, audiences and accessibility in the ongoing development of the technology at a time when the 'reach' of VR is greater than it has ever been.

In the intervening years since Sherman and Craig were writing, much has been written about VR and the *types* of literacy that are needed to understand the *relationships* between production, content and user experience. This book seeks to provide a framework to understand VR through the context of media education and media literacies, thus enabling us as

creators, users or educators to develop the tools and strategies necessary for people to become critically engaged users of the technology. It is split into three distinct sections.

- The first section starts with an interview with one of the major thinkers around VR, Jaron Lanier, where he reflects upon his thinking about VR since the seminal article written with Frank Biocca in 1992.
- The second section is a series of chapters that represent a set of diverse voices. It includes user experiences of 'virtual encounters' with VR, a set of contributory chapters by academics, educators and 'content creators' working at the intersections of theory and practice in VR, along with a round table discussion with, and about, 'content creators', 'content users' and educators in VR (often the same people). This is a deliberate decision on our part: the need to purposefully have different voices curated into a section that applies some of this theory highlights the complex interplays between production, the user experience and education.
- The final section outlines strategies and a framework for VR to help us engage critically with the technology, drawing on the areas of access, awareness, engagement, creativity and action, which we will develop throughout the book.

In order to develop our framework, we have taken a journey through cyberspace and virtual worlds between 2018 and 2021, engaging with a range of people in immersive technology. Some of these are educators taking immersive technologies into their educational settings to enable access to the technology and provide subsequent opportunities; others are more on the content creation side, whether crossing over from more traditional film into immersive technologies for storytelling or being more rooted in the development and creation of virtual social spaces and immersive platforms. Our journey has largely taken the form of semi-structured interviews and all have tellingly taken place virtually, rather than in a physical face-to-face location. The participants were drawn from personal networks, through active research and the participatory culture within an emerging technology field. The interviews all took a similar format and all concentrated on the same general line of enquiry, which was to understand how we can become engaged users of the technology and what the core competencies are that we need to understand and enable this mindset of criticality. They were semi-structured and allowed for divergences into areas such as social VR, brain hacking and the ethical ramifications of immersive technologies.

The set of themes that emerged from these interviews were 'big' ideas that much has already been written about elsewhere: the link between formal and informal education and training, social connections and emotion, democratisation of the technology, and ethics. The use of interviews enabled us to more fully understand how people active in the area were both

encouraging meaningful engagement with immersive media on a daily basis and the opportunities, and threats, associated with their use.

What is clear from these interviews and the collaborative chapters is that we are not yet in the space of the OASIS, although we may well be on a path to something similar. As the creator of the OASIS, James Halliday, says in the final scene of Ready Player One, he created it because "he never felt at home in the real world" but that is still where users of VR inhabit. As Halliday goes on to say: "As terrifying and painful as reality can be, it's also the only place you can get a decent meal. Because reality is real!"

It is that space between the real and the virtually real that this book seeks to illuminate.

Reference

Sherman, W.R. and Craig, A.B. (1995) Literacy in virtual reality: A new medium. *ACM SIGGRAPH Computer Graphics*, 29(4), 37–42.

Mediography

Ready Player One (2018) Directed by S. Spielberg, S. [Film]. Los Angeles, Warner Bros.

Part I
Introducing Reality

1 The Virtual Archives

*Sarah Jones, Steve Dawkins, and
Julian McDougall*

There is something distinct about VR that is not found in other media
forms. It conjures up a sense of presence through which you are able to
potentially suspend all disbelief in the constructed world (Pimentel and
Teixeira, 1993); it removes the computer and any barrier (Lanier and
Biocca, 1992); it can allow for virtual embodiment and the feeling that you
are existing as someone else (Spanlang *et al.*, 2014); and there are argu-
ments that it is an empathy machine (Milk, 2015) helping us to better
understand what it is like to walk in someone else's shoes.

It is, though, a technology that has also long been plagued with hy-
perbole. Headlines that read "VR helping people with intellectual disability
get behind the wheel" (Coggan, 2018), "10 examples of how the future of
shopping will be transformed by VR" (Morgan, 2018), "Virtual reality
joins the mile-high club with IdeaNova's in-flight INPLAY VR program"
(Tucker, 2018) and, of course, the financial predictions around VR's
commercial promise such as "Virtual Reality Market is estimated to be
worth US$ 43 Billion by 2024" (Marketwatch, 2019) all provide a sense of
VRs increasing reach and visibility. While they may all reinforce the ideas of
what the technology could be capable of, they do not necessarily replicate
the lived experience of the technology.

These headlines are all about the types of immersive technology in what
is widely characterised as the 'third wave' of VR. As a brief acknowl-
edgement, we can argue that a first wave of VR technology began in the
1950s and 1960s with Morton Heilig and the Sensorama in 1958 and Ivan
Sutherland, the Sword of Damocles, and the idea of 'the ultimate display'
(Sutherland, 1965). When the dreams of the early technology failed to
materialise, other technological advancements won consumer confidence
with a corresponding rise in the sales of, for example, colour televisions.
There was a re-emergence, or a second wave, of VR in the 1980s and 1990s
pioneered, as we will see, by Jaron Lanier with his company VPL selling the
first headsets and data gloves and then later commercialised further with the
Nintendo Virtual Boy. In this second phase, the thinking and philosophical
frameworks around the technology and the user experience became more
sophisticated, with much more articulation around the possibilities of the

DOI: 10.4324/9780367337032-3

technology and questions around how we would exist in a world with no boundaries or limits. It developed ideas from gaming environments on how we gain presence in a heavily constructed digital world turning to Heim's ideas around networked communities and full body immersion (Heim, 1993). Virtual caves were being developed by Carolina Cruz-Neira in 1992, but again, despite the claims for the technology and the predictions of rooms filled with VR caves, the technology and any audience for it did not align. The technology production, consumption and distribution could not match the potentialities that were envisaged by the leaders in the field at that time. It was only from 2010 and the 'third wave' of VR that the technology caught up with the thoughts about what VR could be and its full potential began to materialise.

The positioning of VR and the meanings that are formed from the technology will be discussed throughout this book as we develop a sense of how we can understand VR and the literacies that we need to develop in order to engage with it in a meaningful way. Given the constantly evolving nature and ever-increasing technological updates that occur, this book does not focus on the technology *per se*: instead, it focuses on how we need to think about it, to engage with it and to develop a framework of immersive and virtual literacies.

The ideas that were developed in this second wave provide the best starting point for these discussions to evolve. In the Autumn edition of the *Journal of Communications* in 1992, Frank Biocca of the University of North Carolina produced a paper entitled *An Insider's View on the Future of Virtual Reality*. This focused on a conversation with Jaron Lanier, the computer scientist who is often credited as defining the term "Virtual Reality" and a pioneer in the field. The interview would have taken place much before 1992 because at this time Lanier had left his company VPL. The paper draws out arguments on the culture of VR, the 'dark visions' of where the technology could lead and communication codes. For Lanier, at the time, it was crucial to talk about what this technology, described as "a medium that could convey dreaming" (Lanier, 2018: 45) could allow us to achieve. The discussion focused on the culture of this 'ultimate technology' and how this could and should evolve, but forewarning how it would be hampered and restricted if it did not develop in the right way. For Lanier, it was essential to understand the issues and be able to influence them.

> *So, that's a lot of why I try to be as vocal about these ideas as I can, because I consider these early years crucial. I'm hoping that it's possible to actually influence the culture in the future by just raising issues now. I'm sure that whatever develops will be completely different than anything I would expect or predict, but nonetheless, I'm hoping that it'll at least be opened up by asking the most provocative questions.*
> (1992: 156)

In the third wave, this is a critical time in the technology's development and with a view to producing a more sophisticated understanding of how we should use it in a critical and meaningful way, it is important to be provocative with the questions again.

In February 2020, that opportunity arose. The conversation with Jaron Lanier was revisited to consider how the technology and the field of VR have developed since the dialogue with Frank Biocca, where the technology is now and how we should be developing virtual and immersive literacy skills. As with all the semi-structured interviews that take place throughout this book, it took place as an online video call.

Following Lanier and Bioccas' (1992) lead, this conversation should be framed accordingly. There is no disputing the reputation that Lanier holds within the computer science and VR communities. It is known that "corporate visionaries come to define the social character of the new media" (Lanier and Biocca, 1992: 150), and Lanier, it can be argued, is one of the visionaries for the development of the technology.

In a room full of grey technicians, he seemed like a prophet from the land of Nintendo, a logical leader to guide the video generation into new virtual worlds.

(Lanier and Biocca, 1992: 150)

Despite developing the first hardware such as VR goggles and haptic gloves at VPL Research in 1985 with Thomas Zimmerman, Lanier's work is not confined to hardware, but extends beyond the technological elements of VR. He has become known for deep philosophical questioning of technology, including post-symbolic communication (2006) and criticisms of the open source movement as hampering the ability to create anything new or innovative in what he terms a form of "digital Maoism" (2010). His work cautions against the collective that has dominated in Web 2.0 at what he argues is the expense of the individual. The sharing collective nature of online communities is a focus in "*Who Owns the Future?*" (2013) with the argument that users are giving away their individualism and identity in exchange for free services, proposing a system of micropayments as an alternative. It is an argument developed in his work in 2018 arguing that social media reduces our own mental capacities, turning us into automated extensions of the platforms (2018).

With the arguments and criticisms of technological advances prominent in his work, it may be surprising that Lanier remains optimistic about the future of VR. Predicting how new mediums develop is a hazardous task (Carey and Quirk, 1970; Morley, 2006; Galloway, 2013) but as Biocca discussed with Lanier in 1992, it is relevant to posit questions around culture, communication, identity and ethics to help us begin to understand the tools that are needed to develop a new virtual literacy.

As Lanier burst onto the screen, apologising for the piano being tuned in the background, it was a chance to ask questions about the past, present

and future. The starting point for the conversation was around the culture that exists now within VR. In 1992, he wanted to see collaboratively created virtual worlds that became a "shared dream space" and wanted to continue to ask those provocative questions. It was important to ask Lanier if those provocative questions had helped contribute to the direction VR technologies have taken. The dream-like technology is still a dream, so have we now gone too far into the technology to establish a new cultural norm? Is there still room to establish something new around the technology?

Jaron Lanier: So digital technology is different from previous technologies and in a few ways. One is that it tends to have more explicit network effects than implicit network effect. This is a problem I wrote about at the start of a book called You Are Not a Gadget *(2013) and in many other essays over the years: that there is a way but that it's harder sometimes to reverse ideas built into networked digital things than it is to previous human ideas.*

In many cases, network effects before the digital era are also hard to reverse. You know there's some ideas about how money works and so forth that would be very hard to reverse at this point. But with digital stuff, I think the difference is that the relation between how quickly things come about and how long it can take to reverse them is more extreme. So, at present we have embedded in the digital world a bunch of ideas about things like where the value lies.

For instance, we have embedded the idea that data from individual people is not worth anything, but as aggregated by a big computer, it's worth everything and it's the most valuable thing in the world. There are ideas like that that very possibly could be questioned intellectually, and it's very hard to enact a difference in practice that reflects any other idea. Nonetheless we have to, we have no choice but to be. Some of these ideas are really terrible.

To my mind, the worst idea is that the only way to make money in the advanced world is through manipulating people with algorithms and everything is funded through that. That's one of the worst ideas in human history. Surely one of the craziest and nuttiest and most hopeless ideas. I'm a kind of a romantic dualist in that I think we should treat people as being sort of mystically special in order to have any values that serve people. And so, I would prefer that all of our ideas that are embedded into digital designs, celebrate a kind of mystical specialness of people. Of course, that's not what's happened.

So, I wish that things had gone differently.

Lanier breaks into his ever-recognisable laugh. It is clear that he is talking about his work on "continuous behaviour modification" (2018: 5). It is something that features prominently in his 2018 work on *Ten Arguments*

for Deleting Your Social Media Accounts Right Now, something that feeds into many debates around media literacy and how we understand the digital footprint that we acquire through online behaviours. In his first argument presented in the book, he warns that we are all being tracked thanks to the smartphones in our pocket, arguing that "we're tracked and measured constantly. We're being hypnotised little by little by technicians we can't see, for purposes we don't know. We're all lab animals now" (2018: 5). Lanier argues that the internet and social media companies are manipulating the users, with the users being the group that is generating all the profits for those companies. He advocated renaming social media as BUMMER: the digital platform that stands for Behaviours of Users Modified and Made into Empires for Rent (2018: 28). When confronted with arguments that some movements on social media, for example, the Arab Spring or Black Lives Matter, can be positive, he disagrees. The argument presented is the cycle of emotions and the companies that are tapping into the negative emotions that are more easily raised online. Lanier talks about this as his ninth argument for deleting social media:

> *Essentially, what happens is Facebook is this machine that takes good intentions and turns them into ugly, horrible social events. So there's no way to use a platform like Facebook for social activism without it being horribly counterproductive in the end.*
>
> (Lanier, 2018)

With these concerns around the commodification of users within social media in mind, it leads to the question of literacy and the principles around access and understanding and the ability to analyse and evaluate different messages. This idea was posited to Lanier: if VR is a technology that is a distinct form of practice which can't be confused with other different media forms, do we then need a different set of skills to engage with it critically? What are those core skills you need to be able to be a critical, engaged user of the tech?

> *It's possible I've had both more and lengthier experience in virtual reality than anyone else at this point, and I'm still not sure I know the answer to that.*
>
> *I used to speculate about this a great deal in the 80s. And one of the things that I proposed is that if taken well, experience through virtual reality might help us to learn to notice the difference between the virtual world and physical worlds, the physical world more readily.*
>
> *And I used to reference experiments from the 19th century with photography and the very earliest experiences with audio recording to support this case. So, there's a story that might be apocryphal about the early photographers running around in the American West during the Civil War with collections of photographs of models who fit different*

archetypes, and they would sell photographs of a different person to help somebody remember their loved one, because at least it would be an image and an image of any kind was hard to come by because where were you going to find an artist? And you certainly couldn't photograph the individual. And so, there was this market in pictures of the wrong people who looked a little bit like your relatives, which is the kind of thing that would sound absurd to us. But in a way, just having an image of a person at all that looked realistic was such a novelty in such an amazing thing that for a little while it made sense. Or a related thing, which is not definitely not apocryphal because it was published as it as in scientific journals, was that people in the earliest traces of audio recording were unable to distinguish the sound of a wax recorder from a real opera singer behind a curtain, sort of an early Turing test, if you like.

And that also, would be inconceivable to us because the audio from those things to our ears would be horrible, but they hadn't learned how to hear those things differentially at all. And so, I think in the same way.

One would hope by extension that the more experience you have with virtual reality, the more your ability to perceive physicality, the more your ability to perceive the real world would increase. And so, for that reason, back in those early days in the 80s, I would try to sneak something like a flower or an interesting gemstone or something, a geode in front of somebody while they were in the headset. Then when they would come out, they would have this thing to look at. And the question is, do you notice an enhanced sense of perception at that time? And so, in a way, the literacy I was most interested in back then was not so much the literacy within VR, but the literacy of baseline life in the physical world as actually increasing our literacy, our sensitivity to nature. And I view virtual reality as a pathway to that, a unique pathway.

This is something that Lanier has spoken of at great lengths, since the emergence of his company in the 1980s to now. In a conversation with Kevin Kelly in 1989, he said:

To me, that contrast, that feeling that you have when you're out of it after you've used it, has universally been more precious than what happens in it.

(Newton, 2014)

The argument was that when you step outside of the headset and readjust to the surroundings, things are hyperreal. Your eyes have adjusted to a lower resolution world, making the surroundings seem brighter and, as Lanier would argue, more beautiful. It will be interesting then to see how the eyes adjust to an environment once the graphics and resolution in headsets are a

higher resolution and what the impact is. Would you then want to spend longer in a VR hyperreality?

Aside from the physical experience and that appreciation for the surroundings, the deeper question is around affect and the emotion of experiences and the value of these in VR as opposed to physical reality.

I'm still a bit of a curmudgeon or a snob or something about virtual reality. In almost all the virtual reality going on at this date in 2020 doesn't seem to me to be even the beginning yet, because most of it isn't social, most of it is solitary, which makes it nothing. It's not even real. I mean, the original definition of virtual reality was social, so it's not even virtual reality, but also the means of interaction are very limited.

The typical way that people interact is either when moving their heads around or using hand controllers that are based on video game controllers that typically only have buttons on them or perhaps a pointer or similar kind of device. And these things are so hobbling, they're so limited that to my mind they're not, they don't qualify as virtual reality. So, I tend to have a very demanding sense of these things and to feel very disappointed in the current, current popular systems.

A core element of Lanier's work and ideas about VR focus on the notion of shared lucid dreaming (Lanier, 2017: 6). Users can enter a VR world which is created as your imagination develops. Instead of VR as being something that simply replicates reality in order to open up simulated environments for education purposes, Lanier's vision is about building dreams through your own thoughts and then interacting and changing this world around you. A different kind of literacy is certainly needed with different ideas of engagement and interaction potentially emerging.

It's one thing to do representational art when the medium imposes a degree of distance from reality. So if you're doing painting, that is representational or even cinema that's representational. I think that the inherent distance of the media form makes it only representational and not confusing. But with virtual reality, it's getting close enough that I think we have to be a little bit more cautious about the idea of representation. And I'd feel less strongly about that if the internet economy hadn't evolved so strongly in the direction of tricking people.

But given that the whole use of information systems has now evolved to fooling people above all else as the commercial motive, it becomes harder to be tolerant of fooling people as a paradigm for anything digital at all. Maybe eventually, when the economy has become less horrible, we could start to talk about that again. But for the moment, I think fooling people is something of an evil, and that might seem to be a tension between that attitude and virtual reality itself. But there isn't. I mean, virtual reality

can be thought of as a medium, as an honest medium of dreams, a sort of serial form rather than a realistic form. And I think that that's the best way to think of it. It's both. It makes it more beautiful.

When considering dream-like environments and the different modes of access, communication and behaviours within them, the question around ethics becomes imperative. It is, for many users, not an 'already-known' environment where established ethical codes and behaviours inevitably apply. The ethical considerations and debates on behaviours, audiences, social contact and more will be discussed at great lengths in this book as a core recurring challenge for anyone approaching VR. In 1992, Lanier referred to these as the "dark visions of the future" (1992: 170). With the growth in social technology and digital media, there is a worry of an increase in 'dark visions' related to ideas such as harassment in VR, PTSD from experiences, deep fakes and their representation in VR. These are all of concern for Lanier:

> *In 1992, I was suddenly out on my own and I started writing critical essays. If you want to see a critical one, there's one called Agents of Alienation that was published first in 92. If you want to see my darkness, it's those pieces. And so, I was reading Agents of Alienation. I started to be quite concerned about the potential for darkness and the potential for trickery. The last thing I would want to do is try to create a future in which everything's perfect and everybody's well behaved all the time. But then maybe the very last thing I'd want to do, that's even worse than that, is a future where all of the incentives economically and socially are to be horrible, where the incentives are to trick people.*

> *What started to happen around the turn of the century, which I abhorred and wrote about at the time, was this sort of Google, Facebook model, where things are free and the only way people are able to do anything online is that there's third parties who are playing to manipulate those people. And so, there is this whole world of incentives to be manipulative and sneaky and creepy, this of course, is one of the worst possible outcomes.*

> *It's not the absolute worst possible outcome, but it's close to the worst for what the Internet could evolve into and therefore virtual reality, as that as something that would have to rely on the Internet. We've entered into a period where we have to fix the underlying economic incentives before virtual reality becomes prominent because virtual reality is more potent than smartphones, let's say. And so, if we combine the present-day Internet economy with the future medium that's much more intense, such as virtual reality or mixed reality. That combination would surely make people too crazy to deal with the real world and the real problems we face, like dealing with the climate and so on. And I'm concerned about that.*

In *Agents of Alienation* (1995), Lanier argues that computer networks would develop automated agents through artificial intelligence. He postulates that the use of these intelligent agents would devalue human intelligence and creativity and diminish the role of conscious experience. The description used for these agents can be likened to what we know as 'bots' and could be used to manipulate advertising and politics, changing the nature of our conscious activity in the online space. In an extension of the *Agents of Alienation*, Lanier's later work established the ideas of Digital Maoism using Wikipedia as an example of the faults within online collectivism (2006) that warned against the blurring of the distinction between computers and machines. In 2000, Lanier wrote, "I think that treating technology as if it were autonomous is the ultimate self-fulfilling prophecy". His arguments focus around the thoughts that were developed in his 2018 work, *Ten Arguments for Deleting Your Social Media*.

In this third wave of VR, there has been a considerable increase in access to creation technologies. Through a rise in 360-degree cameras and higher-powered computers that can cope with programming VR environments, there have been more opportunities for creators. As access to the technology has increased, there has been a need for more content and we have seen a rise in various initiatives from technology companies, such as Oculus's VR for Good initiative, to fund this work. The worry though is that commercially driven projects can often diminish the creativity that is needed for designing content for a new technology.

> *What I view is good news and bad news concurrently in VR. The good news is that I see a lot of interesting artists and developers and activists and users and enthusiasts and who, at least to me, seem to be creative and interesting and surprising and thoughtful. So, I mean, there's a lot to love in the VR community, but these people tend to be on the short end of the economics of it.*
>
> *And then the major centres of spending have tended to fall on the line of the gaming industry, for instance. The big tech companies tend to create stores for VR content that are modelled on gaming stores. I think this is a mistake for many reasons, which I could talk about for hours.*
>
> *One of the issues is that we have to face the fact that gaming culture is troubled, not so much the games themselves but as the culture adjacent to the games. The chat rooms and the society around games has tended to create one of the more nervous and mean spirited and xenophobic and kind of damaging subcultures in the world, you know. I have some thoughts about why that is and what's happened, but I think it's really when you put a bunch of people together in a society in which they're all sort of second-class citizens, they can all talk about the game so they don't really make them. They're all strictly consumers. They're not first-class people. They are not the same thing as the big tech companies, for*

instance. They're all sort of subordinate. And I think it tends to create a sense of hopelessness and reaction in that population. And I think that's probably what happened to gaming culture.

So, to my view, which will be much more positive is a world in which everybody is a first-class citizen and they can make the content themselves and the economics are based on their participation in that world, rather than on purchasing big ticket, you know, procreated packages. And that alternate world is something that's also been experimented with.

For instance, I participated in creating something called Second Life long ago. Then I think many people still remember, although young people don't, sadly.

I think what happened with Second Life was a bit of bad luck in the sense that just when it was starting to bloom, the iPhone appeared and that particular design of Second Life did not transfer well to the small screen. So therefore, it kind of lost its momentum and it had a much more central and visible presence in the culture and it started to lose that about a decade ago.

Nobody has succeeded in creating a widely used headset-based thing like Second Life. There are many folks who are trying it, but the more prominent model now is they're saying is the sort of game store-based model. And then within the game store, you might buy something that gets you access to something like a second life for headsets. But it's therefore two steps removed and it hasn't, so nothing's really gotten much momentum. I hope we can get back to that. I think that that's where we might start to see more widespread positivity in the virtual reality-based community.

One of Lanier's concerns here is around cultures that emerge and about ensuring that VR does not follow the same path as some of the gaming communities. It is important to note that Lanier has been an outspoken critic of Gamergate, the term applied to the misogynistic culture that emerged within gaming communities. This has ranged from the portrayal of women in games, the threats and harassment targeted at female game developers. Lanier (2018) argued that "Gamergate turned out to be a prototype, rehearsal and launching pad for the alt-right".

By his own admission, Lanier has probably spent more time in VR than anyone else. There is an interesting body of research that looks at the value of immersive experiences and their impact on everyday life experiences. When considering the use of technology for learning, there is a question on the value equivalence and whether learning something in VR carries the same weight as learning in a non-digital way. There is further research around memory recall with studies showing the same trigger points within the brain recalling events as if they actually happened (Segovia and Bailenson, 2009). Comparing different realities is something of interest to

Lanier though admitting that for many of these areas, we simply do not know the answers yet.

My sense of these things is that virtual reality and physical reality are different. What my hope is, is that through the use of virtual reality we start to appreciate the physical world more and more. A world in which virtual reality should be the friend of naturalists and ecologists and people who are seeking a more sustainable future and those who are seeking more of a wider spread sense of joy in nature and all that. That's what I would hope.

I think virtual reality is poor for escaping because it's not an escape.

I think one of things about virtual reality is that it (this is a little what we're talked about before) virtual reality, as a consumer experience kind of lets one down pretty quickly. If you buy a gaming experience with virtual reality, you don't tend to use it for a long time. I used to speculate about that. But now we can say it's been empirically confirmed, if you look at the results of what's happened with the many big tech companies who have tried to start virtual reality content stores, it just doesn't really have that much appeal.

Virtual reality is appealing and compelling when you are building and creating within it, which we mentioned Second Life as an example of that. That's a more rarefied experience now because virtual reality doesn't typically come with the tools to build it from within. But when it does, it becomes much more compelling and much more widely compelling.

And so, the thing about that, though, is that it's work. Virtual reality is not so much a less passive media experience than the cinema or even gaming. It's more like going and riding a bicycle, which I used to compare it to. It's a thing where you actually have to engage and put effort into it, and the effort is what makes it so compelling. And so as with riding a bike, there will be a few people who are good at marathons and day long rides and whatnot. But most people will probably have shorter individual sessions with it just because you get tired. The same thing that makes it compelling is kind of a little self-limiting. I think virtual reality in its most compelling form is better understood, like some form of sport or exercise, even if it might not be that physical. But it's one that requires input from you. It requires you to be a creator, requires you to put effort in. And that's what is so rewarding about it.

And things that require effort can be addictive like sports or, you know, the bicycle is what I keep coming back to because I think it does have that feeling. And so, it's just to say that the fundamental dynamics are so different in a way, it's easier to be passive in the physical world and have the physical world still be gorgeous. Like you can lie about passively in the beautiful place of nature. It's actually something I love

to do. You can't do it indefinitely or you might get bitten or something. You could do it for a period of time.

And in virtual reality it almost never is. I mean, the very most compelling and beautiful thing that you can put in virtual reality that's passive is you get older after a while because there's a kind of a thinness to digital stuff as compared to reality.

So, on the other hand, especially if the tools get better, virtual reality empowers you. I used to make the argument that virtual reality addresses the longing of when you're a toddler and you wish you had more power in the world.

It lets you just make anything you can hypothetically. And that ability to be surreal, to be actively, constructively surreal, I think is very different from physical reality and addresses both deep longings. But also, even more importantly to me, it helps us find commonality with other people that might be strange. That's the thing that fascinates me the most. It is this potential for uncovering strange commonalities that we don't find in nature and in other media.

From the conversation, it becomes clear that Lanier thinks that the technology is still very much in that development phase where there is a hope for ensuring that the cultural identity is not closed down to commercial interests and technological developments and ideologies of VR could and should not be. In 1992, Lanier was discussing these issues to try and influence a culture that was collaborative and creative, the fundamentals of which will be developed within our own literacy of the technology.

So, if virtual reality is used in a way where people using it improvise the content of worlds together, collaboratively, then virtual reality would seem to come closest to providing the kind of shared dream space that makes the technology more coherent with all the marketers have promised Westerners.

(Lanier and Biocca, 1992: 156)

We are still not there. We are in a situation where we have evolved into a third wave of the technology where our expectations and the technology have caught up and where we can begin to see a wide range of potential opportunities materialise.

However, it is still critical that the questions Lanier raised in 1992 are raised again in the hope that we will define the culture and literacy that we need to enable a critical and meaningful engagement with VR. Biocca concluded his 1992 research with Lanier with the reminder that Lanier's look at the future may not only be his, but it may become our understanding of the future too (1992: 152). With this in mind we can begin our

understanding of developing core literacy skills to understand VR. These will be rooted in creativity and collaboration with criticality around technology companies, commodification of users and the ethical concerns that can arise. The ideas around access, awareness, engagement, creativity and action will be essential to shaping our own understandings and literacies of immersive technology and as Lanier states, the "long term survival for a technological species like ours" (Lanier and Biocca, 1992).

References

Carey, J.W. and Quirk, J.J. (1970) The mythos of the electronic revolution. *The American Scholar*, *39*(3), 395–424.

Coggan, M. (2018) VR Helping People with Intellectual Disability Get behind the Wheel. Available from: https://probonoaustralia.com.au/news/2018/09/vr-helping-people-intellectual-disability-get-behind-wheel/ [Accessed 22 March 2022].

Cohen, J.N. and Mihailidis, P. (2013). Exploring curation as a core competency in digital and media literacy education. *Faculty Works: Digital Humanities & New Media*, *4*. https://digitalcommons.molloy.edu/dhnm_fac/4

Galloway, A. (2013). Emergent media technologies, speculation, expectation, and human/nonhuman relations. *Journal of Broadcasting & Electronic Media*, *57*(1), 53–65.

Heim, M. (1993). *The metaphysics of virtual reality*. Oxford University Press on Demand.

Kelly, K., Heilbrun, A. and Stacks, B. (1989). Virtual reality: An interview with Jaron Lanier. *Whole Earth Review*, *64*(108–120), 2.

Lanier, J. and Biocca, F. (1992) An insider's view of the future of virtual reality. *Journal of Communication*, *42*(4), 150–172.

Lanier, J. (1995). Agents of alienation. *Journal of Consciousness Studies*, *2*(1), 76–81.

Lanier, J. (2006). Digital Maoism: The hazards of the new online collectivism. *The Edge*, *183*(30), 2.

Lanier, J. (2017). *Dawn of the new everything: A journey through virtual reality*. Random House.

Lanier, J. (2018). *Ten arguments for deleting your social media accounts right now*. Random House.

Marketwatch (2019) Available from: https://www.marketwatch.com/press-release/vr-market-size-share-analysis-challenges-and-future-growth-forecast-2022–2028-2022-03-10. [Accessed 22 March 2022].

Milk, C. (2015). How Virtual Reality Can Create the Ultimate Empathy Machine. *TED talk*. Available from: https://www.ted.com/talks/chris_milk_how_virtual_reality_can_create_the_ultimate_empathy_machine?language=en [Accessed 22 March 2022].

Morgan, B. (2018). 10 Examples of How the Future of Shopping Will Be Transformed by VR. Available from: https://www.forbes.com/sites/blakemorgan/2018/09/10/10-examples-of-the-how-the-future-of-shopping-will-be-transformed-by-vr/. [Accessed 22 March 2022].

Morley, D. (2006). Unanswered questions in audience research. *The Communication Review*, *9*(2), 101–121.

Newton, C. (2014). Digital Natives: A Conversation between Virtual Reality Visionaries Jaron Lanier and Kevin Kelly. Available from: https://www.theverge.com/a/virtual-reality/interview. [Accessed 22 March 2022].

Pimentel, K. and Teixeira, K. (1993). Virtual reality: Through the new looking glass. Blue Ridge Summit, PA: Windcrest/McGraw-Hill/TAB Books.

Segovia, K.Y. and Bailenson, J.N. (2009). Virtually true: Children's acquisition of false memories in virtual reality. *Media Psychology*, 12(4), 371–393.

Spanlang, B., Normand, J.M., Borland, D., Kilteni, K., Giannopoulos, E., Pomés, A., ... and Slater, M. (2014). How to build an embodiment lab: Achieving body representation illusions in virtual reality. *Frontiers in Robotics and AI*, 1, 9.

Sutherland, I. (1965). The Ultimate Display. Proceedings of the IFIPS Congress 65(2):506–508. New York: IFIP

Tucker, K. (2018). Virtual Reality Joins the Mile-high Club with IdeaNova's In-flight INPLAY VR Program. Available from: https://www.shacknews.com/article/107257/virtual-reality-joins-the-mile-high-club-with-ideanovas-in-flight-inplay-vr-program. [Accessed 22 March 2022].

2 The Virtual Space

*Sarah Jones, Steve Dawkins, and
Julian McDougall*

The positive view of technology in a dystopian future as represented in *Ready Player One* opens important and useful discussions about the opportunities and potential for immersive technologies.

Although positioning this as an imagined future within a science fiction film, content creators and educators are already using VR to enhance and deepen the learning experience in ways that start to open up the type of possibilities seen in the film. The world represented in *Ready Player One* shares many of the same opportunities and challenges that we face today and the place of VR and immersive technologies within that world is becoming increasingly complex and fluid.

There is nothing innate about using any new technology. The skills and behaviours needed to use that technology, and the assumptions about how it could and should be used, are learned. In Chapter 1, in response to a question in his interview about the core skills that one needs to be a critical, engaged user of immersive technologies, Lanier responded:

> *Wow. It's a tough one. That's a really interesting question. That's a profoundly interesting question. So, it's possible I've had both more and lengthier experience in virtual reality than anyone else at this point, and I'm still not sure I know the answer to that.*

Part of the reason for his reticence may be that there is not *one* answer but a series of interrelated answers.

This chapter will examine aspects of the contemporary virtual space in order to understand actual use cases and experiences in order to conceptualise frameworks to develop the kinds of literacies that *this space* requires. It will provide an overview, not of the technology, but of the various ways in which the technology is used and the permeation in communities that stretch much further than the usually discussed gaming environments.

In writing this book, we were keen that it was not just a theoretical exploration of the terrain of VR but that it was rooted in the experience of people who produce, create and use the technologies on a daily basis. In order to illuminate these experiences, we interviewed a range of creators

DOI: 10.4324/9780367337032-4

and educators in order to gain a greater understanding of the emerging concerns and opportunities that are rooted in the daily use of VR. This chapter will seek to tease out some of the issues that our creators and educators raised in their interviews and to provide some preliminary, and possibly tenuous, answers about what it means to be a critical, engaged user of immersive technologies. The interviewees were:

> Catherine Allen runs Limina Immersive, a VR research and consultancy company.
> Steve Bambury is an educator specialising in the impactful integration of VR and AR in classrooms.
> Jamie Cohen is a digital media researcher and educator specialising in the fields of new and digital media and where they intersect with culture both in real life and in digital spaces.
> Dr. Angelina Dayton, known as "The VR Lady", is the Senior Virtual Reality Research Scientist at the Virtual World Society and an Aspen Institute Tech Policy Fellow. She is a virtual reality researcher, user experience designer, speaker, consultant and trainer.
> Nick Peres is a creative technologist working in healthcare.
> Sam Watts works at Make Real, a UK-based immersive company that creates and makes experiences focusing on learning and development, training and simulations.

The themes and issues that they raised in their interviews are interspersed as quotes throughout this chapter.

Virtual Access

In the previous chapter, we alluded to the fact that, despite only recently entering mainstream consciousness and media representations, VR technology is not new but can be considered to be in its third wave.

- The first wave began with the pioneering work of mainly academic researchers in the 1960s, beginning with Sutherland's concept of the 'ultimate display' (1965) and Heilig's Sensorama, which presented developers and researchers with some of the core blueprints for the concepts that encompass VR today.
- The second wave began in the 1990s, with the launch of Nintendo's Virtual Boy (Boyer, 2009). Despite little commercial success, it opened up more philosophical ideas around, and discussions of, immersive technology exploring the essential aspects of the technology, presence and virtual worlds (Pimentel and Teixeira, 1993; Heim, 1993). These ideas and discussions provide us with scope to understand the complexities at the heart of the technology and allow us to present an argument as to how we could and should understand and think about it.

- The third wave can be identified as being when the technology developed since the 1960s aligned with the ideas of the nineties about what VR could and should be. One of the key factors in driving VR forward in this third wave was the development of the Oculus Rift by Palmer Luckey. Luckey is often credited with this revival of the technology, describing in the LA Times in 2013 how other waves of the technology were not realised; "The technology wasn't ready. Even if they did everything perfectly, they couldn't possibly make a VR device that made consumers happy. It's only in the past couple years that it has become possible to make a VR device that is low-cost and high-performance" (Palmer Luckey in Martens, 2013).

This third wave was aligned to more affordable and accessible technology, as evidenced by Google Cardboard in 2015, allowing users to use their mobile phones inside a cardboard headset for non-interactive immersive experiences. It also coincided with the development of consumer-grade 360-cameras to enable access for filmmakers, documentary makers and journalists to create a wide range of content for a wide range of different experiences to view within VR headsets.

This divergence of content and the moving of the technology away from being the almost sole preserve of the gaming industry and into more areas including entertainment and education has meant that this wave of VR has brought much greater awareness in public consciousness and more access for more people. As such, we would argue that we need to revisit the ways in which we educate and train people about the opportunities, and threats, afforded by VR, and other emerging immersive technologies.

We are proposing a model of understanding that includes five main areas: access, awareness, engagement, creativity and action.

However, we need to consider whether VR is a new technology that shares features with other existing media forms while having new features that necessitate new ways of thinking about the technology and the experience of using VR. In our interviews, opinion was divided:

Nick Peres (NP): I think one of the mistakes some people make, and I might be wrong, is that they're approaching this medium as completely and utterly new. I really believe there are things from other [disciplines], it's just a combination of those things. You've got theatre, there's a lot from documentary, there's a lot from how we've used cameras in the past. And if you go all the way back to early cinema, there's actually a lot in early cinema in their first touches of the camera and the projector and things which relate totally to how we should be experiencing 360.

but an opposing viewpoint was articulated by Angelina Dayton:

Dr. Angelina Dayton (AD): I think we don't give people context: we just give them rules that we sometimes carry over from previous media that don't reflect it. If you're not looking at the ways in which those rules have to change and you're not defining the new environment, then you are moving forward but you're moving forward blind because you're importing ideas from the other mediums and you're not clear about the environment that you're in now. One of the key components is the realization, more so even than web 2.0, that you are creating. You are content creators now and where you could create a web page, the content is so much more dynamic.

Virtual Awareness

Originally positioned within media representations as something inhabiting imaginary science fiction worlds, information about and knowledge of VR has been entering the mainstream media and public consciousness increasingly frequently over the past decade.

Early representations of VR 30 years ago in the Lawnmower Man (1992) and later in the Matrix (1999), showed VR as being a gateway to new experiences and becoming an imagining of the art of the possible. This is also evident in the more recent film adaptation of Ernest Cline's *Ready Player One* (2018) showing a future, which is perhaps much more realisable in the third wave.

As the technology for content creation becomes more accessible and the reach of VR becomes greater, representations of VR are not now solely limited to science fiction but are increasingly to be found in a wider range of different media:

- In 2001, Disney's *Monster's Inc* showed monsters using VR to help them learn how to scare children.
- The escapist nature of the technology has been documented in a number of forms. *The Big Bang Theory* television series, which ran for 12 years from 2007 to 2019 in the United States, regularly represented ideas from science fiction and technology. In the 12 seasons, VR was mentioned on a number of occasions. One of the best examples came in an episode in 2016 where the idea that the technology allowed you to escape and engage in activities that you wouldn't want to do in real life was developed. The main character, Sheldon, was using a VR headset to explore a forest, reaching out to touch a butterfly. The character used an air freshener to add to the sensory experience.
- The escapism and opportunities to live other lives have also become a feature in music videos. *I Got U* (2014) by Duke Dumont shows the

main character wanting to escape a world that is grey and rainy. By ordering special VR glasses known as a 'waiver' these transport him to a tropical holiday island, leading to celebrations, relationships, bungee jumping and more. The end reveals two people in their own rooms playing against each other as the male and female protagonists. Similarly, in *Let Me Love You* (2016) by DJ Snake and Justin Bieber, it becomes increasingly clear to the viewers that the Bonnie and Clyde-type characters in the video are, in reality, people of a range of ages taking part in a collaborative video game in VR.

- The BBC has released many news documentaries in VR including *Congo* (2018) where the BBC Africa correspondent Alastair Leithead takes viewers on a three-part immersive journey through the Democratic Republic of Congo.
- Charlie Brooker's Netflix series *Black Mirror* explores the darker side of technology: how it can impact everyday life, destroy relationships or build new worlds. In one episode, *Striking Vipers* (2019) characters are shown wearing VR headsets to enter a game physically. This allowed them to move around the VR environment, as if they were in the game, allowing them to interact, think and feel in the game. It explored the ideas of building relationships within virtual environments, something that has been spoken about a lot in the media. Augmented reality is also explored throughout the series from AR horror games to AR contact lenses that let you record and replay visual memories. There are themes that are written as a fictional representation of the world through immersive media are already beginning to enter consumers' minds and those of developers. Some of these themes around brain-hacking, manipulation of the mind and becoming another in a virtual space are ones that we will return to later in the book.

The importance in providing these examples of media representations is to show how VR has been entering the public consciousness in everyday spaces. Even if an audience is not the target demographic for something like *Black Mirror*, they may be for the UK BBC daytime show *Your House Made Perfect*, where architects use VR to remodel people's houses and where they then get to do a virtual walk-through of what it could look like when completed.

Virtual Engagement

In 2018, Jeremy Bailenson of Stanford's Human Interaction Lab considered the range of opportunities for VR and immersive education, from specific training for dangerous environments to the development of cognitive skills, like negotiation and public speaking. He identified the four scenarios when VR should be used; when an experience is expensive, dangerous, impossible or rare (2018: 236). Initially confined to gaming environments and sub-cultures, there are now many more reasons and opportunities for people to

use VR in a wide range of experiences. As such, user numbers have increased dramatically in the third wave (Statista, 2022).

A range of public speaking training simulators that gave audience feedback in response to performances (El-Yamri *et al.* 2019) were some of the first to be launched on mobile headsets such as the Samsung Gear VR to demonstrate that the technology reached beyond the perceived gaming industries. *Virtual Speech* was one example where users could choose from a range of virtual environments, from small meeting conference audiences, add in reactions and noise and upload presentation slides to complete the experience of presentation.

Sam Watts (SW): We've done 35 VR training applications now. Some of them are assessment, so they will do something in the real world, and then they will go into VR and do the assessment. And by doing it in VR, they take it more seriously and you get more effective results, because they're concentrating on the task and the assessment, and what they're doing, not what their mates are doing when they're mucking about in college next to each other.

The technology has long been used in surgery and medical education, architecture and in the fashion and tourism industries. The recent pandemic has also seen a wider range of people using the technology for different reasons. Ball *et al.* (2021) surveyed a number of users during 2020 and found most people reported buying VR for work, education and gaming. The leading use was gaming (64%) but this was followed by watching movies at 53%. Interestingly, 39% of users used VR for escapism tourism, at a time when travel was limited or prohibited. Thirty-seven per cent of use cases were for education.

Extending the use of VR in medical situations, lecturers in Radiography in Australia used VR as a response to the lack of placement opportunities for their students (Hayre and Kilgoura, 2021). With access to clinical placements being suspended, VR became the alternative assessment point for students. In doing so, they found the importance the technology could have for widening participation for students who found it difficult to manage the physical agility side of the programme and access to placements which were previously restricted. Although it opened up opportunities and ensured valuable learning experiences, it didn't expose students to the full range of experiences that they would face from being in a clinical environment, which is critical in ensuring students have a full learning experience.

Virtual Audiences

In her interview, Catherine Allen makes the point that there are currently essentially two audiences for VR:

1 those with a headset, especially high-end ones, which are statistically men between 16 and 24 years old who use VR as part of gaming activities,

2 more diverse groups who are more likely to have lower-end technology, such as Google Cardboard headsets, at home and those who will experience location-based VR in more social locations such as arts venues and arcades.

Limina's extensive research studies across more than 15,000 audience members and public attitude surveys with Ipsos Mori have found that many more women were likely to participate in location-based VR activities: up to 40% of the audience in their studies (Allen *et al.* 2020). Echoing Lanier's thoughts about VR as a social, not solitary experience, it appears that for many people, not just women, the social element of the experience is of vital importance and so, although it seems obvious, in any new media literacy for VR, the location and sociability of the experience must be fully considered.

Limina has spent a lot of time and effort on stressing the marketing of any location-based experiences. When they ran VR events, it was important that images were not of people wearing headsets, precisely to ensure that diverse audiences and different demographics are attracted:

Our biggest audience segment in Bristol during the six months was women 25 and upwards. It may not be that they're a part of the creative industries but they have a creativity in the curiosity within them, that kind of adventurous spirit. They come because of the content. It's not that they want to try VR.

However, it is not just the location that needs to be considered but the experience of the VR experience itself. Once marketed to attract diverse groups, the build-up to the actual experience is crucial to the sense of immersion that the audience will feel. For Allen, there is a job to do with audiences who may be experiencing VR for the first time, to 'normalise' the technology behind the experience of VR to ensure that they do not over-focus on it:

This is influenced by Brecht, I suppose. Like theatre, we don't hide the technology so we have our headset table. We put some fairy lights and fake candles around this table which has got the headsets on so people can see them. When they enter the room, they will see the headsets. We're happy about people seeing our workings and aware that this is an illusion.

These ideas focused on the environment to show immersive experiences were a feature of many of the conversations. The experience cannot be from the moment a headset is put on and taken off but the arrival, the

environment and the subsequent conversations that follow a period in VR all need to be considered when developing a new literacy:

SW: *We've quickly realised that climatization and giving the user control of when to start the experience is key and then it also feeds back into ensuring that when we're creating training and learning content, if they are acclimatised and ready for it, and they've got over the initial, oh, wow, I'm in VR, then they're more tuned in and the amount of learning goes up, because they're actually paying attention to the outcomes as opposed to how cool is being in VR and looking at their hands and gesticulating or whatever.*

LMichelle Salvant (LMS): *I do think there's going to be some questions and some discussion needed when a student or young person or someone has a headset, and they just kind of have free rein, like how to be immersively responsible, we have digital citizenship, but we may need to have something with immersive assistantship at some point, just to kind of let our young people know what's what's in and what's out.*

Nick Peres (NP): *It was always really important to have a debrief based around the experience. I like the fact that with VR, if it's done correctly, you can have this discussion beforehand and you can have a very powerful discussion afterwards. it was almost like VR was just a trigger point for these experiences, which is the trigger point for those post discussions. And again, replaying it after the discussion had been made, we found on the second time viewing, it brought to life a kind of another layer.*

Virtual Creativity

We have already noted that the technology to produce content is becoming more accessible. This brings us to a critical point with the technology and a need to understand the making process as well as being able to 'read' the VR experiences that have been created. Virtual creativity then extends to the 'co-creation' of the experiences within VR.

Almost all of the interviewees stressed the need for production to be part of any project of increasing literacy around VR. These themes included ideas of production cultures, experimentation, representation of marginalised voices and the influence of Big Tech that has already been discussed in Chapter 1:

NP: *I love the idea of people being their own content creators and actually giving them the tools to go out and film. It's about people using it and understanding the medium. That's a massive part of media*

literacies. It's understanding how things are made. It can feel quite mysterious, and it's really not, it's actually really simple.

SW: There's a number of friction points around getting into VR, and just using VR currently, that once you're aware of them, and once you've come up against them, you know how to either avoid them or ignore them. It could be coming to the edge of your tracking space, or it could be momentarily losing your hands because you're looking that way. I think that then a lot of people, until you point them out, are not actually aware of it. They don't really know the limitations. They just expect them to do everything. When people see virtual reality, they expect it to be as close to reality as what they know.

JC: VR is still a time-based situation, you have to make its build, you have to render it, there's so many steps. It's very much like early digital video from the 1990s. When Avid first came out, and people were doing nonlinear editing for the first time, they're like: "I can move a clip". That's where we are with VR. People can make it but in the access space, it still needs a lot of work.

One of the key tasks for any project of VR literacy has to include criticality *before* any VR experience: that, in Jamie Cohen's words, "how do you create a pre knowledge of VR so that you can put it on and be critical without falling into the magic almost instantly?".

Virtual Action

In an article on the EdTech website, Craig (2018) asks, "how can we prevent a digital divide 2.0 as Virtual Reality expands?" and then answers the question in the sub-heading: "Creating wide access on campus can ensure all students get to experience transformative learning". Although he does state that "we must ensure that we don't create more barriers to access", the focus of this article means that it falls into the same trap of replicating the already existing divide between the 'educated' and 'uneducated'. This means that the structural divisions that prohibit access to higher education remain unseen, thus replicating the cycle of the digital divide: those privileged enough to access higher education also get privileged access to VR technologies.

The notion of the digital divide is one that developed during the 1990s and, initially at least, was confined to discussions around access to the hardware and software of the internet. The term has since grown to include access to hardware and software but also to include other areas such as having access to the bandwidth needed to use emerging technologies such as VR as well as having the necessary education and skills to use those technologies.

As we will argue throughout this book, any new media literacy has to encompass both production and consumption of VR experiences. As such, we would argue that there are five main *interlinked* areas that need to be

considered in relation to accessing the technology and the experiences through that technology:

Nedwich (2018) argues that VR as a technology can actively bridge the digital divide. but, as Pimienta (2009: 33) notes:

> *Offering an access to ICT does not necessarily imply that the people who benefit from the technologies can thus access opportunities for human development; education, more specifically a digital and information literacy, plays an essential part in the process.*
>
> (2007: no page)

So, in developing a new literacy for VR, it is clear that the starting point is most probably one of acknowledging difference: differential access to the tools of production, the production cultures of creators and the means to access a wide range of VR content. Not surprisingly given the focus of this book, for us, the key elements in eradicating any divide are access, education and literacy: educating about production methods, education about the politics and ethics of production, education about the representations experienced in VR.

Part of the concern about VR is its relative newness and the fact that many users of VR do not have the necessary skills or 'cultural capital' to fully engage critically with the technology.

In his interview, the educator, Steve Bambury, makes the point that:

> *... now is the time to kind of be forward thinking rather than wait until it's happened, and then look at what this technology is. What could the negative connotations of this be? What could the social issues and the issues related to children's use of it be moving forward? And in 5-years' time or in 10-years' time, how are we going to prepare for that and what systems are going to be in place to ensure that kids are protected?*

This continues with concern around Big Tech and privacy and data issues.

> *JC: Since Facebook owns Oculus, and corporations own these major systems, and Microsoft has the HoloLens and all these devices, what we're looking at is what data is being collected from the body, or potentially could be taken from the body.*
>
> *It's really not like a dystopian point of view, it's just more about consumer protection, consumer understanding and better and savvy use of embodied data.*

Virtual Moral Panics

With VR becoming more culturally prominent, it is clear to see the possibilities afforded by the technology. However, there is still scepticism about the technology and a reluctance on many peoples' part to embrace it.

Accessibility in terms of the 'digital divide' is one area of concern which will be discussed further in Part II, however the issue runs deeper than that. The idea of entering virtual worlds, experiencing things through forging new memories and relationships provides the catalyst for a moral panic.

Moral panics are often defined as being where "a condition, episode, person or group of persons emerges to become defined as a threat to societal values and interests" (Cohen, 1973). They are magnified by a media-led reaction causing public concern and panic (Marsh and Melville, 2011) though it is important not to use this as a means to discredit the problem in hand. Cavanagh (2007) recognised that defining an issue as a moral panic can be "a deliberate attempt to spin social problems".

New technologies have often been credited with causing moral panics: whether it be through supposed harmful effects (often to children) or an increased use of the technology leading to detachment from communication and physical environments, along with other examples (Livingstone, 2009). Genevieve Bell (2011) looks at how technology regularly causes a moral panic and outlines categories where a moral panic is more likely to emerge: if the technology changes your relationship to time, your relationship to space or your relationship to other people. It is evident then how VR, which ticks all three boxes, may cause moral panics.

Headlines in press reports across the world in 2016 noted that Microsoft were claiming VR could make a person hallucinate in the same way as LSD, whilst other headlines include VR porn becoming the norm by 2026, Meta users being given God-like powers and VR users being subjected to online rape. All these stories were predicted by Catherine Allen, a VR creator in 2017 when, writing for Wired, she noted that:

> ... there'll be a rash of VR-induced mental-health stories, ranging from post-VR panic attacks to episodes of psychosis. Then there'll be concerns about addiction: what if the virtual world's lack of limitation creates environments that are more enticing than the real one?
>
> (Allen, 2017)

As with all media and technological moral panics, there are reasons behind this and with limited access to the technology and representations having been dominated within science fiction, the emergence of the panic is clear. As we now see an increase in the development and infiltration of this within everyday lives and within training and education, there is certainly a need to understand it better. As Sherman and Craig identified the need for literacy skills to understand VR back in 1995, there is a need that "the use or 'reading' of VR has to be learned". A greater understanding and literacy of the technology will enable a critical examination and fewer panics about what it can lead to.

The Need for New Literacies

Through the emergence of immersive media, VR exists as a media form in itself. The defining features have signalled cultural shifts in our understanding and our relationship with the technology. The distinctive nature of VR as enabling a sense of presence defines the medium and necessitates this approach. Letting go of the reality around us and beginning to transport ourselves to another time or place means that now, more than ever, we need tools to critically understand this new world that is presented in front of us.

The ideas of developing a deeper emotional response to specific narratives or environments can open questions around manipulation, a long-time feature of competencies of media literacy. Ideas around embodiment are again unique to this media form and the implications that this can have when you spend time in another body need to be analysed. Ethical concerns range from production and consumption with a technology that has been demonstrated to change brain patterns and behaviour (Markowitz *et al.*, 2018).

This book seeks to offer an understanding to the emerging form of VR and requires a study of it that is unique to itself. It requires the same critical interrogation that has been required of television, radio, newspapers and the internet. How we understand this emerging technology is of vital importance as we see a growing infiltration of experiences throughout our media life from entertainment to health to education. We cannot wait to understand it fully. We need to begin that conversation of how we become an engaged user of VR in a meaningful way and how the technology can enable us to challenge perspectives and make us more human

In this chapter, we have tried to illuminate the key areas of any future digital literacy for VR through first-hand testimony. While we are not claiming that the testimonies of any of our interviewees are widespread or representative, their insights into lived experiences of VR do enable us to start to map what areas do need to be in such a literacy or, as we will see in the next chapter, *literacies*.

In her interview, Michelle Salvant from *LMichelle Media* calls this kind of understanding, digital futurism. For her, a digital futurist is:

> ... *a person who is able, when they're exposed to newer emerging media, is able to kind of flesh that out with all of the great things about it, and all the challenges that comes with it, and still kind of stay in the game, not get frustrated, and find ways not only to use it, maybe in personal use cases, but also for the betterment of their own communities. And so I think a digital futurist looks at the emerging media tools, and sees how they can not only bring advancement to their own personal space, but to the communities that they serve.*

It is this sense of betterment – of the individual, of the community, of the content, of the experiences – that suggests a bright future.

References

Allen, C. (2017). It's Time to Prepare Yourself for 'VR panic'. *Wired* [online]. 16 May 2017. Available from: https://www.wired.co.uk/article/catherine-allen-virtual-reality [Accessed 5 July 2022].

Allen, C., Kidd, J. and McAvoy, E. (2020). *Beyond the Early Adopter: Widening the Appeal for Virtual reality.* Creative Industries Policy and Evidence Centre. Available from: https://pec.ac.uk/policy-briefings/beyond-the-early-adopter-widening-the-appeal-for-virtual-reality [Accessed 5 July 2022].

Bailenson, J. (2018). *Experience on demand: What virtual reality is, how it works, and what it can do.* New York: Norton.

Ball, C., Huang, K.T. and Francis, J. (2021). Virtual reality adoption during the COVID-19 pandemic: A uses and gratifications perspective. *Telematics and Informatics, 65,* 101728.

BBC (2018). BBC Launches Congo VR, a New Virtual Reality Documentary Series. Available from: https://www.bbc.co.uk/mediacentre/latestnews/2018/bbc-launches-congo-vr [Accessed 22 March 2022].

Bell, G. (2011). Women and children first: Technology and moral panic. Interview by Ben Rooney, ed., Tech Europe Blog. *Wall Street Journal.* https://www.wsj.com/articles/BL-TEB-2814

Boyer, S. (2009). A virtual failure: Evaluating the success of Nintendo's Virtual Boy. *The Velvet Light Trap, 64,* 23–33.

Cavanagh, A. (2007). Taxonomies of anxiety: Risks, panics, paedophilia and the Internet. *Electronic Journal of Sociology, 1198,* 3655.

Cohen, S. (1973). *Folk devils and moral panics: The creation of the mods and rockers.* London: Routledge.

Craig, E. (2018). https://edtechmagazine.com/higher/article/2018/04/how-we-can-prevent-digital-divide-20-virtual-reality-expands. [Accessed 10 December 2020].

Dilanchian, A. (2019). Virtual Reality and the Digital Divide. Accessible at: https://diginole.lib.fsu.edu/islandora/object/fsu%3A660901. [Accessed 10 December 2020].

El-Yamri, M., Romero-Hernandez, A., Gonz alez-Riojo, M., & Manero, B. (2019). Designing a VR game for public speaking based on speakersfeatures: a case study. *Smart Learning Environments, 6*(1), 1–15.

Hayre, C.M. and Kilgour, A. (2021). Diagnostic radiography education amidst the COVID-19 pandemic: Current and future use of virtual reality (VR). *Journal of Medical Imaging and Radiation Sciences, 52*(4), S20–S23.

Heim, M. (1993). *The metaphysics of virtual reality.* Oxford: Oxford University Press.

Livingstone, S. (2009). *Children and the internet.* Polity.

Markowitz, D.M., Laha, R., Perone, B.P., Pea, R.D. and Bailenson, J.N. (2018). Immersive virtual reality field trips facilitate learning about climate change. *Frontiers in Psychology, 9,* 2364.

Marsh, I. and Melville, G. (2011). Moral panics and the British media – a look at some contemporary 'folk devils'. *Internet Journal of Criminology, 1*(1), 1–21.

Martens, T. (2013). The Player: Palmer Luckey's Oculus Rift Could Be a Virtual Reality Breakthrough. Available from: https://www.latimes.com/entertainment/herocomplex/la-et-hc-palmer-luckey-s-oculus-rift-could-be-a-virtual-reality-breakthrough-20160326-story.html [Accessed 22 March 2022].

Milk, C. (2015). How Virtual Reality Can Create the Ultimate Empathy Machine. *TED.com* [video]. March 2015. Available from: https://www.ted.com/talks/chris_milk_how_virtual_reality_can_create_the_ultimate_empathy_machine [Accessed 31 August 2021].

Nedwich, R. (2018). https://www.commscope.com/blog/2018/virtual-reality-breaks-down-the-digital-divide/. [Accessed 10 December 2020].

Pimienta, D. (2009). Digital divide, social divide, paradigmatic divide. *International Journal of Information Communication Technologies and Human Development (IJICTHD)*, *1*(1), 33–48.

Pimentel, K. and Teixeira, K. (1993). Virtual reality through the new looking glass. New York: Intel/Windcrest.

Sherman, W.R. and Craig, A.B. (1995). Literacy in virtual reality: A new medium. *ACM SIGGRAPH Computer Graphics*, *29*(4), 37–42.

Statista (2022). VR Statistics/. Available from: https://www.statista.com/topics/2532/virtual-reality-vr/#dossierKeyfigures [Accessed 22 March 2022].

Van Dijk, J. (2020). *The digital divide*. Cambridge: Polity Press.

Young, A. (2020). https://bankingblog.accenture.com/the-digital-divide-in-learning-and-why-it-matters. [Accessed 10 December 2020].

Mediography

Big Bang Theory (2007–2019). Warner Bros.

Black Mirror, Endemol Shine UK.

I Got U (2014). Duke Dumont featuring Jax Jones, Isis Production.

Lawnmower Man (1992). Dir: Brett Leonard.

Let me Love You (2016). DJ Snake featuring Justin Bieber. Dir: James Lees.

The Matrix (1999). Dir: Lana Wachowski and Lilly Wachowski. Warner Bros.

Monsters Inc. (2001). Dir: Randy Newman. Disney.

Virtual Speech. https://virtualspeech.com.

Your House Made Perfect (2019–). BBC.

3 A Multitude of Literacies

*Sarah Jones, Steve Dawkins,
and Julian McDougall*

This is about thinking through what needs to happen to literacy for it to inclusively encounter the virtual, or in other words what reading the virtual, or virtually reading reality, 'does' to literacy. But the proposition is not to establish another new literacy, or place another layer, towards 'virtual literacies' with a set of competences for such. Rather, it is to understand literacies as evolving and plural. In a sense, then, this is 'just' literacy, albeit a multiple interplay of litera*cies*. But whilst that is the case, as ways of being literate in 2021 encompass a range of practices from reading print to being agentive in immersion, it is also crucial to understand literacy itself as negotiated and in flux, as ideological and dynamic.

Back in 1995, Sherman and Craig articulated an emerging conceptual framework for asking new questions about literacy in virtual reality, importantly distinguishing between 'entry level', possible from prior ontological and textual experiences in the world, and more advanced, critical engagement with immersion:

> *So, since we have experienced 'a' reality and that knowledge allows us
> to understand the virtual environment, we must be literate in VR, right?
> Well, perhaps, but we are about as literate as a beginning reader.*
> (Sherman and Craig, 1995: 38)

Drawing on this relatively early sense of a hierarchy of literacies for VR, we might reasonably offer a framework of competences and levels of skills, as has been attempted for media literacy. But seeing the virtual itself as a neutral space – 'the' virtual environment – ignores the material circumstances inherent in producing the immersion, the economic imperatives of technology ownership or the political engagements in the (re)production and (re)-imagining of ontology in the virtual space. Instead, the social arrangements of virtual spaces are such that the real and virtual come together and in often more complex and ambitious designs than may be possible to understand with more static systems for defining and measuring literacies, which do not sufficiently address the 'dynamics' of literacy practices in transition spaces such as VR. There is also the 'always-already'

DOI: 10.4324/9780367337032-5

layering qualities of virtual and augmented realities, which in their inherent pre-requisite for transmedia literacies, cannot be accounted for by static models either, as literacy scholars and educators in this space need to:

> ... *focus on the layers of augmented reality as a model for comparatively analysing other media to support critical multimedia awareness and to understand the extension of combining tools, such as the layer, beyond a singular medium.*

<div align="right">(Blevins, 2008: 13)</div>

Literacy

Definitions of, and frameworks for measuring 'literacy' are constantly in play from and between a wide array of academics, policy-makers, institutions, educators and interest groups. Every iteration is a response to the proliferation and perennial acceleration of technologically mediated texts and artefacts in our lived experiences, or 'literacy events' (Street, 2003).

Too often, literacy is presented as a fixed, neutral and objectively evident collection of skills and competencies needed to make sense of texts and communicate through language. Another view is that skills and competencies are needed and must be learned and developed to be a person with agency in the social world, literacy is ideological and a site of challenge and conflict, embedded in wider socio-material and economic contexts. Going further, we can see that literacy itself adapts in response to "changed artefacts, social arrangements and practices" (Lievrouw and Livingstone, 2006) which, in turn, means that failing to expand our thinking about what 'counts' as literacy, in education most immediately, to integrate new mediated, digital, networked or virtual, immersive textual experiences, risks increasing digital inequalities (Helsper, 2021) but also abandons young people, in particular, to a greater risk of harm than would be the case if digital media and online, networked social practices were allowed to 'count' as literacy in school.

Literacy is generally seen as an undeniable positive, there is little evidence of people being overtly 'against' literacy:

> *Literacy is a fundamental human right and the foundation for lifelong learning. It is fully essential to social and human development in its ability to transform lives. For individuals, families, and societies alike, it is an instrument of empowerment to improve one's health, one's income, and one's relationship with the world.*

<div align="right">(UNESCO, 2016)</div>

But despite this close to universal acceptance of literacy for the greater good and the more of it the better, usually, how societies and institutions define, categorise, put boundaries around and then go on to measure literacy often

excludes literacy practices at work in the wider social and cultural lives of citizens. Research evidence into people's 'funds of knowledge' show literacy to be contingent, culturally situated and contextual, so that the ability to use language and its constituent 'schooled' elements (in what is called the 'second space') is developed more successfully when they can be applied in our life-worlds and in communities (our 'first spaces') and, crucially for this book, when they can be negotiated and adapt to meet new textual experiences.

This more ideological understanding of literacy was a major contribution of the New Literacy Studies.

New Literacies

The New Literacy Studies (NLS) offered a resistance to the 'autonomous' view of literacy:

> What has come to be termed the "New Literacy Studies" (NLS) ... represents a new tradition in considering the nature of literacy, focusing not so much on acquisition of skills, as in dominant approaches, but rather on what it means to think of literacy as a social practice.
>
> (Street, 2003, see also Gee, 2015)

The NLS approach starts out from a concern that the autonomous framing of literacy assumes, and imposes, when adopted in education, a linear development model, whereby literacy is understood to be an internal, individual, mental process. The alternative view, supported by research, is that literacy is socially augmented, impacted by social, material and economic conditions and exchanges. The NLS project has been to acknowledge and research everyday literacy practices in media and digital culture, multimodal literacies and to explain the rich implications of these for education. Bezemer and Kress articulated this movement as comprising three principles:

> First was the core, the 'substance': the connection between communication and learning as the constant, recurring issue throughout the different projects we (had) worked on. The second was our use of a social semiotic theory, which meant we were bound to look at all of the means for making meaning. It provided us with the overarching frame of multimodality. The third, equally crucial, matter – the other large constant – as and is our settled understanding of the significance of the social as the frame, as the shaping force for all actors and all action.
>
> (Bezemer and Kress, 2016: ix)

In the 15 years since the quote above, literacy research has continued to ask questions about digital media practices, up to and including virtual reality, with attention to the details of how machines, bodies and minds, space, artefacts, systems and platforms enable and shape the performance of

literacies in new ways, to *"become attuned to a conceptual framing of literacy as lived"* (Pahl and Rowsell, 2020: 166). Literacy studies working through these approaches are more ethnographic, seeking to offer 'thick description' of literacy practices on the terms of the participants they work with, in 'first space' communities and 'third spaces' where these living literacies can be exchanged with the epistemologies at work in formal spaces for education and work.

Media Literacy

Media literacy is now also established by UNESCO as a human right, but, perhaps surprisingly, the same situation has unfolded, with an autonomous model of MIL (media and information literacy) in circulation. This model foregrounds the 'what' of media literacy rather than the 'how' of living media literacies in context of the *uses* of media literacy (Bennett *et al.*, 2020).

> *He can mess up our TV remote. And he can turn up my Bose radio, usually to the classical music channel. Yet, despite Tigger's media experience, I wouldn't classify him as media literate, certainly not possessed of critical media literacy ... Let's call it the Tigger Paradox, the gap separating experience and adeptness from critical analytical ability.*
>
> (Cortes, 2012: 24)

In the UK, media literacy was given policy attention by inclusion in the 2003 Communications Act, under the auspices of the regulator Ofcom (see Wallis and Buckingham, 2013). This development bridged a gap between protectionist ideas about media literacy as a safeguard against media harms and neo-liberal 'citizen responsibilities' for our own engagements with media, the internet and digital culture more broadly. A year later, Culture Secretary Tessa Jowell stated *"... in the modern world, media literacy will become as important a skill as maths or science. Decoding our media will become as important to our lives as citizens as understanding literature is to our cultural lives"*. But five years later, the *Digital Britain* report annexed media literacy as a specialist area, replacing it with ambitions for digital participation, much more about access than critical reading or creative media practices. As Buckingham reflects, at the policy level in the UK, *"Any extended educational conception of media literacy ultimately gave way to a much more reductive, functional notion of technological skill; and to the need to be seen to be 'doing something' about online safety"* (2019: 36).

Internationally, media literacy has traditionally been presented along similar axes of affordance and protection, with genealogical and geo-cultural inflection, as Lin describes with regard to Asia:

Sometimes, various discourses are adopted strategically. The citizenship discourse with a negative assumption from the protectionist discourses of media is an example of a hybrid discourse. As late-comers to media education, advocates in Asia are aware of the dangers of solely applying the protectionist discourse. They strategically adopt the negative effect as rationale for promoting media education while adding the flavour of the active 'civic engagement' rhetoric. The hybrid discourse carries contradictions in itself.

(Lin, 2009: 40)

Lin's observation speaks to the emergence of a set of interrelated and interesting discursive models emerged across the international field of media literacy. The social model has situated media literacy within a broader set of plural 'literacies', as above, whereby *"the competencies that are involved in making sense of the media are socially distributed, and different social groups have different orientations towards the media, and will use them in different ways"* (Buckingham, 2003: 39). Protectionist models share characteristics with attempts to determine competences and skills that can be benchmarked against ages and contexts and are based on normative judgements and definitions of a media literate person, group or whole society. The Citizenship model mobilises a response to technology as a conduit for a 'new civics' to safeguard democracy but this also intersects with the dominant 'employability' discourse, from the 'macro' neo-liberal hegemony, so that media literacy skills are required for contemporary participation in the public sphere and for employment in the 'cultural industries' (Hesmondhalgh and Baker, 2019). The Creativity model is perhaps the most contested variant and can only be fully 'unpacked' through recourse to enduring debates around the nature of creativity itself and its relation to literacy (see Connolly and Readman, 2018). The shift to digital has made a difference to each model, but it is clear that new digital media transitions have never *in themselves* caused a paradigm shift but they have, at each turn, obliged a more reflexive engagement with media as fluid and flowing in the age of 'realised' participation.

The UNESCO declaration on Media and Information Literacy is an overarching set of principles which can be seen to combine the discourses described above. It includes an objective to *"enhance intercultural and interreligious dialogue, gender equality and a culture of peace and respect in the participative and democratic public sphere"* (UNESCO, 2016). Clearly, this is neither a literacy 'competence' for an outcome of literacy that we can assume, to believe that media literacy is somehow innately manifested in enthusiasm to participate in the public sphere and foster respect for the other would be at best naive. Indeed, something very different appears to be happening if we consider what high-level media literacies are being used for at the time of writing – misinformation, rampant commercial exploitation, data harvesting, new forms of propaganda, 'deep fakes' and mutant algorithms.

It is not a lack of media literacies which are fuelling these developments, but a mis-use of them.

The Uses of (Media) Literacy

Richard Hoggart wrote about *The Uses of Literacy* in the north of England in 1957, observing the societal implications of 'mass literacy' and half a century later, reflected on the shifts to a 'mass media society'. The book's original title was *The Abuses of Literacy* and Hoggart asserted that "*As many as possible of the citizens of a democracy must be not only literate but critically literate if they are to behave as full citizens*" (Hoggart, 2004: 189). The criterion for a democracy in this statement endures, and with renewed urgency as societies grapple with disinformation, 'fake news' and new forms of propaganda and media literacy is frequently cited as an answer.

A recent review of media literacy education across the European Union (McDougall *et al.*, 2018) located best practice in moving away from competence models and protectionist approaches to combine and/or cross boundaries between spaces and roles, the classroom and the extended 'third space', with teachers and students working in partnership to co-create learning, and professional development for media literacy educators in hybrid combinations of physical and virtual networks.

In the US context, Mihailidis (2018) advocates for community engaged, activist design principles for a values-driven, civic orientation for media literacy (as opposed to an assumed relation):

> *Between and beyond explorations of national politicians, refugee crises, the dark web, and fake news, there exists a groundswell of innovative and dynamic small-scale and hyper-local initiatives that have leveraged technologies to impact positive social change in the world.*
>
> (Mihailidis, 2018: x)

On the subject of the "information disorder" zeitgeist which gives media literacy more urgency in educational and policy rhetoric, less solutionist, deeper dives into media literacy resist false binaries between fake news and authoritative, trustful information (see McDougall, 2019). Instead, critical media literacy with empirical impact tends to facilitate healthy cynicism about and resilience to *all* media in combination with the capacity to act through the kinds of collective civic uses of media literacy which Mihailidis speaks to. When applied to inter-cultural media development contexts, the geo-cultural nuances and situated, decolonising objectives for media literacy and communicative resilience provide another rich intersection between the legacies of Cultural Studies, media literacy and the NLS (see Rega and McDougall, 2021).

A 'where are we now' assessment of the field of media literacy, prior to application to the context of virtual reality, presents three meeting points – (1) the need to converge the political and conceptual legacies of Cultural

Studies with the NLS; (2) the shift from competence frameworks to a negotiation of *dynamic*, experiential and reflexive media literacy practices in context and (3) the urgent need to understand how literacies are impacted by and, in turn, impact on social media, data and algorithms and immersive mediation in augmented and virtual spaces.

Dynamic (Media) Literacies

Since the shift in focus to a theoretical lens for seeing *transmedia* literacy (Scolari et al., 2018), there has been a convergence of the 'nouns' and 'verbs' of media literacy, as the field has entered a 'next level' phase, beyond competencies and protectionism.

This more *dynamic* approach to media literacy is informed by Cultural Studies and NLS, the former represented by Hoggart (1957) and Hall (1983 and see Decherney and Sender, 2018) in consort with methodologies from NLS as discussed above (Gee, 2015, Street, 2003, Kress, 2003) to offer a more agile, responsive and intersectional way of seeing media literacy in terms of its uses. The dynamic version of (media) literacy is opposed to static conceptions in traditional systems, in the same way as, but extending the ideological approach's resistance to the autonomous model of literacy. People come to be 'interpellated', to mis-recognise themselves as less of more literate in static, performative second spaces (such as education).

> *Dynamic literacies* is a term which is both *synchronic*, inclusive of current situated practices, and diachronic, a term which opens the possibility of movement through time as an incorporated principle as a sharp contrast with the static nature of the literacy of 'the basics', of performative systems to take account of dynamic literacies in an agentive and inclusive way, is a prerequisite to addressing inequality and disconnections in educational settings.
>
> (Potter and McDougall, 2016: 36)

Understood in this way, dynamic media literacy can be a *conduit* for the capacity for action but the social inequalities that impede equal access to media literacy are understood to be often more deep-rooted and structural than binary discourses of centres and margins can account for. For this reason, 'neutral' frameworks for media literacy skills and competences fail to address both the desired 'uses' of media literacy, as has been argued above, but also the way that such competences are related to external and existing hierarchies of social capital and intersect with other forms of stratification:

> *Women, ethnic minorities, younger people, and those with fewer socio-economic resources historically have less access to formal social capital. It is mostly their lack of this formal social capital, rather than their lack*

of skills, interests or economic resources, that drives inequalities in digital civic engagement.

(Helsper, 2021: 113)

More 'activist' media literacy research in transcultural contexts can be seen as dynamic in these ways. The *Transmedia Literacy Project* (Winicur and Dussel, 2020) examined meme production as parodic activism across eight European and Latin American countries, finding evidence of irony and carnivalesque media production developing capability to navigate axes of inclusion and exclusion. Saraway (2020) provides a similar study of young people's meme cultures in India and Uzeugbunam (2020) offers a synthesis of case studies of African youths' hybridised mediated navigation of global youth cultures and indigenous cultures and from these findings, generating a set of recommendations for the field and its institutional framing by UNESCO from a Global South perspective, towards a 'glocalised' media literacy:

> *The tropes of hybridity could lead to a less protectionist approach to media education and a more participatory, active, complex and creative approach. Ultimately, notions and concepts such as hybrid cultures, transculturation, glocalisation, cultural negotiation, and cultural poaching could benefit the field of media education, especially in their shared dimensions of intercultural communication, multiculturalism, cultural empathy, cultural intelligence and cultural literacy.*

(2020: 109)

Thinking about the dynamic *uses* of media literacy also enables, and necessitates, a deep consideration of feminist, post-colonial, intersectional and post-human approaches can, and must, 'decenter' media literacy work. Socio-material media literacies see media literacy as more-than-human but also just as much stratified by inequality and power reproduction as 'just human' understandings. These developments move towards decolonizing the epistemologies of media literacy, as opposed to seeing it as in itself a decolonising project for literacy, crucially, so media literacy can be 'in use' as "*a constellation of unfolding and enveloping, a being/doing/knowing of the world*" (2019: 135).

This version of media literacy situates itself as always-already in 'meta', reflexive mediation. In this way, relations and assemblages of people, machines, media and literacies will always be transforming as they are learned and taught, informed also by Deleuze and Guattari (2004), potentially. Whilst the fields of media, cultural studies and literacy are increasingly attuned to self-knowledge as rhizomatic, these ideas have much to offer media literacy, particularly as it casts its gaze with more rigour on the virtual, as the remainder of this chapter will attest to.

Dynamic Literacies in Virtual Reality

It should be stated at this point that the efficacy of virtual reality as a medium for the development of literacy is not the focus here. This discussion pertains to the difference virtual reality might make to literacy, or whether the kinds of literacy a person needs to engage with VR fully are different to the kinds they need to read and write language, watch films, play videogames, use Facebook, write code, decide how to deal with algorithms. How does a critical, 'full citizen' experience VR?

What VR *does* to (and for) media literacy is important. The scene set above accounts for the tension between a model of literacy which is static and one which is dynamic, and we can reasonably observe that VR is the first 'medium of interest' to force the issue in favour of the dynamic, in so much as it is impossible to conceptualise literacy for virtual world immersion any other way, as is still possible, at a stretch, for previous digital meaning-making environments. Virtual reality is a meaning-making space which requires a dynamic, playful interaction with, and within media and this is an interaction or a mode of engagement which is necessarily reflexive, since it layers onto our ontological perception of lived experience of being in the world with others. This layering is always situated, physically, culturally and socially, and appears to return us, in part, to a perpetual state of augmentation (imaginative worlds overlaid in 'the real'), familiar from childhood, so that:

The ephemeral nature of play is part of the experience, the testing out of a world, being agentive and adapting the narrative, even as you change the direction of travel of the experience and, in turn, experience the provisionality of the world.

(Potter, 2020, see also Yamada-Rice *et al.*, 2020)

This is also important as it loops back to literacy as a broader concept in ways that both support and challenge Lanier's thoughts in our opening chapter. He sees virtual reality requiring forms of literacy practice which are distinct from those required for other textual engagements, a literacy repertoire which can enable enhanced perception and the interplay of creative agency and critical reading. This is what we call dynamic. But whilst, as stated above, the issue is undoubtedly pronounced in and by virtual media, the 'trigger point' is not for another new literacy, but for virtual reality to be the space that lays bare the dynamic nature of all literacy, as it cannot be reduced to an either/or deficit model. Virtual reality, in this way, is positively unsettling and requires unsettling literacies (Lee et al., 2022).

Whilst a dynamic view of literacy will always be socio-material and account for embodied, relational and experiential textualities, the more holistic and, again, deeply situated way of being in the world with people, things and texts, it is clear that virtual reality immersion puts the

experience, negotiation and curation of texts in space and space as text at the forefront of our thinking. And whilst there are important futuring elements of this, so to do the literacy possibilities afforded by virtual worlds as positive problem spaces return us to 'classic' objectives for powerful and transformative literacies from Freire (1970). The social construction of reality as mediated, and the subjectivities and biases in inherent to this mediation, brought to the surface in VR, clearly flows back to the 'real world', or its mediated simulation outside of, or 'before' VR as critical (media) literacy. The argument is over whether we need a new literacy framework for spatial immersion, emotional and empathetic 'worlding' that distinguishes between access, understanding and critical thinking, as has been attempted in models for all the 'other literacies' hitherto, or whether the dynamic nature of literacy means that these skills and dispositions were always in play, at the margins of recognised, validated and 'schooled' literacies.

'Back' in 2017, a legacy text in such a fast-moving field and also, pre-pandemic, Lanier returned to the well-rehearsed evocation of Plato's cave to assert that "interpreting humans as having responsibility is the only of the available interpretations that gives us a chance to take responsibility", but also offered a simple but pivotal other projection of, at least by our interpretation, the need for us not to worry so much about what virtual reality literacy is or isn't but to be very concerned with its 'uses':

> ... an exercise in (haptic) co-ordination that ideally would lead to remarkable empathy and sympathy could just well become a narcicissm magnifier ... This is how VR will be, like all the media before it: capable of amplifying both the best and worst in people.
>
> (2017: 142)

This is the crux because the limitation of attempts at extending 'official' literacies for those previous new media has been to pre-occupy with defining the literacy, prescribing the skills required and attempting to traverse an impossible impasse between protectionist moral panics and neo-liberal economic modalities. For example, a media literacy for playing *Grand Theft Auto* well whilst critically reading its ideological premise but also a media literacy for coding and game development so you can work for Rockstar Games. Using your media literacy for social justice objectives has been, at best, an assumed outcome. But with the Lanier quote above in mind, perhaps VR makes the uses impossible to any longer ignore? Interpreting humans as having responsibility implies a desire for social change and resonates with understanding literacies as 'living', an approach which "recognizes the role of affect, embodiment and emotions in the ways people live literacies" (Pahl and Rowsell, 2020: 8). This enables us to see virtual reality as a 'maker-space' in which people become designers of experience and sociality in ways that return to the world experienced as real.

Dengel (2018) suggests a framework for a 'virtuality literacy' which requires a meta-cognition of '*the representation of perception*':

> Virtuality Literacy focuses on the transfer process of information from the real or fictional world into a virtuality and vice versa. To split Virtuality Literacy into teachable segments, we distinguish the *Representation of Sensory Stimuli, Immersion and Presence* as well as *Virtual Information and Media Literacy* as partial competences of the transdisciplinary computational thinking concept of Virtu-ality Literacy.
>
> (2018: 2)

This is helpful theory-building in terms of the intersection forged between elements and the sense that a fully literate VR experience will require a preparedness to experience the immersion as mediation, and in the moment critical media literacy par excellence, to read the perception of representation of experience as it happens. And yet this account appears to set out these related elements as being akin to the ability to read, or not.

By contrast, the argument here, again, is that exploring VR literacy is more about harnessing the 'VR moment' to recharge media literacy so it can dynamically account for how literacy is always-already about participation, various forms of collaboration, an interplay of reading and writing (in the broadest sense), multimodal textuality, the impulse to be creative through the *making* of meaning and fluid negotiations of space and time. Watching *The Tempest* at the RSC, listening to Kae Tempest, modding Atari's retro *Tempest*, all of these textual experiences require those dynamic repertories, but VR gives them a kind of sensory epiphany.

A 'Model' of Media Literacy That Works for Virtual Reality but Also Loops Back to Media Literacy Better

In previous work (Bennett *et al.*, 2020), we've distinguished the positive *uses of* media literacy from the more neutral 'composite model' of competences (see McDougall *et al.*, 2018) generated by international networks and framed by UNESCO and others at the policy-steering level.

In the composite model, whilst access is an 'entry-level' pre-requisite, the distinction between media literacy skills and competences, critical media literacy and then the development of that critical literacy into capability for action, is achieved through a combination of all the elements. The tension between the composite model of skills and competences and our interest in the uses of media literacy is that the latter is too often assumed to be a positive outcome of the former. It is this more nuanced and challenging interest in what people use media literacy for as part of being in the world with others that we want to take forward into media literacy in virtual reality, and then take back into media literacy from our exploration of VR.

What's important here is the way that current theory about media literacy is useful for understanding what is happening in virtual reality at the same time as what is happening in virtual reality is useful for emerging theory for understanding media literacy, as VR is described as "the farthest-reaching apparatus for researching what a human being is in terms of cognition and perception" (Lanier, 2017: 1) whilst current media literacy theory is concerned with *"drawing attention to the discursive frames that shape everyday lives and the literacy practices that are a part of them, and disrupting these frames through research and practice which challenges how they are set"* (Jones, 2018: 14).

This book is about understanding virtual reality, by using frames of reference from media literacy, but it will also help us understand media literacy better, as, whilst virtual reality, now in its third wave, is not new, the intersection of media literacy thinking about dynamic, living practices and virtual reality's affordances for foregrounding immersive, embodied literacies is hitherto under-developed. The way that the virtual reality text responds to the active participant in real time is a compelling example of these *living* media literacies. So, we are not thinking about immersive media experience as a contrasting media literacy, from within the screen, to 'traditional media' literacies, in a before/after relation. Rather, we are finding ways to loop back what we learn about sensory experience and negotiations of culture, memory and presence in VR for how we think about media literacy in general in more dynamic ways. There might also be an important contribution to media literacy as a developing field in the exploration of the ways in which VR might potentially, its pursuit of imagination and the pursuit of dreams, enable critical reflection on the limits and constraints *of* media, a space to foster deconstructive, de-centring meta-literacies.

Whether virtual reality *requires* empathy, *generates* it through the immersive experience of another perspective or whether the difference between levels of empathy enacted by participants is similar to degrees of 'emotional literacy' is one important question for this analysis. The problematic idea that VR is an 'empathy machine' and that the very nature of the immersive media experience will be a good thing for humanity is congruent with the equally problematic assumption that media literacy is in itself a good thing for resilience to media harms and for the future of democracy and social justice. No engagement with media, however critical, is necessarily going to do anything to change how we think of ourselves as people in the world with others. That is a question of the uses of literacy, including the uses of literacies for and in VR, and whether these uses generate empathy depends on other things.

Another is how the experience of immersion is 'read', more or less critically and how the current work on living literacies helps us understand the lived experience of presence in virtual reality. And another is around the importance of storytelling in immersive media and whether the literacies required to experience such stories are different to those required to engage

with stories in other media. To cite Lanier again, if *"this thing we seek, it's a way of being that isn't tied just to our given circumstances in the world"* (2017: 3), then how do we read, more or less critically, our disconnection from our everyday, physical situation, and how do we use this more sensory, reflexive mode of media literacy? There's also an extension of dynamic literacy as agency to unpack here, as the agency of the experiencer is more immediate, and may therefore have value for how we can understand better the agency of the critically media literate 'full citizen' in all textual practices. Going further, how is the virtual reality experience used for good in the world and what are the living media literacies at work in such capacity to act, for example in community settings where space and place are reconfigured for efficacy and voice? (Mikelli and Dawkins, 2020).

To conclude this chapter, here, then, is a provisional framework for all this. In Part IV, we will return to this and fill in the blanks.

Table 3.1 VR for Media Literacy for VR: A Provisional Framework

Media Literacies	The Uses of Media Literacy	The Uses of Media Literacy in VR	The Uses of VR for Media Literacy
Access	Using access to media to challenge access barriers and inequities.	Socio-material, pedagogic and social access points.	
Awareness	Critical, meta reflexion on everyday mediated practices.	Reading presence and immersion. Interpreting choice.	
Engagement	Dynamic Agency in Media Spaces.	Perspective, degrees of empathy, adapting the text.	
Creativity	Curative and maker literacies.	Creative media practice in and of VR.	
Action	Counter-script media, capability for positive change.	From virtual empathy to positive action in space and place.	

References

Bennett, P., McDougall, J. and Potter, J. (2020). *The uses of media literacy.* New York: Routledge Research in Media Literacy and Education.

Bezemer, J. and Kress, G. (2016). Multimodality, learning and communication: A social semiotic frame. *Multimodal Communication, 5*(2), 147–2149.

Blewins, B. (2018). Teaching digital literacy composing concepts: Focusing on the layers of augmented reality in an era of changing technology. *Computers and Composition, 50*(2018), 21–38.

Buckingham, D. (2003). *Media education: Literacy, learning and contemporary culture.* London: Polity.

Buckingham (2019). *The media education manifesto.* London: Polity.

Connolly, S. and Readman, M. (2018). 'Towards Creative Media Literacy'. De Abreu, Lee, A. B. Mihailidis, M., McDougall, J. and J Melki, J. (eds). *The Routledge International Handbook of Media Literacy Education.* New York: Routledge. 245–259.

Cortes, C (2012). Tigger in Cyberspace: Ruminations on McDougall and Sanders. *Journal of Media Literacy, 59*(2–3), 24–32.

Decherney, P. and Sender, K. (eds) (2018). *Stuart hall lives: Cultural studies in an age of digital media.* London: Routledge.

Deleuze, G. and Guattari, F. (2004). *A thousand plateaus.* London: Continuum.

Dengel, A. (2018). Virtuality Literacy: On the Representation of Perception. Proceedings of the international conference on computational thinking education.

Freire, P. (1970). *Pedagogy of the oppressed.* New York: Herder and Herder.

Gee, J.P. (2015). *Literacy and education.* London: Routledge.

Hall, S. (1983). *Cultural studies 1983: A theoretical history.* Durham, NC: Duke University Press.

Helsper, E. (2021). *The digital disconnect: The social causes and consequences of digital inequalities.* London: Sage.

Hesmondhalgh and Baker (2019). *The cultural industries.* 4th Edition. London: Sage.

Hoggart, R. (1957). *The uses of literacy.* London: Chatto & Windus.

Hoggart, R (2004). *Promises to keep: Thoughts in old age.* London: Continuum.

Jones, S (2018). *Portraits of everyday literacy for social justice: Reframing the debate for families and communities.* London: Palgrave.

Kress, G. (2003). *Literacy in the new media age.* London: Routledge.

Lanier, J. (2017). *Dawn of the new everything: A journey through virtual reality.* London: Bodley Head.

Lee, C., Bailey, C., Burnett, C. and Rowsell, J. (Eds.). (2022). *Unsettling literacies: Directions for literacy research in precarious times Singapore.* Springer.

Lievrouw, L. and Livingstone, S. (eds.). (2006). *Handbook of new media: Social shaping and social consequences.* London: Sage.

Lin, Z. (2009). Conceptualising media literacy: Discourses of media education. *Media Education Research Journal, 1*(1), 29–42.

McDougall, J. (2019). *Fake news vs media studies; travels in a false binary.* London: Palgrave.

McDougall, J., Zezulkova, M., van Driel, B. and Sternadel, D. (2018). Teaching media literacy in Europe: Evidence of effective school practices in primary and secondary education. *NESET II report.* Luxembourg: Publications Office of the European Union.

Mihailidis, P. (2018). *Civic media literacies: Re-Imagining human connection in an age of digital abundance.* New York: Routledge.

Mikelli, D. and Dawkins, S. (2020). VR Kaleidoscope: Reconfiguring space and place through community-based media literacy interventions. *Media Practice and Education, 21*(1), 54–67.

Pahl, K. and Rowsell, J., with Diane Collier, Steve Pool, Zanib Rasool and Terry Trzecak (2020). *Living literacies: Literacy for social change.* Massachusetts: MIT press.

Potter, J. (2020). Digital literacy/'dynamic literacies': Formal and informal learning now and in the emergent future. *The Routledge Companion to Digital Media and Children*, 256–264.

Potter, J. and McDougall, J. (2016). *Digital media, culture and education: Theorising third space literacies*. Basingstoke: Palgrave MacMillan.

Rega, I. and McDougall, J. (2021). Dual Netizenship: https://dualnetizenship transferableprinciples.wordpress.com/

Saraway (2020). '"We Don't Do That Here" and "Isme Tera Ghata, Mera Kuch Nahi Jata": Young People's Meme Cultures in India'. Frau-Meigs, D., Kotilainen, S., Pathak-Shelat, M., Hoechsmann, M. and Poyntz, S. (eds). *The Handbook of Media Education Research*. Oxford: Wiley-Blackwell: 85–96.

Scolari, C., Masanet, M., Guerrero-Pico, M. and Establés, M. (2018). Transmedia literacy in the new media ecology: Teens' transmedia skills and informal learning strategies. *El Profesional de la Informacion, 27*, 801.

Sherman and Craig (1995). Literacy in Virtual Reality: A New Medium. *Computer Graphics*, November 1995.

Street, B. (2003). *Social literacies: Critical approaches to literacy in development, ethnography and education*. London: Longman.

UNESCO (2016). *Riga recommendations on media and information literacy in a shifting media and information landscape*. http://www.unesco.org/new/fileadmin/ MULTIMEDIA/HQ/CI/CI/pdf/Events/riga_recommendations_on_media_and_ information_literacy.pdf

Uzuegbunam (2020). 'Toward Hybridized and Glocalized Youth Identities in Africa: Revisiting Old Concerns and Reimagining New Possibilities for Media Education'. Frau-Meigs, D., Kotilainen, S., Pathak-Shelat, M., Hoechsmann, M. and Poyntz, S. (eds). *The Handbook of Media Education Research*. Oxford: Wiley-Blackwell: 97–106.

Wallis R. and Buckingham D. (2013). Arming the citizen-consumer: The invention of 'media literacy' within UK communications policy. *European Journal of Communication, 28(5)*, 527–540.

Winocur, R. and Dussel, I. (2020). 'Memes Production as Parodic Activism: Inclusion and Exclusion in Young People's Digital Participation in Latin America'. Frau-Meigs, D., Kotilainen, S., Pathak-Shelat, M., Hoechsmann, M. and Poyntz, S. (eds). *The Handbook of Media Education Research*. Oxford: Wiley-Blackwell: 33–46.

Yamada-Rice, D., Dare, E. Main, A., Potter, J., Ando, A. Miyoshi, K., Narumi, T., Beshani, S., Clark, A., Duszenko, I. Love, S., Nash, R., Rodrigues, D. and Stearman, N. (2020). *Location-Based Virtual Reality Experiences for Children: Japan-UK Knowledge Exchange Network: Final Project Report*.

Part II
Understanding VR

4 Understanding VR

Sarah Jones, Steve Dawkins, and
Julian McDougall

The previous section of the book concluded with a provisional framework for new media literacies that contained five main areas of interest in relation to media literacies in general:

- access: *using access to media to challenge access barriers and inequities.*
- awareness: *critical meta-reflection on everyday mediated practices.*
- engagement: *dynamic agency in media spaces.*
- creativity: *curative and maker literacies.*
- action: *counter-script media, capability for positive change.*

In this section of the book, we start to unpack some of the issues related to those five areas in specific relation to our task of developing media literacies for VR, the second column in our table. Through a series of chapters that cross over in their detailed exploration of each of these areas, this section will provide a more focused exploration of VR in action.

It begins with some first-person 'virtual encounters' with specific experiences of VR. These provide a sense of the importance of space and place for VR, which may be less important in other media forms, as well as the specific aspects of these experiences that provide their power. Implicitly and explicitly, they highlight how each of our five areas of interest directly impact on, and are impacted by, the lived experience of the experiencers of VR texts: their *"being in VR"*. It is challenging to write a book on VR without experiencing VR so these illustrate the sense of being immersed in the technology.

The section then includes a series of specific, theoretically informed chapters that explore aspects of VR in order to more fully understand the different areas of VR that feed into our discussion of the necessary literacies needed to be a critically-engaged user.

Verity Mcintosh explores how VR functions as a specific technology and provider of experiences that enable the audience to become "frameless, boundless and transformed". In doing so, she highlights the important, specific features of VR in relation to *awareness, engagement and action* that require further analysis in terms of media literacies for VR.

DOI: 10.4324/9780367337032-7

Jenny Kidd and James Taylor develop this further by relating debates around *creativity* and *access*, especially around the digital divide, to a discussion of the types of "positive action in space and place". They argue that educators have the power and responsibility to provide this by looking at a specific case study within their Higher Education institution and through the results of some preliminary research from educators in other HE institutions in the UK. Although preliminary, this research provides useful clues as to what the final two columns of our table in the previous section might contain.

In their chapter, Turo Uskali, Matti Rautiainen, Merja Juntunen, Riitta Tallavaara and Mikko Hiljanen provide an international case study of "positive action in space and place" through a discussion of their JYUXR campus in Finland that provides a sense of the difficulties of, and possibilities for, social VR in an educational setting. Although the result is the need for their institution to develop alternative means of educating students owing to the pandemic, it usefully highlights issues around *access, awareness* and *engagement*.

Andy Miah focuses on *creativity* and *action* and how an ethical foundation is necessary for XR creatives. Following his provision of a "typology of XR experiences", he works towards a set of principles for the ethical design of XR experiences.

Vicki Williams explores what she calls the *unruly encounters* in immersive environments: encounters that break the sense of immersion so often touted as a key feature of VR. In doing so, she highlights how these encounters can be pedagogically important in developing a critical, meta-reflection on the part of the experiencers.

The section concludes with an exploration of our five key areas through the results of discussions – both individual and in a round-table discussion – with a range of VR creatives and educators.

 The overall aim of this section is to both explore and interrogate some of the already-sedimented understandings of the limitations, potentialities and possibilities of VR. The ideas and analysis enable some conclusions to start to be drawn about what an 'immersive literacy' might look like and how, as educators, creative producers or users of VR, we can engage meaningfully with immersive technologies.

5 Virtual Encounters

Edited by Julian McDougall

Accounts by

David Smith, Rain Fruits
Melanie Hogue, Notes on Blindness
Steve Dawkins, Cirque du Soleil
Sarah Jones, Catatonic
Bertie Millis, PTSD

Unable to travel due to the COVID-19 pandemic, many of my most memorable experiences during 2020 took place in my home or in short, masked, trips to the store for essentials. I craved travel and new experiences more than ever, and luckily the Tribeca film festival made their 360-degree, 3DoF films available through the Oculus Store. This was one of the few benefits of life during the pandemic – films and experiences that would ordinarily only be accessible to attendees at the major festivals were distributed more widely. Because of this, I was able to download onto my Oculus Quest a twelve-minute film called Rain Fruits, a dramatic interpretation of the true story of an immigrant worker. Then I was instantly transported from my couch in Pittsburgh, Pennsylvania to Myanmar and South Korea, and into the life of Thura.

The sound of raindrops falling on water. I try to focus on the scene, but it's dark and fuzzy, with only animated raindrops falling from above visible. They make ripples in the dark water below. I was expecting an immersive, realistic traditional 360-degree video, but this is clearly not that.

Then brush strokes appear above the water, outlining a curving dirt path into the distance, down which a boy follows other children as a voice begins, calmly: "It rains a lot in Myanmar … my mom always told me, if I lie, thunder and lightning will punish me". An animated scene of the boy, at night, during a thunderstorm, is visible in the distance.

Fade back to the blurry, dark rain, then a new, peaceful scene as the narrator continues: "When heavy rain stops, water drops turn into jellies. We call it 'rain fruits.' If you grab them too hard, they just break and become plain water drops. Mom told me, if I really want to have something precious, I must treat it with all my heart".

DOI: 10.4324/9780367337032-8

I later realise that by placing me, literally, in the middle of this scene at the beginning of the film, the pastoral intro plants a seed of nostalgia in my mind – a warm memory of the past that lingers throughout the coldness to come.

Next, I'm in a completely unfamiliar cloud of particles. I'm on the streets of Seoul, with the ghostly impression of buildings set against darkness, with our narrator, Thura, only feet away. I can't make out any of his features, as he's only depicted by a series of horizontal, wavy lines that float as he moves. As someone who's familiar with the technology, I recognise how this was produced: hazy, half-visible holograms (volumetric video) of the characters placed in scenes consisting of pointillistic buildings.

I don't control the camera in this film as it moves through these scenes. I'm fixed, unable to change perspective other than looking around. Sometimes, the camera moves through a scene at about 6–8 feet high, while at others it stays fixed and the action moves around me.

Without knowing the purpose of Thura's move to Seoul, among the first impressions I feel is the loneliness of someone overwhelmed by the speed and impersonal nature of life in a large, bustling city. As the narrator describes how people enter the subway and scurry underground "like rats", then remarks how he feels like a caged rat in his tiny apartment, I also feel lost in a world of abstract scenes.

The camera shifts and I'm in another scene, move slowly for a full minute, through a factory floor – where, instead of learning a skill, Thura is taught to "push five buttons". He becomes increasingly aware that his Korean co-workers so fear losing their jobs that they relegate immigrants to simple manual labour. I see everyone as ghostly outlines, including an abusive boss wielding a bat, quick to crush workers' rights protests with violence.

As Thura is beaten for protesting, his outline explodes into a cloud of red, fiery points in a sea of darkness, and the sound of the bat making contact fills my ears. It's a chilling moment, and I flinch after each swing of the bat.

Next I hear Thura's description of filtering the truth in his letters home. While he describes his anguish of hiding his failures, I watch as he meets other unemployed immigrants and struggles with his identity in a strange country. The whole time, I float through these point-cloud scenes ... down a city street, through a park, into his new factory where he finds meaning and actually starts learning a craft. Although each scene is incomplete – with edges fading to darkness and humans with indistinguishable faces – this only draws me into the narrator's voice more. The effect is a dream-like experience where I feel as unmoored as the narrator. There is no floor, no foundation, no clearly-defined boundaries.

Finally, I see Thura writing at a desk in his tiny apartment. "It's time to go back", our narrator says, "to the place I belong". The point cloud particles that define the walls of his apartment fall away, like rain. And then I see those same particles form trees as the soothing sound of rain drowns out his voice: "I ... am going home".

Although the film was not at all what I expected when I put on my headset, I realised after removing it that the slow movement of the camera kept me disoriented, much like Thura's disorientation when removed from his foundation. Sitting in my chair, it took a minute to shake the memory of floating through swarming point particles that appeared, dissipated and re-formed as impressionistic images. Reflecting on the experience, it reinforced for me the ability of virtual reality to alter viewers' sense of space and time, and to create new worlds through abstraction and metaphor. But most importantly, the poetic narration and visual storytelling helped me better understand the perspective of someone half a world away.

Looping back to Chapter 3, which proposed a framework for understanding VR through media literacy, and understanding media literacy better or differently with VR, we are on the way to completing that mapping, but not there yet.

To think through how we can account for some key elements of that tentative framework – critical, meta reflexion; reading presence and immersion, perspective, empathy and adaptation – the literacy practices we think about when we talk about dynamic agency in media spaces – we are aided by these first-person accounts of being at once 'in the affordance' and at the same time critically engaging. In Simone Natale's recent exploration of our experiencing artificial intelligence as 'banal deception', she observes that:

> Our vulnerability to deception is part of what defines us. Humans have a distinct capacity to project intention, intelligence, and emotions onto others. This is as much a burden as a resource. After all, this is what makes us capable of entertaining meaningful social interaction with others. But it also makes us prone to be deceived by non-human interlocutors that simulate intention, intelligence and emotions.
>
> (Natale, 2021: 132)

This being in VR is then, a matter of habitus and we know from the long-established field of literacy, how important habitus is to how we read ourselves into being in the world with others, or as Natale concludes, negotiating 'our sophisticated selves'. Hanley (2017) reflects on her experiences of social class, cultural reproduction and the habitus clash in moving between social mobility and divided identity and in so doing describes Richard Hoggart's *The Uses of Literacy* as an 'intellectual backbone':

> When he writes about the 'fine topcoat' of empty salmon and fruit tins on the Hunslet middens at Sunday teatime in the nineteen thirties, I'm instantly transported back to my parents' kitchen in Birmingham in the late eighties, sticking on Radio 1 to hear the Top 40 countdown, getting out the can opener, mashing the salmon with vinegar and plopping Dream Topping on the peaches. I felt kinship with Hoggart's essential loneliness as

every exam he passed took him further away from his working class neighbourhood and closer to a place that was more comfortable in every way except for the emotions that accompanied him on his journey.

(2017: xiv)

Back in 1950s Yorkshire, this maybe seems a leap (back) from the virtual reality futuring we are largely concerned with in this collection. But, albeit a lazy soundbite, the 'back to the future' this presents is established elsewhere in this book series, where we have offered a contemporary application of Hoggart's 'Uses' to the broader field of media literacy. And so, a critical reading of the literacy practices at work in the 'VR experience' is clearly part of the same project and habitus, via Natale on AI, connects us to Hanley and Hoggart and our emerging theorising of 'VR literacies' as also dynamic, 'meta' and living

It is early morning when my bike skids to a stop behind the Communication building. It's part of a morning routine I've developed after joining Stanford University's M.A. Journalism program. Entering the familiar double doors, I am welcomed by the gaggle of voices and laughter that normally beckon me upstairs. But, today I choose the silence.

Entering a seemingly empty studio downstairs, I leave all of this morning's thoughts at the door. Here, anything can be left behind in place of an alternate reality of my choosing. All I need is the simple switch of a VR headset.

Today, it is "Notes on Blindness".

A blanket of darkness replaces the bright room as I settle the headset over my eyes. The studio fades away but the solitude I once had is quickly replaced by audio that fills my senses.

A familiar environment comes to life and I'm quickly enveloped by nature. A cacophony of activity and life is all around me. The room is filled with birds and wildlife that were not there moments ago.

I hear everything, yet see very little.

There is text on the screen that introduces me to John Hull. The sounds are those he documented through audio diaries. His voice welcomes me into a world he has come to know well – the acoustic world.

John Hull has lost his eyesight.

The environment is dark with faint silhouettes of light that change along with the narration. The echo of different footsteps appears as light graphics tap across the screen. People gather, trees rustle, conversations happen and suddenly the space is filled with bustling activity that I can almost see.

But, I start to wonder whether my mind should be filling in the gaps. Isn't the point to understand better? I have the urge to close my eyes.

Just as quickly as the thought crosses my mind, it all is taken away.

The activity ceases.
The sound stops.
The world dies.

There is only silence.
Suddenly, I think I understand. When the cassette recording clicks off
and I am left with sounds of rippling water, I find myself wanting back a
visual world I hadn't yet realised I was already missing.
Notes on Blindness allowed me to experience the world in a way I had never
done before. It was the first time I fully understood the power storytelling
mediums could have when used for the right purpose. In this case, VR didn't
force me to walk in someone else's shoes but allowed me the opportunity to see
where they stood. It was a lesson in providing new perspectives that I would
take with me throughout my career in immersive journalism ... and life.

"*Suddenly, I think I understand*". This is powerful, and yet, and cru-
cially, the understanding is that meta-reflection on the always-already,
through a new perspective.

Mark Fisher's *Capitalist Realism* (2009) was critically celebrated when
published over a decade ago now and recently reappraised for the various
significances of 'the moment' – covid, populism, climate crisis, polarisation
in public discourse and/or the chance to future post-covid with any flavour.
Fisher invokes Lacan, Zizek and Deleuze to discuss environmental cata-
strophe as a Real which must be suppressed within the order of things, of
capitalism, via dreamwork and 'memory disorder' – forgetting as an
adaptive strategy in the face of 'ontological precarity' – which resonates
with 'strategic ignorance' (McGoey, 2019) of power and bias and also the
recent films of Adam Curtis' (2021), which suggest (in my interpretation of
something more of a deep social imaginary) that the dynamic inner mind of
our contemporary mediated being is profoundly at odds with static, un-
developing civic and political structures.

These ideas intersect to help us think about the ideological configurations,
not *of* VR, but of *our being in* VR. Are there 'real', present opportunities to
harness VR immersion as event (in the postmodern, but radical, sense in
which Lyotard uses the idea, as ethically charged), as "*The tiniest event can*
tear a whole in the grey curtain of reaction which has marked the horizons of
possibility ... suddenly anything is possible again" (Fisher, 2009: 81).

My experience began on a wet and windy Sunday morning at an Arts
Centre in the UK Midlands. The Arts Centre was undergoing a huge re-
furbishment and so entrance to the venue was not the usual front entrance but
a rarely-used back entrance that took some finding. The conversation in the
queue waiting to go in was about how unsatisfactory the signage to the room
had been and how cold and unwelcoming the corridor in which we stood was.
When the doors to the 'screening' room opened, we were led into the
room and asked to leave coats and bags near the door before being shown
to a seat. The immediate sense of the room was one of calmness. The
lighting was low and there was a table with rows of head-mounted displays
on, lit by candles. The 18 or so chairs were set out in a circle in the middle
of the room with a pre-pandemic one-metre gap between them and, once all

seated, there was a palpable air of anticipation amongst the people in the room. The overall breakdown of people was predominantly white (with only one person evidently from a minority ethnic group), split equally between genders and with a range of ages from late teens to (possibly) early 70s. The staff from Limina Immersive asked who had experienced VR before and about half of the group raised their hands. There was a short introduction to the experience by the staff before our HMDs were put on.

The experience itself comprised two experiences – Through the Masks of Luzia and Ka: The Battle Within – and was of the quality that one would expect from Cirque du Soleil with beautiful costumes, lighting and activities. In both, the full 360-degree space was used with audio and visual clues used to direct the experiencer's gaze. Given the quality of the experiences and the content of them, what was noticeable was the lack of sound that anyone in the rooms was making: even when viewing the most gravity-defying activities, for example, there were only minor moans and groans. This quiet carried on when the HMDs were removed with very little discussion between people and, what there was, being carried out in hushed whispers. As such, it was difficult to get a sense of what the collective sense of the experience was but the two comments that were heard by me were: "That was amazing" and "Now I can say I have done VR".

There was something exciting about experiencing VR as a sense of occasion, rather than in the usual ways (at home, at work as part of a project) but, on reflection, the whole experience felt quasi-religious: the quiet room, the collective experience of something very different to normal and the personal experience in a collective social space.

Curry and Kelly (2021) foreground media engagement, of all kinds, as an exercise of power, through an ontological layering that reminds us how:

> Media literacy does not challenge the power of media if it encourages critique of the text as misrepresenting worldly things while neglecting to reveal the social relations and practices of its production, dissemination, and consumption. Moreover, emphasis on misrepresentation implies that authentic representation is possible, ignoring what interests us—social processes that mediate our knowing as the operation of power.
>
> (2021: 11)

This 'layered ontology' is so important to us here because it prevents us from 'sleepwalking' into a view of what VR does to media literacy (and vice versa) as a temporal shift. Instead, we are obliged to acknowledge here that mediation is/was always-already virtual. Through the lens provided by Curry and Kelly, we can focus on the empirical layer (text); actual layer (the representing text, in communication) and the deep real layer, where *"meaning embedded in the text embodies social relations and practices"* (2021: 11)

What we need to work through, for media literacy, is not, as we might have assumed, the notion that VR adds a layer to the onto-epistemology of media literacy, but rather, how such a layered ontological approach to media literacy can offer a way of seeing how being in the virtual is to experience the mediation of knowing and how this at once the same as for any media, but with some kind of liberation from the deception of the authentic.

I was in a non-descript hotel room in London. I'd been for a work dinner with eight peers and was ready to retreat. At that time, I always seem to carry a mobile VR headset with me, I think this was the Samsung Gear VR. It was essential to make sure I could always give people their first VR experience. Switching off for the day, I decided to step into the virtual world and experience something new. I opted for Catatonic.

I am sat in a wheelchair. When I look down I can see my hands are strapped to the arms of the chair. I can't move them. I'm in a hospital robe. A turquoise style robe that patients would be wearing. I don't know why.

I'm in a lift. The doors are closed. I think I'm moving. It's dark. It feels old and grey. The doors open and I'm pushed out. As I look around, I can see I'm in a hospital of sorts and a nurse walks towards me, showing me which way to go.

I can see now where I am heading, the psychiatric ward. She smiles slightly as she opens the door.

It feels ominous. I'm on edge as I am pushed down the corridor. It's dark and the lights are flickering, on and off. As I move through the corridor, I glance into the rooms and see people. I see shadows. I see silent pain inside the rooms. Patients screaming. Mess on the floors. In one room, it looks like there is a cage on the floor. A wooden box. Someone crawls out from behind. Tentatively peeking out. I don't know if it's a child or a small adult. They are distraught. I am frightened.

Still the man in the black bow tie pushes me through.

I am pushed past a man tied to a bed, legs spread out, naked. A spotlight shines down on him as he looks at me. I go to look away but am drawn back to his gaze.

Another room. A nurse sits beside a glass box. Coffin size. A woman lies within, only her legs are moving.

I stop moving. I am no longer being pushed. The man in the bow tie walks away and I am alone.

I start moving again. Another man has taken over and pushes me out of the corridor to the top of the stairs. My heart races. I am perched at the top looking down. I cannot move my arms. I am stuck in a chair and yet I am balanced on the top step.

The screen flickers back.

A man, maybe a man, I'm not sure rushes towards me, springing out of a chair. He goes to push me but I can't see his face. He has something over it with rope, or tape around it. How can I see? Who is he? Is he a patient or someone working here?

I am still at the top of the stairs and then suddenly I am going down. I bump and bash down as the lights go dark and flicker on and off.

I'm then in a room. Lights are still flickering and I am finding hard to orientate myself. I don't know where I am. I can see people. Women. They're all facing the wall and all wearing long gowns. They're almost floating but I know that can't be the case.

There is a strobe on the screen and I don't know where I am but I can see the outline of a man. When it flashes, I can see a room, almost like a makeshift hospital operating theatre, lights and a transparent screen. A man comes towards me, right up close in my face. I can see he is holding something that looks like an injection.

The flashing and strobe is making me feel disorientated. In one second he's in my face, the next he's far away. I don't know what is happening, but I am terrified. Suddenly I'm surrounded by other patients and they're coming close to me.

I scream and throw off the headset.

This experience still terrifies me. I remember the faces vividly. When I think about it, I can see the man in the glasses getting closer, breaking all boundaries and social etiquette. He's there whenever I hear the words Catatonic. It is so clear in my head. The haunting images of the characters inside their rooms. My stomach is in knots at the top of the stairs. The flashing lights blinding me. The power of this experience has stayed with me. It's the power of an experience to have a long-lasting effect on the mind. I am still haunted by this.

The power of an experience. Haunting. This stark, visceral and deeply personal account might seem to evade more sober 'theorising'. And yet, how we can 'pedagogise' such direct experience as reflective literacy practice is at the heart of our endeavour.

In formal education, media literacy is itself haunted by ghosts of social realism. Connolly (2021) draws our attention to the epistemological precarity of a discipline whose very existence can be said to problematise the notion of subject-object knowledge transfer beyond any function. But he sees a way through this in combining critical realist pedagogy (whereby students are seen as dynamic agents, re-contextualising subjects through the experience of it) with the deep interest in students' funds of knowledge that we can take from decades of literacy research, culminating in a view of media learning as a kind of curation of experiential media engagement events, assemblages of embedded social relations. Thinking about 'learning to learn' both through and about virtual realty, this resonates with both the 'layered ontology' considered above, as well as accounting for 'virtual habitus' and the media literacy practices of meta-reflexion and adaptation we want to apply to VR. We are 'getting there'.

And yet, there is a difference, and this obligates a pastoral concern, something happens in the 'amplified scale' of mediation. Ethical concerns meet the inexpert pedagogy we need for 'VR literacy', giving up on knowing, moving (back) to feeling and thinking

Alongside the day-to-day work of looking after clients and trying out VR experiences, one of most important parts of my job is showing virtual reality to the general public.

I believe that a VR experience begins before you even put a headset on, it starts the moment you enter the room. There is a right and a wrong way to demo VR.

It is hugely important that we make people feel comfortable before and after trying VR. I am quite obsessive about how we (as a company) demo content, but that is all down to years of learning the best practices.

I think that is a good thing that I obsess about this, and that my team cares too.

On several occasions, we have been requested to run VR cinemas or demos for upsetting content. A particular memory that remains with me is when we were running screenings for a VR documentary piece about a tragic event that took place in London.

We were aware of the immense emotional impact that this piece would have on the witnesses, survivors and bereaved.

We made it a priority to ensure we have the support of NHS mental health and wellbeing professionals that could be there to talk with and comfort anyone who needed help.

It turned out, I needed it too.

In this job, you become an emotional sponge. You're the first point of contact for people when they come out of the headset. You absorb a lot of information and a lot of emotion from other people.

I spoke with witnesses of the tragedy and those who were directly affected – those who were in the streets and those who lost friends and loved ones. I heard harrowing stories. My heart broke over and over again for three days straight, but I wanted to be the right kind of support from the moment the headset came off. I had to be there to listen, to comfort and to be there for any questions or comments.

After talking to one of the NHS workers about the process of showing the documentary she was interested to learn more about how, as a professional working on an intense project, I was being affected. I was shocked to discover (after being assessed by the NHS worker) that I was showcasing early signs of PTSD.

It is only now, that I realise how much psychological weight from people's stories you hold onto.

I really appreciate the NHS workers being present during the screenings and I feel incredibly grateful that they were able to look after us and our viewers. This experience is one that I will not ever forget. It has allowed me to really reflect on the importance of having the correct support.

We were extremely fortunate to have the support of NHS workers who helped those in need, but also for helping us maintain our own mental fortitude when handling such heart-breaking topics.

Emotional Impact – Film can elicit emotion. Film in VR does this on an amplified scale. We think VR film tends to be about 4x more impactful than traditional film. If someone watches a 15-minute VR film, it will have an emotional impact akin to someone who watched a 60-minute traditional film.

It can bring joy, humour, nostalgia ... But what happens when content makes people feel upset, frustrated or even re-live a tragic moment in life? As the person running a VR showcase, how do you react?

If you are the first person that a viewer sees when the headset is removed, what is your responsibility in that moment?

I have been to events where the viewer finished a VR experience, they are tearful, maybe even openly weeping, they're rushed along so the headset can be used for the next person. This is a damaging way to conduct a VR screening.

Being a part of the industry, I can see from both sides, when it comes to running event, you have the pressure to get numbers through each day but we have a responsibility to people that we are showing the content to.

Sometimes if content has certain themes you cannot throw anyone into the mix. Warnings and conversations need to happen.

Additionally, it is important for everyone watching the experiences to have time afterwards to decompress.

Our process for running VR cinemas, particularly for emotional content.

Inform the participants: let your audience know how the screening works, how the headset is used. Ensure they are comfortable and know any belongings they brought with them are in a safe space. There are no fire alarm drills scheduled today, the exit is this way, if you need to contact me or do not want to watch it anymore, you can remove the headset at any time.

Provide context about the experience: this can be done in a group setting, let them know what they are watching, if there are any trigger warnings to be aware of. Reiterate that they can remove the headset at any time if they no longer want to watch.

Monitor the experience: watch your audience whilst they are in VR, the film has taken over several of their senses and now you are responsible for them and their wellbeing. Learn how people tend to react at certain moment of the experience. Look out for outliers as these are the people who are having difficulties. It could be the headset is not working, it could be they are emotional, or perhaps something else.

Allow decompression after watching the content: when the film has ended, make an announcement saying thank you for joining us, if you have not done so, you can remove your headset now. Please take your time, there is no rush to leave the room. Take as long as you need. People may want to talk to one another, they may want to talk to you.

Be empathetic, listen to what they have to say, try to answer questions where possible.

But be ready to admit you do not know the answer.

References

Connolly, S. (2021). Towards an epistemology of media education: Confronting the problems of knowledge presented by social realism. *Pedagogy, Culture & Society, 29*(2), 315–329.

Curtis, A. (2021). *Can't get you out of my head*. London: BBC.

Fisher, M. (2009). *Capitalist realism: Is there no alternative?* London: Zero Books.

Hanley, L. (2017). *Respectable: Crossing the class divide*. London: Penguin.

Hoggart (1957). *The uses of literacy*. London: Chatto Windus.

Kelly, D. and Currie, H. (2021). Beyond stereotype analysis in critical media literacy: Case study of reading and writing gender in pop music videos. *Gender and Education, 33*(6), 676–691.

McGoey, L. (2019). *The unknowers: How strategic ignorance rules the world.* London: Zed Books.

Natale, S. (2021). *Deceitful media: Artificial intelligence and social life after the turing test.* Oxford: Oxford University Press.

6 Understanding VR Audiences

Verity Macintosh

Let's get something out of the way immediately. There is no good, or at least mutually accepted word for what or who you become when you take part in virtual reality (VR). This is a relatively new medium, and the language that we use to describe it is yet to settle into a tidy set of cultural norms. A handful of options currently doing the rounds for your consideration:

- Participant
- Audience
- Player
- Actor
- Visitor
- User
- Viewer
- Viewser
- Youser
- Immersant
- Actant
- Interactant

To save you from grinding your teeth to dust trying to resolve the matter during this chapter, we will adopt "audience" and "audience member" as our erstwhile descriptors here. "Audience" is far from perfect, skewing heavily towards traditions of art and culture rather than games or apps for example, but for our purposes it runs a helpful gamut of behaviours, from sitting in a darkened room, eyes glued to a cinema screen, to running through the streets shrieking as you escape heinous villains in an immersive theatre experience.

What Is It Like to Be an Audience Member in VR?

VR as a creative medium can offer audiences a wide range of experiences. In these peculiar, awkward, Tardis-like headsets which are somehow bigger on the inside than they are on the outside, we as audience members might

DOI: 10.4324/9780367337032-9

find ourselves tip-toeing through dramatic story worlds, communing with nature, or travelling to distant lands. We might tower above familiar neighbourhoods as giants, or shrink to the size of an atom as we tour the nanosphere. Perhaps we will use VR to connect with people thousands of miles away, coming together for a chat, a dance, for work or to see a show. Perhaps we will find ourselves in a body that is different to our own, witnessing events unfolding as though through someone else's eyes. Perhaps we will sit quietly with someone who is not really there as they tell us about their life and their ideas. And perhaps we might contribute our own voice, or use our virtual hands to create and destroy virtual worlds brought forth by our own imagination.

Whatever we choose to do in VR, we as the audience will be at the heart of this world. There is no glowing rectangle here for us to tap or look at. We are frameless, boundless, transformed ... and at least partially oblivious to the flailing, face-bucket-wearing, pseudo-cyborgs we have become.

How Is Being an Audience Member in VR Different to Anything Else?

To avoid falling for the hype and hyperbole sometimes afforded to this novel technology, one of the questions that any scholar of virtual and extended realities must ask themselves is "what, if anything at all, is genuinely different about this particular medium?"

Immersion

VR is often described by evangelists as "immersive". More immersive perhaps than any other form of media or live performance that has come before it. Some have even suggested that experiencing immersion in VR can induce behaviour-altering empathy, and even elevate our humanity (Milk, 2015). Many fantastic scholars have taken the time to explain why these assertions should be met with a generous dollop of scepticism (Nash, 2018; Rose, 2018; Nakamura, 2020) and I will not attempt to repeat their insights here. Setting aside such grand claims for now, it can be helpful to consider the term "immersive" in terms of its everyday use, and decide for yourself whether this quality may be as particular to VR as we are encouraged to believe. Director and composer Tanuja Amarasuriya describes what she calls "emotional immersion" as "the private, personal, hard to measure, but deeply impactful sense of involvement that keeps us watching, listening, playing, searching, questioning, caring. It's what moves us. It's what gets under our skin" (Amarasuriya, 2021). This is a powerful force that might sometimes be relevant to VR, but could equally be used to describe an amazing movie, a binge-worthy TV series, an engrossing book, an epic game, a powerful piece of theatre, or even a really good conversation.

Presence

Perhaps a more useful term to explore than "immersion" is "presence". The extraordinary experience of putting on a VR headset and feeling that you are now in the middle of, and surrounded by something completely different from what you objectively know to be your physical reality. Jeremy Bailenson describes this somewhat more succinctly as "that peculiar sense of "being there" unique to virtual reality" (Bailenson, 2018).

There have been multiple attempts to unpack and understand this sensation of presence as it relates to VR; with reports ranging from the near total abandonment of your physical reality to the more pragmatic focus on how much attention you extend to digitally mediated sensory information received in VR, over that which you receive through external stimuli i.e. "presence as the condition when a virtual environment becomes more salient as a source of cognition for a user than the real environment" (Nunez, 2004).

You may find it useful to consider the presence along three interconnected but distinct lines

- Environmental presence, the feeling of being present in a space,
- Social presence, feeling present with other people and
- Self-presence, the sensation of being a physically present entity (Lee, 2004; Ratan, 2012).

In one study, audience members were asked to report what they thought of an experience and whether they had experienced any of these three types of presence in VR. Reporting of one or more proved to "be a useful predictive experiential component of a successful high-impact experience" (Lessiter et al., 2018).

Ideas of presence in VR and what it can do for us as audience members can connect neatly with ideas of Cartesian Metaphysics; the sense that we can separate our minds from our bodies and embark on voyages of transcendent imagination. Maria Sanchez-Vives and Mel Slater suggest that "Presence in a VE [virtual environment] involves transporting a participant's consciousness to a place other than that in which the physical body is actually located" (2005).

In the 1990s, Robert Switzer went so far as to describe VR as "Over-writing the body", suggesting that it might become a tool for transcending our physical selves and circumstances to achieve a sort of mental liberation and escapism to virtual worlds (Switzer, 1997). These ideas have proved particularly popular over the years in those interested in psychedelics and post-humanism. And of course, sci-fi imaginings such as "Ready Player One" or "The Matrix" use fictionalised versions of VR to examine whether we might find it preferable to separate mind from body and live in a virtual world.

It's worth noting that few of those who advocate for VR as a form of Cartesian metaphysics suggests that we should expect or desire this "full

immersion" scenario, that in which an audience member truly believes that they are somewhere, or someone else. More this position suggests that our capacity for cognitive dissonance gives us the ability to voluntarily leave our fleshy meat bags behind us as we mentally commit to an alternate reality.

In her seminal work "Hamlet on the Holodeck", Janet Murray refers to the illusion of presence as an active and consensual act of self-deception, that as an audience member in VR "We do not suspend disbelief so much as we actively create belief. Because of our desire to experience immersion, we focus our attention on the enveloping world and we use our intelligence to reinforce rather than to question the reality of the experience" (Murray, 1998).

Embodied Cognition

The idea of VR as a form of Cartesian metaphysics was probably at its most popular during the last wave of VR in the 1980s and 1990s and speaks to the attitudes and technical limitations of the time. As the higher computational powers of modern headsets have started to enable VR experiences that respond more swiftly and precisely to the way that we look, listen and move, another framing has become popular. Despite running almost contrary to the corporal transcendence of its predecessor, "embodied cognition" has been offered by some as a different way of understanding the "secret sauce" of the VR audience experience.

"Embodied cognition" theory suggests that we explore and make sense of the world (VR or otherwise) through our bodies, using senses such as touch, taste, proprioception (understanding of where our body is in space) and kinaesthesia (understanding of how the body is moving through space) to map and reinforce the experiential reality of our experiences.

Despite earlier citing them in relation to Cartesian metaphysics, Sanchez-Vives and Slater have been among those quick to suggest that embodied cognition may be a more appropriate and nuanced path to understanding of how presence is constructed in VR, suggesting that presence is "tantamount to successfully supported action in the environment ... reality is formed through actions, rather than through mental filters". They go on to explain that "The key to this approach is that the sense of 'being there' in a VE is grounded on the ability to 'do' there" (Sanchez-Vives and Slater, 2005).

Examining this question of embodiment as a differentiator for VR, we can look to a study undertaken by games studies scholars in 2014. Subjects played two versions of the same game, and found that "compared with a conventional joystick controller, embodied gameplay elicited more subjective control, involvement and a sense of interaction with the [...] gaming environment". They also found that "natural whole body movements facilitate social interaction" (Coppi et al., 2014). This study used depth-sensing cameras rather than VR equipment to translate body movement gameplay so parallels can only be lightly drawn. However as depth-sensing cameras have declined somewhat in terms of their use in the gaming sector

(the Microsoft Kinect camera used in this study was officially discontinued in 2017 (Wilson, 2017)), VR may offer audiences a comparable experience of "embodied interaction" using quasi-natural movement as a means to engage with games and mediated experiences in their own homes.

Audience and industry-facing thought-leaders including Sol Rogers (Robinson, 2016), Catherine Allen (Allen, 2017) and Gabo Arora (Connect4Climate, 2017) have called for the use of the "story doing" or "story living" to replace "story telling" when it comes to describing narrative-led experiences in VR. These terms are most likely inherited from the Marketing industry (Montague, 2013) and have found resonance in a VR context. Perhaps they offer a more active, embodied, somatic description of the experience of using your head, your hands, and your body in VR to navigate through a story world as it unfolds in front of, and all around you.

As "story do-ers", audience members in VR can be understood as having an active role to play within a virtual scenario. Perhaps they even "'co-produce' immersive experiences" (Bennett et al., 2021) by choosing where they do and do not look within a 360-degree scene, or more overtly making decisions that affect the way in which a story progresses.

An "Audience Insight Report" by StoryFutures in 2021 takes this idea further to suggest that with this enhanced sense of agency and responsibility "Immersive stories can also create a space where a new kind of politics can form by enabling users to experience a differently-composed world, within which they feel emotionally, viscerally and physically present" (Bennett et al., 2021).

We should take care not to infer that this kind of audience agency is particular to VR. Computer games, immersive theatre, live-action role-play, board games, interactive TV and many others offer differing degrees of agency and can inspire visceral and transformative thinking from their audiences.

Perhaps then VR sits on a continuum with a number of other mediums, containing within it the potential to offer audiences a heightened sense of agency and to implicate the audience in the act of "story-doing".

Co-Presence

It is worth noting that the audience's sense of embodiment within a virtual environment gives rise to another of the more distinctive affordances of VR, that of "co-presence". Slater explains "when several participants are in the same virtual environment simultaneously, co-presence is the illusion of being in the same space as and directly interacting with the other participants. Assuming that each participant is embodied in a virtual body, they can interact with another" (Slater, 2021).

The illusion of co-presence is being used to great effect in myriad "Social VR" platforms such as AltSpace VR, VRChat, Mozilla Hubs and Spatial, each with their own flavour of audience experience and interaction, but ostensibly all providing a virtual space for people to meet, and to have the

sensation that they are together, regardless of where they may physically be around the world.

For many, this affordance of co-presence signals a more expansive potential for immersive technologies and their role within society. The potential for these VR spaces and their augmented reality cousins to morph into a kind of "metaverse", a concept described by the Facebook founder, Mark Zuckerberg as "an embodied internet, where instead of just viewing content – you are in it. And you feel present with other people as if you were in other places" (Newton, 2021). We will return to some of the ethical implications of this kind of emerging social communications paradigm later on.

Dual Consciousness

To this point, we have more or less assumed that the desirable state for VR audience members is to feel present in, and committed to the virtual world that they might encounter with a headset. One really interesting trend to watch out for is the creation of experiences that cause audience members to remain simultaneously conscious of both the virtual and physical worlds that they inhabit.

This approach can hold a mirror up to the artifice and illusion of VR, leveraging our ability to have one foot in each reality as a material quality of the form. In a way, this exposure of the dual consciousness of VR resists the idea of a friction-free "metaverse" in which our physical and virtual selves would become further enmeshed. In "The Cyborg's Dilemma: Progressive Embodiment in Virtual Environments", Biocca warns that "the development of increasingly "natural" and embodied interfaces leads to "unnatural" adaptations or changes in the user. In the progressively tighter coupling of user to interface, the user evolves as a cyborg" (Biocca, 1997).

In the puzzle game, "Keep Talking and Nobody Explodes" by Steel Crate games one audience member in a headset can see a ticking bomb with its tantalising wires, buttons and dials, however to defuse it safely they must keep in constant verbal communication with their fellow audience members outside of the headset, as only they have access to the bomb defusal manual. If the first audience member starts to lose themselves in the headset and stops attending to their colleagues outside of the constructed reality, they will certainly fail.

Interactive story "The Collider" by Anagram encourages a slippage between worlds by subverting the ordinary use of VR equipment. A VR headset is given to one audience member and the corresponding hand controllers to another. The narrative motivates a series of connected movements from each partner, allowing them to become tacitly aware of one another's experience without either possessing the full picture. At one point the audience member with only the controllers is encouraged to talk to, and physically touch their partner, creating a continuous dialogue between the virtual and physical environment for both, and highlighting the

inherent duality of the experience. Here but not here. There but not there. With you but not with you.

Is There Really an Audience for VR?

The size of the current global market is hard to pin down, however to give an indication, in 2020 the United Kingdom's communications regulator, Ofcom reported that 1 in 17 of UK households now owns a VR headset (Ofcom, 2020), a marked increase from one in 20 in the previous report (Ofcom, 2018). In April 2021, Facebook reported "non-advertising revenue, which is primarily sales of its Oculus virtual reality headset, increased 146% in the first quarter to $732 million" (Heath and Varnham O'Regan, 2021), suggesting that the numbers may be even higher. Shortly afterwards, Andrew Bosworth, VP of Facebook Reality Labs announced that their all-in-one headset, Quest 2 had sold more units than all Facebook's other headsets combined, which in his opinion is "a tremendous indicator that we are now at that point where we have broken through from the early adopter crowd to an increasingly mainstream crowd" (Bloomberg, 2021).

Headset ownership is only part of the picture, and some studies suggest that after an initial flurry of interest in the new kit, usage can drop off significantly for reasons we will return to later (Green et al., 2020). Data on overall headset usage is tricky to come by, not least as one of the largest companies, Facebook does not share usage data, however, we can find some clues in data released regarding specific apps:

- In March 2020, VR first-person shooter game *Half-Life: Alyx* by Valve broke all the records for VR experiences, registering 42,858 concurrent players on its release date.
- Rhythm game *Beat Saber* from Czech games company Beat Games (owned by Facebook since 2019) reported that in February 2021 alone they had sold over 40 million songs as in-app purchases, and have now surpassed 1.4 billion koruna (approx. $65 m) in total revenue (Houska, 2021).
- Social VR platform *VRChat* has seen a steady growth in its user base since its launch in 2017, with a rapid acceleration in the last 18 months. Since the WHO declared COVID-19 to be a global pandemic, concurrent usage of VR Chat has increased by approximately 91%, with an average of 7,979 users per day in February 2020, rising to 15,228 by July 2021, with a peak usage hitting 26,251 in December 2020[1] (Steamcharts, 2021).

Where Are Audiences Experiencing VR?

There are two main places to consider when thinking about where audiences are currently encountering VR. Quite simply are the "in-home" or out of their home environments. The audience dynamics in each can be quite different so we will explore the affordances and particularities of each in turn.

In-Home

In the United Kingdom, domestic headset ownership has accelerated in recent years, with a 2020 Ofcom survey revealing that 6% of UK households now own a VR headset (Ofcom, 2020).

Despite the steady growth, headsets are not yet familiar household objects for most people. We have few easily transferable rituals for how to put them on, when and where is best to do so, and what will happen to us when we do. The idea of placing something that looks like a heavy, plastic blindfold over your eyes and ears, and blocking out your familiar comforts can feel quite unintuitive.

Bennett et al. (2021) highlight three key barriers to audience adoption of VR in the home, which they refer to as "frictions" that will need to be addressed if in-home use is to proliferate.

Friction 1: Social

The incompatibility of VR with shared, multi-person and inter-generational activity in the home, alongside "the perceived isolation of VR".

In a recent user study (Green et al., 2020), 14 households received a VR headset and were given access to a range of nonfiction content that they could experience in their own homes, at their own pace over a period of several weeks. There is a lot to learn from this study, but one message received from multiple audience members was that using VR in-home use felt anti-social. They suggested that the form factor of a headset "cuts the user off from their surroundings", removing their ability to keep an eye on the safety of their family or the security of their home. Some compared it unfavourably to TV viewership, where more than one member of the household might otherwise watch something together, having a shared experience and discussing it afterwards (Green et al., 2020).

Interestingly, this very feature of VR as a solitary, one-at-a-time experience has elsewhere been identified as a positive affordance of the technology. The increasingly unusual phenomenon of being un-distractable, unable to check your phone and focussing completely on the virtual world might offer a sense of relief in a culture where "our attention is already overdrawn by the devices we have" (Case, 2016). In an ethnographic investigation of audience members reflecting on their VR experience, StoryFutures propose that "the headset provides a safe haven from sensory overload triggered by multitasking, where engagement energises users and high interactivity increases a sense of immersion and presence" (Bennett et al., 2021).

It seems plausible in this context that VR might find its place in the home as a form of "me time", more akin to taking a warm bath or playing games online with your door shut, more so than as a new version of a located, shared media experience.

Alternatively, or perhaps additionally, future immersive designers may make more use of the passthrough capabilities of modern headsets,

blending VR and AR paradigms to give their audiences a more subtle or explicit connection to their physical surroundings. One step in this direction has been the recent decision by Facebook to open up the "Passthrough API" for their Quest 2 headset, giving developers the tools to integrate the feed from the front-facing cameras into their VR experiences (Oculus, 2021).

Added to this, content "casting" functionality has been steadily improving across platforms, with companion apps enabling the "in headset" experience to be viewed externally via a flat screen such as a smart TV or mobile phone. Mixed reality companies such as LIV offer tools that give a real-time blended view of the person doing VR with the 3D world that they inhabit, giving onlookers a window into the primary audience member's immersive experience and creating a secondary "live streaming" audience experience akin to that of Twitch or Facebook Live that might enliven and socialise domestic (and online) viewership of VR.

Friction 2: Spatial

The challenge of how much, and what type of space is available to you in your home environment.

For a time, domestic use of VR would involve either sitting or standing on the spot, viewing 360 experiences that allow the audience member to look up, down and all around (known as having 3 degrees of freedom or 3DOF) but did not encourage them to move away from a central pivot point like a swivelling chair. In recent years, most VR manufacturers have re-focussed on headsets that allow free movement around a living space (six degrees of freedom or 6DOF). As such, many VR designers now favour experiences that encourage and reward the active motion of their audience through a space. Objects placed just out of reach, characters glimpsed around corners and obstacles to avoid alongside and sound, light and motion "lures" can motivate audience members to move through a scene in VR, and correspondingly in real life.

All of this movement carries with it an expectation that there is space in the domestic environment to accommodate all of this reaching, dancing and scampering about. But of course, this notion of "free space" that can be cleared for participation in VR is not something that is universally available. Circumstances such as household income, family size, urban vs rural location, and where you are in the world can all impact on whether "in-home" VR feels viable for you. To take one example, average house sizes vary widely across the world:

- United States of America – 2,204 sq ft
- United Kingdom – 826 sq ft
- India – 504 sq ft

(Demographia, 2019; Thuakur 2008)

Facebook stipulate that for "roomscale" experiences (another term for 6DOF) "you'll need a safe and unobstructed play area of at least 6.5 feet by 6.5 feet (2 metres by 2 metres)" (Oculus, 2020). Steam similarly recommends "a minimum of 2 metres by 1.5 metres of free space (6.5 ft × 5 ft)" (Steam, 2020). For many, however, the ability to designate that amount of space to VR in an already crowded home environment is prohibitive, especially given the need to keep space clear of other family members and pets for fear of collision and harm. For those with modest space available, and who persist in using VR within such spatial constraints, seated or static VR experiences may continue to be the most accessible content available to them "in-home".

Friction 3: Time

When might this new form of audience experience fit into our busy home lives?

In a crowded media landscape, a novel medium that requires our undivided attention can seem at odds with our modern, multi-platform lifestyles. Carving out time in our daily lives just to experience VR can feel unmanageable or indulgent.

In a 2020 report, Catherine Allen points out that time scarcity or perceived time scarcity varies enormously depending on your personal circumstances. Class and gender are strong signifiers of whether or not you feel able or willing to engage with VR in your own home.

Allen reminds us that "When time is precious, mainstream audiences may not be prepared to risk it on new and strange digital things" (2020).

She explains that in the United Kingdom, "People in skilled trades get almost eight hours less leisure time than the average" and that "women get five hours less leisure time per week than men". Allen goes on to explain that "Two of the extra hours men get are spent on 'computing and hobbies'", suggesting that this time may be more readily transferrable to installing and experimenting with VR. Allen also points out that "Women's leisure time also tends to be more frequently interrupted" (Allen, 2020), implying that it may be less readily compatible with headset-based VR which effectively blocks out or de-prioritises the visual and auditory features of the home environment in favour of those in the virtual world.

Out-of-home or Location-Based Experiences (LBEs)

This category encompasses a huge range of contexts, from theme parks and games arcades, to VR cinemas, art installations, shopping malls, conferences and festivals.

Pre-pandemic we saw a proliferation of LBE co-operative play experiences such as "The Void" which invited groups of friends to "suit up" and play games in VR based around well-known IP such as Star Wars or Ghostbusters in a large warehouse.

Often, experiences designed for Out-of-Home contexts are bespoke and particular to the venue or utilise specialist equipment, such as DIVR by Ballast, an underwater scuba diving experience that takes place in a swimming pool but gives the audience the sensation of exploring the depths of the ocean, or "Galactica" at UK Theme Park, Alton Towers. The Galactica VR experience launched in 2016 and re-purposed an existing rollercoaster, mapping an epic VR space adventure onto the predictable loops and twists of the rollercoaster's rails. Interestingly, and seemingly unrelated to pandemic concerns, Alton Towers have since quietly decommissioned the VR aspect of this experience, officially due to "guest feedback" (Alton Towers, 2019) although some have speculated that it was a more commercial decision as the time it took to fit headsets for each audience member was making is less cost-effective than had been hoped (Riderater, 2019).

Many festivals and cultural organisations around the world have chosen to develop "out-of-home" VR experiences more akin to art installations or immersive theatre, with elements such as tactile sets, interactive objects, or even live actors playing a role. In "Draw Me Close" at the National Theatre, a performer playing the audience member's mother is simultaneously physically and virtually present, even reaching out offer a hug that is experienced visually as an encounter with a black and white hand-drawn illustration, and felt as a warm embrace from a living, breathing person. Some experiences such as Somnai or War of the Worlds by dotdot.london regularly switch between live performance and headset-based experiences, taking audience members in and out of VR as a means to expand and reveal the story world one scene at a time.

The guiding of audiences in and out of headset-based experiences has come to be known as "onboarding" and "offboarding" and is arguably one of the most important, and most neglected peculiarities of the audience experience in VR.

Bennett et al. caution that "A lack of attention to the transition of the user in and out of virtuality results in poor levels of enjoyment, disengagement, fatigue and potentially physical or psychological detriment" (2021). They also report that "LBEs where headsets are handed to the user with little or no guidance, supervision, or orientation receive much lower user experience rating", suggesting that audience member's enjoyment of content is likely to be contingent on the level of on- and off-boarding support that they receive.

Onboarding

Experts in XR audience management, Virtual Umbrella recently published a tongue-in-cheek tool entitled "Eliminating Unfortunate Events: A Checklist of Things to Think On When Delivering VR Installations" (Nalley, 2021). The tool is designed to assist in briefing invigilators and docents who will be looking after VR audience members in a range of scenarios. It includes practical tips such as "do they know how to accommodate glasses wearers, chair users, or large hairdos" and contains a reminder about "robust cleaning procedures" particularly in light of the COVID pandemic.

Limina Immersive, another globally recognised expert in XR audience strategy have shared multiple learnings about the importance of ensuring VR audiences are well supported out of the home. Founder and CEO, Catherine Allen makes a particular case for audience privacy during VR experiences. She highlights a tendency across the sector to use the spectacle of someone in VR amuse onlookers, entice people to take part and give those who might be waiting in a queue something peculiar to look at.

"It is not fair to put people through a new experience they are likely to be nervous about and then expect them to simultaneously be a photo opportunity for strangers" Allen adds that in a recent survey "Being seen publicly wearing a headset was for many, a deal breaker" (Allen, 2020).

In 2018 I did a quick and highly unscientific straw poll, inviting people to share their biggest concerns about using VR in public places for a talk that I was preparing. I ended up with what I affectionately term "The Out of Home VR, Big Map of Anxiety".

Image by Verity McIntosh, 2018.

"Clockwise from top left, anxieties include: am I being watched, photographed or filmed, where is my bag, coat, stuff? Is anyone looking after it? Will this headset even work with the hair that I have or the headscarf that I am wearing? Will I get tangled in the wire? Will I fall over? Will someone jump out at me, or touch me in some way? What if I accidentally touch or bump into someone myself? Will it work with my hearing aid, my glasses, my wheelchair? Will this create a sense of sensory overload? What if I feel sick? What if I need to go to the bathroom? Is this a game? Will I be expected to interact or participate in some way? Is this hygienic? Is the kit being cleaned between participants, what if the last person to do this was sweaty, oh no, what if I get all sweaty? Or cry? Or my make-up rubs off on the headset?" (McIntosh, 2018).

Concerns of being watched or filmed may have compounded over recent years as sites such as YouTube, Reddit and TikTok have become well populated with images of people being "pranked" whilst in VR, both in and out of the home environments. High among the online tropes is one of "friends" waiting until an audience member is at a scary part of a VR experience then grabbing them in real life, inducing them to panic, lash out, or to stumble and fall.

We can also expect hygiene concerns to have moved up the list considerably as a result of COVID-19. In pre-pandemic times, VR equipment would frequently be shared between multiple audience members, one after the next with minimal cleaning between instances. The risks of contagion through inadequate hygiene practices cannot be overstated and given heightened awareness of transmission via hands and faces, it seems unlikely we will see a return to previous standards. Many out-of-home VR venues have been closed throughout the pandemic, and it will be interesting to track whether, and how quickly LBE offerings start to re-emerge as public health conditions improve.

Offboarding

For those that do decide to take part in Out-of-Home VR in the future, their experience as they come out of the headset may be as important as any support that they may have received before or during their experience. The 2021 StoryFutures report discusses challenges that may be experienced by the audience member. Challenges that "can be cognitive (involving confusion between real and virtual information), emotional (involving a continuation of the emotions that were prompted by the experience) and behavioural (relating to adaptations that have occurred during the experience, such as adapting to a different body type)" (Bennett et al., 2021). Audience members often need to take a minute to reorientate, re-connect with their physical surroundings and process their thoughts before returning to normality or speaking to anyone.

As audience members, we may be feeling the lack of an ending ritual for VR, something along the lines of watching the credits in a cinema. As the credits roll, the lights generally remain low and facilitate a soft transition back to everyday life. This kind of thresholding ritual can offer audiences a moment of calm to share a furtive glance with a friend, wipe away a tear, take a minute to check for ice cream on clothes and popcorn in beards, and to find bags and coats that have become jammed between the seats before stepping out into the cold light of day.

In venues such as their VR Theatre in Bristol, UK, Limina Immersive has offered one such possible ritual that might align with VR audience needs: "users were allowed to remove the headsets in their own time, to readjust their senses to the real world where they sat, before having headsets collected and being invited to move to a 'decompression zone' where they could sit in a quiet environment, in low light, with access to water and comfortable seating, to transition at their own speed to the real world before heading back out to the busy Bristol waterfront" (Bennett et al., 2021).

This can be a costly approach to audience care, requiring additional space, slowing throughput and making timings somewhat erratic. Allen, however, asserts that it is not just reasonable, but necessary for audiences to expect a *pleasurable* experience at the end of their viewing, and that this will be integral if we are to develop new audiences and achieve scale in the XR industry.

"After a pleasurable welcome into tech-driven experiences, there is a whole world of content that awaits. It is important, however, that broader audiences are offered that first pleasurable gateway experience" (Allen, 2020).

Who Is, and Who Isn't in the Audience?

As has been hinted at a few times in this chapter, current audiences for VR do not follow the demographics of the overall population. In the United Kingdom, evidence suggests that "early adopters are still overrepresented by young, white males" (Bennett et al., 2021).

Allen tells us that "'Upper socioeconomic group' households are almost twice as likely to own a VR headset than 'lower socioeconomic group' households" (Allen, 2020). And that "In terms of experiencing VR, rather than owning a headset, according to the Global Web Index 2019, 16% of women have tried it whereas 30% of men have done so in the UK and the US". Allen goes on to explain that "Audiences of VR are also disproportionately younger, with only 18% of users over 45".

In a recent interview (Newton, 2021), Mark Zuckerberg, CEO of Facebook talked about the "gender skew" observed in early adopters of VR, and has committed to addressing issues related to the harassment experienced by many women in social VR spaces (Cortese, 2019). Facebook's approach, and that of several other social VR platforms has thus far been to

give audience members more and more tools to limit contact with others in these spaces through "personal bubbles" or filters, such as limiting who you can hear in a given space and personally blocking individuals whose behaviour you find objectionable.

Arguably, such tools whilst useful, put the onus on those being harassed, inhibiting their ability to participate on an equitable platform with other audience members. As conversations about a ubiquitous "metaverse" gain momentum, some are calling for audiences and platforms "to critically reimagine social VR spaces as equitable, safe, and radical" before certain norms become entrenched (Ratuszynska, 2021). Artist and researcher, Tessa Ratuszynska further provoked this conversation by launching "Club XXY" a space that "explores how systemic exclusion and oppression are built into the fabric of built and digital environments, and the critical resistance practices employed by space makers in order to centre and affirm the marginalised communities they serve" (Ratuszynska, 2021).

Inclusivity in social VR is certainly a factor influencing who will choose to participate and in this early moment for consumer VR, and who will not, however, this is far from the only consideration. If Zuckerberg and others are genuinely interested in addressing "the gender skew" in VR and inclusivity more broadly, many other factors, including the prominence and availability of content that speaks to diverse interests and tastes must also be on the agenda.

Publishing platform Steam (and its Steam VR function) is one of the main places people can look for PCVR content (headset-based VR driven by an external computer). Steam originally launched in 2003, long before the current wave of consumer interest in VR, and has been designed and heavily specialised for audiences who identify as gamers. Steam's approach to content classification and discovery has remained constant for VR content and it can be difficult for alternative content to break through.

When it comes to standalone headsets (with no external computer), one of the main content libraries is Facebook's Quest store. Unlike Steam, this is a heavily curated space, and creators have to get through a stringent and somewhat opaque approval process to get their work to audiences. The store gatekeepers take a very specific curatorial position on what is considered audience-ready, publishable content, and experiences that doesn't fit with Facebook's interpretation of what the market is looking for are frequently rejected, regardless of the quality.

Interestingly, Facebook's own "Gamer Segmentation" study (Oculus, 2020), acknowledges that the largest segment of the market (23%) is currently those they have classified "Story Seekers". They say "These players are patient, imaginative, and amiable. Story Seekers play games to escape and immerse themselves in a different world". They acknowledge that this group "is the single largest segment we have identified, and the most gender-balanced" however these users are deemed to be a "low VR Target"

as they exhibit a "lower purchase intent". Instead, the advice to developers is to pursue a group which they have designated the "Dedicated Gamer". This group represents just 18% of the sample, but are described as "One of the most relevant groups for VR, these players are impulsive, boastful, and competitive" and "spend 2x more on games and devices than the average gamer".

Michel Reilhac, co-director of Venice Expanded, the XR branch of the international film festival, Venice Biennale has publicly criticised current platforms, suggested that they have inculcated "a very strict moral code with very strictly defined family moral values", and are encouraging creators to self-censor if they wish their work to reach audiences. As an example, he points out that "Nudity and sex are completely impossible to show on any of the platforms ... which really contradicts the notion that VR is a new art form and that therefore new artists want to use the medium to express freely their story worlds" (MacNab, 2021).

These sorts of limitations and guidance early on about what content should and should not be prioritised for VR could have significant implications for who will choose to engage with and shape the industry as it evolves, both in terms of audience, and the process of content creation.

The challenge for the sector now, is how to build more diffuse infrastructure for the distribution and exhibition of VR experiences, moving beyond the specific curatorial positions of a handful of tech companies. Opening up new and more various ways for content creators to connect with their audiences.

Conclusion

This is a transformative moment for VR. For perhaps the first time in its decades-long history, a voracious audience appetite for experiences in which they feel present, embodied and connected is being matched by technological innovation, corporate investment and a wealth of creative experimentation. The potential for a new paradigm in audience experience is tantalisingly close.

As we have explored, however, there are many known "frictions", disincentives and assumptions being made about "who VR is for" that could stymie this potential and limit the audience to a predictable few. My hope is that by focussing on the specific duty of care appropriate to VR audiences, by working to address known "frictions", prioritising accessibility and user experience design for both in, and out-of-home VR, and by actively addressing some of the structural inequities inherited from VR's predecessors, we might yet see a flourishing and a diversification of audience experiences in VR that will allow it to take its place in shaping the cultural landscape for years to come.

Note

1 These data are shared by publishing platform Steam and include users connecting without a headset via a browser, estimated to be approximately 48% of users (Lang, 2020). The data does not include users connecting via Facebook's Oculus headsets as these operate through a separate app store and usage figures are not published.

References

Allen, C. (2017). With VR, Publishers Must Focus on Storydoing, Not Storytelling. *The Bookseller* [online]. 8 February 2017. Available from: https://www. thebookseller.com/futurebook/win-vr-publishers-must-master-storydoing-not-storytelling-480356 [Accessed 6 September 2021].

Allen, C. (2020). Beyond the Early Adopter: Widening the Appeal for Virtual Reality. *Creative Industries Policy and Evidence Centre led by NESTA.* [Accessed 10 August 2021]. https://pec.ac.uk/policy-briefings/beyond-the-early-adopter-widening-the-appeal-for-virtual-reality

Alton Towers (2019). Alton Towers Resort. *Twitter* [online]. 17 March 2019. Available from: https://twitter.com/altontowers/status/1107267874631098373 [Accessed 6 August 2021].

Amarasuriya, T. (2021). Feeling Being. *Bristol+Bath Creative R+D* [blog]. 29 May. Available from: https://bristolbathcreative.org/article/feeling-being [Accessed 6 September 2021].

Bailenson, J. (2018). *Experience on demand: What virtual reality is, how it works, and what it can do.* New York: Norton.

Bennett, J., Dalton, P., Goriunova, O., Preece, C., Whittake, L., Verhulst, I. and Woods, A. (2021). Audience insight report: The story of immersive users. *StoryFutures* [Accessed 10 August 2021].

Biocca, F. (1997). The cyborg's dilemma: Progressive embodiment in virtual environments. *Journal of Computer-Mediated Communication*, 3(2) [Accessed 7 September 2021].

Bloomberg (2021). Facebook Reality Labs VP: VR Will Transform Global Work. *Bloomberg.com* [video]. 29 March 2021. Available from: https://www.bloomberg. com/news/videos/2021-03-29/facebook-reality-labs-vp-vr-will-transform-global-work-video [Accessed 12 August 2012].

Case, A. (2016) *Calm technology.* Sebastopol, CA: O'Reilly Media.

Connect4Climate (2017). VR: "It's not a storytelling. It's a story living". *Connect4Climate* [online]. 2 November 2017. Available from: https://www. connect4climate.org/initiative/virtual-reality-it-is-not-storytelling-it-is-story-living-uniting4climate [Accessed 6 September 2021].

Cortese, M. and Zeller, A. (2019). Designing Safer Social VR. *Immerse.News* [online]. 2 November 2019. Available from: https://immerse.news/designing-safer-social-vr-76f99f0be82e [Accessed 9 September 2021].

Coppi, A.E., Freeman, J. and Lessiter, J. (2014). Get in the Game: The influence of embodied play on presence and flow in videogames. In: *Interactive Technologies and Games Conference (ITAG)*, Nottingham, October 2014.

Demographia (2019). International House Sizes. *Demographia* [online]. Available from: http://demographia.com/db-intlhouse.htm [Accessed 4 September 2021].

Green, D.P., Rose, M., Bevan, C., Farmer, H., Cater, K. and Stanton Fraser, D. (2020). 'You wouldn't get that from watching TV': Exploring audience responses to virtual reality non-fiction in the home. *Convergence: The International Journal of Research into New Media Technologies, 27*(3), 1–25.

Heath, A. and Varnham O'Regan, S. (2021). Facebook Revenue Grows 48% as Ad Prices Increase. *The Information* [online]. 28 April 2021. Available from: https://www.theinformation.com/briefings/c85ea6 [Accessed 12 August 2021].

Houska, F. (2021). The creators of the game hit beat saber are already among the largest in the Czech Republic. The studio's revenue shot well over a billion for the first time. *CzechCrunch* [online]. 9 August 2021. Available from: https://cc.cz/tvurci-herniho-hitu-beat-saber-uz-patri-k-nejvetsim-v-cesku-trzby-studia-poprve-vystrelily-daleko-pres-miliardu/ [Accessed 9 August 2021].

Lang, B. (2020). Spurred on by Quest 2 Launch, 'VRChat' Hits Record 24,000 Concurrent Users, More Than Half in VR. *RoadtoVR* [online]. Available from: https://www.roadtovr.com/vrchat-record-concurrent-users-traffic-quest-2/ [Accessed 8 September 2021].

Lee, K.M. (2004). Presence, explicated. *Communication Theory, 14*(1), 27–50.

Lessiter, J., Mitchell, S., Ferrari, E., Borden, P., Bakhshi, H. and Freeman, J. (2018). *Evaluating immersive user experience and audience impact*. London: Digital Catapult.

MacNab, G. (2021). Freedom of Expression Issues Clouding Virtual Reality World, According to Venice VR Expanded Heads. *Screen Daily* [online]. 3 September 2021. Available from: https://www.screendaily.com/news/freedom-of-expression-issues-clouding-virtual-reality-world-according-to-venice-vr-expanded-heads/5162986.article [Accessed 8 September 2021].

McIntosh, V. (2018). I Always Feel Like, Somebody's Watching Me. *Medium* [online]. 16 December 2018. Available from: https://veritymcintosh.medium.com/i-always-feel-like-somebodys-watching-me-d50f2db2694b [Accessed 2 September 2021].

Milk, C. (2015). How Virtual Reality Can Create the Ultimate Empathy Machine. *TED.com* [video]. March 2015. Available from: https://www.ted.com/talks/chris_milk_how_virtual_reality_can_create_the_ultimate_empathy_machine [Accessed 31 August 2021].

Montague, T. (2013). Good companiesare storytellers. Great companiesare storydoers.Harvard Business Review Blog Network. https://hbr.org/2013/07/good-companies-are-storyteller

Murray, J.H. (1998). *Hamlet on the holodeck: The future of narrative is in cyberspace*. Cambridge, MA: MIT.

Nalley, V. (2021). Eliminating Unfortunate Events: A Checklist of Things to Think on When Delivering VR installations. *Medium* [online]. 9 February 2021. Available from: https://medium.com/virtual-library/eliminating-unfortunate-events-dd32b0ac68e5 [Accessed 31 July 2021].

Nakamura, L. (2020). Feeling good about feeling bad: Virtuous virtual reality and the automation of racial empathy. *Journal of Visual Culture* [online], *19*(1), 47–64 [Accessed 8 September 2021].

Nash, K. (2018). Virtual reality witness: Exploring the ethics of mediated presence. *Studies in Documentary Film* [online], *12*(2), 119–131 [Accessed 8 September 2021].

Newton, C. (2021). Mark in the Metaverse: Facebook's CEO on why the social network is becoming a 'metaverse' company. *The Verge* [online]. 22 July 2021. Available from: https://www.theverge.com/22588022/mark-zuckerberg-facebook-ceo-metaverse-interview [Accessed 22 July 2021].

Nunez, D. (2004 , November). How is presence in non-immersive, non-realistic virtual environments possible?. In *Proceedings of the 3rd international conference on Computer graphics, virtual reality, visualisation and interaction in Africa.* (pp. 83–86).

Oculus (2020). How Much Space Do I Need to Use Oculus Quest 2 or Quest? *Oculus Support* [online]. Available from: https://support.oculus.com/1190192431422476 [Accessed 6 September 2021].

Oculus (2020). Understanding the VR Gaming Market. *Oculus for Developers* [online]. Available from: https://developer.oculus.com/blog/understanding-the-vr-gaming-market/ [Accessed 6 January 2021].

Oculus (2021). Passthrough API. *Oculus for Developers* [online]. Available from: https://developer.oculus.com/experimental/passthrough-api/ [Accessed 12 August 2021].

Ofcom (2018). Ofcom Nations & Regions Technology Tracker - H1 2018. United Kingdom: Ofcom. Available from: https://www.ofcom.org.uk/__data/assets/pdf_file/0015/113172/Technology-Tracker-H1-2018-technical-report.pdf [Accessed 8 September 2021].

Ofcom (2020). Ofcom Nations & Regions Technology Tracker - 2020. United Kingdom: Ofcom. Available from: https://www.ofcom.org.uk/__data/assets/pdf_file/0037/194878/technology-tracker-2020-uk-data-tables.pdf [Accessed 8 September 2021].

Ratan, R. (2012). 'Self-Presence, Explicated: Body, Emotion, and Identity Extension into the Virtual Self". R. Luppicini (ed.). *Handbook of Research On Technoself.* New York: IGI Global: 332–336.

Ratuszynska, T. (2021). Club XXY (Project Deck). *Tessaratuszynska.com* [online]. Available from: https://www.tessaratuszynska.com/work/club-xxy [Accessed 2 September 2021].

Riderater (2019). Galactica: VR removed from Alton Towers rollercoaster. *Riderater* [online]. Available from: https://riderater.co.uk/7438/galactica-vr-removed-from-alton-towers-rollercoaster/ [Accessed 12 August 2021].

Robinson, A. (2016). Where Story-Living Happens: "Home – a VR Spacewalk". *Autodesk – Journey to VR* [online]. 27 October 2016. Available from: https://area. autodesk.com/blogs/journey-to-vr/where-story-living-happens-home--a-vr-spacewalk-based-on-a-conversation-with-sol-rogers-founderceo-of-rewind/ [Accessed 6 September 2021].

Rose, M. (2018). The immersive turn: Hype and hope in the emergence of virtual reality as a nonfiction platform. *Studies in Documentary Film* [online], *12*(2), 132–149. [Accessed 8 September 2021].

Sanchez-Vives, M.V. and Slater, M. (2005). From presence to consciousness through virtual reality. *Nature Reviews Neuroscience* [online], 6, 332–339. [Accessed 8 September 2021].

Slater, M. (2021). Beyond Speculation About the Ethics of Virtual Reality: The Need for Empirical Results. *Frontiers in Virtual Reality – Virtual Reality and Human Behaviour.* 12 August 2021 [Accessed 31 August 2021]. https://doi.org/1 0.3389/frvir.2021.687609

Steam (2020). What are the space requirements of the Vive? *Steam Support FAQs* [online]. Available from: https://help.steampowered.com/en/faqs/view/14AE-8D60-24E6-AA67 [Accessed 31 August 2021].

Steamcharts (2021). VRChat. *Steamcharts: An Ongoing Analysis of Steam's Concurrent Players* [online]. Available from: https://steamcharts.com/app/438100 [Accessed 12 August 2021].

Switzer, R. (1997). Over-writing the body: Virtual reality and cartesian metaphysics. *Philosophy Today*, 41(4), 507–519.

Thuakur, A. (2008). 33% of Indians Live in Less Space Than Us Prisoners. *Times of India* [online] 25 November 2008. Available from: https://timesofindia.indiatimes.com/india/33-of-indians-live-in-less-space-than-us-prisoners/articleshow/3753189.cms [Accessed 6 September 2021].

Wilson, M. (2017). Exclusive: Microsoft Has Stopped Manufacturing the Kinect. *Fast Company* [online] 25 October 2017. Available from: https://www.fastcompany.com/90147868/exclusive-microsoft-has-stopped-manufacturing-the-kinect [Accessed 30 August 2021].

Mediography

AltSpace VR [social VR platform] by Microsoft

Beat Saber [VR game] by Beat Games

DIVR [VR experience for waterparks] by Ballast Technologies Inc.

Draw Me Close [VR experience] by Jordan Tannahill, All Seeing Eye, Teva Harrison, National Theatre and National Film Board Canada

Facebook [social media platform] by Facebook, Inc.

Galactica [VR experience for roller coaster] by Merlin Entertainments

Half-Life: Alyx [VR game] by Valve

Keep Talking and Nobody Explodes [VR game] by Steel Crate games

LIV [media production tool] by LIV Inc.

Mozilla Hubs [social VR platform] by Mozilla

Ready Player One [book] by Ernest Cline

Somnai [immersive theatre] by dotdot.london

Spatial [social VR platform] by Spatial Systems

The Matrix [film] by the Wachowski sisters

The Collider [interactive story] by Anagram

The Void [VR experience company] by The Void (now owned by VR Exit, LLC)

Twitch [video streaming service] by Amazon

VRChat [social VR platform] by VR Chat Inc.

War of The Worlds [immersive theatre] by dotdot.london

7 Teaching XR: Digital Inequalities and Education

Jenny Kidd and James Taylor

Introduction

As is documented in this book, uses of immersive technologies and content have developed dramatically and dynamically in recent years. By some estimations, a continuation of this trend will see the global market for immersive media worth something in the region of USD 125.2 billion by 2026 (MarketsAndMarkets, 2021). This growth is being driven by a surge in use within education, industrial training, the automotive industry and healthcare, as well as increasing demand for immersive experiences in the entertainment and gaming sectors, heritage, tourism and architecture. The development of affordable consumer devices as well as improvements in technology, such as cloud computing and artificial intelligence, is factor here (Wersényi *et al.*, 2021), as is, more recently, the global pandemic of 2020/21 which it is argued, may also have accelerated adoption (Castellanos, 2021; Perkins Coie, 2021).

There is, however, according to repeat studies within the UK, a continuing scarcity of the skills that are necessary to support development in the immersive sector(s), and to maximise the potential of this growth. In a 2019 survey of 100 UK companies working with immersive technologies, 97% of respondents felt there was a lack of related skills in the workforce, 77% identified a lack of technical skills as a barrier to growth, and 28% cited a lack of experienced creatives, including writers, directors and designers (Immerse UK & Digital Catapult, 2019). Sixty-eight per cent of respondents indicated that sourcing the right skills to develop content was 'difficult' or 'mostly difficult' (ibid).

Within the UK Higher Education context, there has been rapid development of dedicated courses – as well as individual modules within related programmes – which recognise and respond to this changing landscape, and which attempt to close that skills gap. Undergraduate and Postgraduate qualifications have emerged within a host of disciplinary contexts, many of which have significant practical components.

There has been little scope during this period however to reflect upon how learners' experiences of that provision are impacted by digital

DOI: 10.4324/9780367337032-10

inequalities, and on how those inequalities might in turn be shaping, or indeed limiting, our vision for immersive technologies and content more broadly. This chapter and the study that underpins it begin to make space for those reflections.

In the next section we briefly explore how digital inequalities and the notion of 'the digital divide' have been – and continue to be – understood, including within educational contexts. Following that we explore how some of these challenges have manifested in our own teaching of a module on Immersive Media at Cardiff University, before drawing out to include the perspectives of others who teach on similar courses in and beyond the UK.[1] In doing so, we consider how educators can respond more emphatically to the significant and enduring concerns digital inequalities raise for these sectors, and the training of those who may go on to work in them.

The Digital Divide in Education

There have been a small number of studies exploring the digital divide in the context of immersive media education. These have tended to pay particular attention to issues around access to kit and connectivity. For example, a study into the teaching of immersive journalism (by Uskali and Ikonen, 2021) noted challenges in access to 'the right equipment', and another (by Rubinstein-Ávila and Sartori, 2018) proposed that students connecting via cell phones tended to progress less well than those connecting via other means.

In this chapter however we wish to connect with debates about these issues that go beyond concerns solely with access (see for example van Dijk, 2005, 2020; Eynon and Helsper, 2010; Reilly et al., 2017). Our approach reflects recent scholarship which, as Wilkin, Davies and Eynon note, shifts from a "binary focus on access or no access" to a "more nuanced understanding of internet access being situated in a complex web of social, economic, and cultural factors" (2017: 333). Robinson et al. characterise this as a shift from focusing solely on 'first-level' digital disparities, to a recognition of 'second-level' digital inequalities "such as those related to skills, participation, and efficacy" even for those who might nominally be considered 'users' (2015: 570). Ragnedda and Muschert make the case that "digital inequalities and digital inclusion/exclusion are social phenomenon, rather than being simply technological or economic phenomena" (2018: 2), and Watkins (2018) argues in considering the digital media use of black and Latino youth that their uses "are influenced by broader social and economic currents that give rise to distinct practices, techno-dispositions, and opportunities for participation in the digital world".

It can be seen then that debates about the digital divide have moved beyond concerns with digital 'haves' and 'have nots', to consideration of what kinds of sociality, participation, culture and opportunity follow from that access. In her exploration of digital inequalities, Ellen Helsper

powerfully makes the case that "digital engagement for its own sake is not of interest" until it has "tangible outcomes in people's everyday lives" (Helsper, 2021: 2). As such Helsper prefers to talk about 'socio-digital inequalities' and sees them as a site of constant struggle (ibid.) This is important because digital inequalities have "the potential to shape life chances in multiple ways" ranging from academic performance to health service uptake to political participation (Robinson *et al.*, 2015: 570). Robinson et al. go on to remind us that these inequalities combine with race, class, gender and other "offline axes of inequality" in ways that remain profound (2015: 569).

For us as educators, the profundity of these observations was never more apparent than in the context of the COVID-19 pandemic when so much of our social, educational, community, cultural and civic lives made a wholesale move online. This of course served to exacerbate digital inequalities as scholars have begun to demonstrate (Lai and Widman, 2021). We were made acutely aware of these issues as we worked remotely with our own students during that period, as we go on to discuss in the next section.

Reflecting on Our Own Teaching Practice: MC3636 Immersive Media

Our jointly delivered Immersive Media module is taught as a third-year option at a UK University for students studying towards a BA in Journalism, Media and Culture, or a BA in Media and Communications. It has grown year on year since its launch in 2019, running with 64 students in the 2020/21 academic year. Over the course of the module (12 weeks) we work closely with students as they develop a better understanding of the uses of VR, AR, MR, 360 video content and spatial audio in a variety of contexts, and as we help them to translate that knowledge into practice through group activities and individual project work.

In the module we have foregrounded problem-based learning (Biggs and Tang, 2007), setting tasks that promote professional decision-making and the development of an appropriate knowledge base, through discussion and demonstration. Ours is an example of Industry Orientated Education (IOE), with activities and assignments clearly linked to skills for employability, which is typically a key concern for students in the final year of their programme.

Taking inspiration from 'progressivism' (Gourley, 2015) students are encouraged to engage beyond the classroom/lecture theatre, and emphasis is put on process, activity and interaction. The module is built on the concept of 'communities of practice' (Wenger, 2010), with 'students as partners', and our ambition is that they work collaboratively with one another and in continuous dialogue with us throughout the course.[2] Students build upon their pre-existing knowledge and understanding through experience and

reflection, independently and in group learning experiences (Vygotsky, 1980; Mintzes *et al.*, 2005).

Over a series of structured but interactive lectures students are introduced to key theoretical debates relating to immersive media. They also have access to additional learning resources specific to the topics being covered, which can take the form of video content, articles and interviews with industry professionals and practitioners. These are designed to support the students in their understanding of the subject matter and how it relates to industry practice.[3]

Lecture themes include:

- introductions to different formats and technologies, exploring opportunities and challenges associated with them.
- unpacking key terms e.g. 'immersion', 'presence' and 'flow'.
- understanding impacts of immersive media.
- contemporary production of immersive experiences.
- immersive storytelling.
- user experience design.
- key ethical considerations.
- possible futures for the sector.

It is worth noting given the concerns of this chapter that discussions about digital inequalities, accessibility and usability are foregrounded at various points throughout these sessions, but perhaps especially in the sessions on ethics, possible futures and user experience.

Through seminars, students are encouraged to engage with noteworthy and state-of-the-art exemplar experiences from a range of contexts and through different technologies. This forms the basis of regular group discussions and critical analyses of the content they encounter, which help to inform development of their own ideas and project proposals. Workshops are introduced later in the module to support students as they develop, produce and test immersive experiences using different industry standard tools. These include sessions directly relating to the use of professional real-time game engines such as Unity, but also simpler web-based tools that allow for quick prototyping.

The practical sessions take the form of a design sprint (albeit over five weekly sessions rather than five days), enabling the students to map practice, ideate, prototype and test their ideas.[4] Scheduled into the module are multiple opportunities for students to share ideas and demonstrate project development to us and their peers; including through pitching, commissioning meetings and a showcase of early prototypes towards the end of the module. Here students can gain feedback on their projects from both invited industry experts and users.

Since launching this module, the assignments have evolved continuously in order that they might meet the needs of industry (Gharehbaghi, 2015).

In the most recent iteration students first complete a 1500 word project proposal introducing and outlining a product or experience that they would like to develop. Following feedback, the second assignment sees students submit a working prototype of that experience, accompanied by a design pack of supporting materials[5] that would (in theory) allow potential investors or commissioners to assess how well the prototype meets the stated objectives and delivers for the target market.

Prior to the global pandemic of 2020–2021, all taught sessions (lectures, seminars and workshops) took place on campus, face-to-face, as was common across our programme and others like it. The 'pivot' to remote learning required during the pandemic was not a challenge when it came to delivering the core module content; pre-recorded lectures and a podcast, online articles, software guides, how-to videos and other asynchronous models of learning were easy to implement for the module and were received positively in most cases.

The main difficulties were experienced when students tried to interact with and better understand existing immersive content, and when it came to developing their own proposals. We took it as a given that students would not have access to any kind of HMD at home, and were right to do so. Although all students did have access to a computer to work on, it became clear that some lacked processing power or a reliable internet connection, and that others were having to share devices within their household, restricting the time available to them for project work. We had made the decision to accept prototypes made on simple in-browser programmes rather than expecting them all to use the high-end software that would have been available on campus, but some struggled to make even those work for their needs, and required a lot of support. Whilst the module was designed with plenty of opportunity for help from us as their instructors – including regular one-to-one sessions – it was clear that some students felt more inclined to access or ask for these sessions than others (as is no doubt always the case).

It was in their written reflections, submitted alongside their final prototypes, that it became clear the level of creativity and tenacity some of our students had had to demonstrate in order to get the work done against the backdrop of the pandemic. There was frustration at this for a few students, but most considered that they had learned a huge amount about real-world project development and delivery, and the work they submitted reflected their enthusiasm for the subject.

This led us to reflect more substantively – during our own discussions about how the module had run – on digital inequalities and the myriad, often unpredictable, ways in which our students experience them. This year brought those inequalities starkly into focus for us, but they have always been there of course. We decided to explore what more we might be able to do to further anticipate and ameliorate those disparities going forward, and so we turned to our peers for input.

Broadening the Perspective on Digital Inequalities

To illuminate our discussion about these issues we asked colleagues from other academic institutions to offer insight into how they teach immersive media, and to reflect upon how consideration of digital inequalities informs and underpins their approach. A survey was shared with centres that teach Undergraduate and/or Postgraduate courses in XR. We asked tutors about their understanding of digital inequalities and how they impact teaching and learning in this area, as well as how and whether they tailor their programmes and assessments so as to reduce their impacts. As has been noted our invitation to respond on these themes coincided with a period of reflection on digital delivery following the disruption of the 2020–2021 academic year. We thus also asked respondents whether their perception of these issues had changed in light of that particular context.

When asked to reflect upon their understanding of digital inequalities most of our respondents do mention issues of access first and foremost (Robinson et al.'s 'first-level' digital disparities). As we have always found when teaching our own module, many students do not have access to VR headsets or high-spec PCs for development, with some lacking adequate wifi capability, and this was echoed in the responses of other educators. Respondents were keen to get beyond access at a superficial level, however, in order to consider how digital confidence and skills, as well as practices of participation, shape student experience, and to note how these are in turn shaped by students' contexts and backgrounds (Robinson et al.'s 'second-level' digital inequalities). Below are a sample of responses:

Q: As an educator what is your understanding of the digital divide in the context of teaching and learning?

"I understand digital inequality to refer to a student's access to, and familiarity with digital technologies. Students coming to us from different backgrounds, different sectors and different stages of life will often have quite disparate comfort levels will some of the tools, platforms and paradigms that we introduce during the master's programme. It is our responsibility as educators to support students equitably, regardless of their digital literacy and confidence when they join us. To do otherwise is to withhold the opportunity to really connect with and contribute to the course and cohort".[6]

"Access to technologies for learning and making is inflected by personal circumstances, availability of hard- and software, bandwidth, proximity and access to peers for community-building, etc."

"The lack of support or support after-the-fact for differently-abled international communities continues to limit access and interactivity. The lack of affordable stable and high speed internet within as well as

beyond cities, especially in rural areas, is debilitating for students, job seekers, and businesses that choose to work outside of cities. Without an internet connection, there is no access".

"Some students have multiple working computers at home and have for many years, while others have one shared computer that maybe works, or possibly no devices at all. The latter case is more common in minority communities. There is also a divide between students who have to do a lot of extra work to earn money and those who have time to try new things. Finally, some students are able to bring their own laptop to class and continue to work at home, while others use the computers at school and have to save their work for later".

Respondents are acutely aware of what is ultimately at stake here; such disparities *"could impact a student's learning experience and potentially [their] degree outcome".*

As is evident above, respondents are in some cases keen to note how disparities in access combine with other kinds of inequality to amplify challenges, including differences in ability, ethnicity and socio-economic status. One respondent noted that access to time was one of the biggest challenges for many in their cohort, particularly first-generation students, and another noted cognitive preferences and differences as an important consideration. There is reference to the XR industry, and the various digital ecosystems it interacts with, potentially having a negative impact on student experiences, especially considering their tendency (at least in their rhetoric) towards rapid change and even risk, which could impact the confidence of teachers and learners:

> *the XR landscape is very volatile, this makes teaching a major challenge as the requisite resources in terms of software and infrastructure are inadequate with frequent updates impacting the teaching and learning experience.*

Relatedly, one respondent was keen to highlight a paucity of skills and a lack of familiarity with the technology and its possibilities amongst those who were doing the teaching, or amongst those in allied University roles who remained unaware of the potential here, or of the challenges.

Most respondents see student confidence and familiarity with immersive approaches and content as something to be worked on, and educators told us that this is a significant focus during the early weeks of most courses, as it is on our own programme. This provides something of a levelling function, highlighting gaps in experience or confidence that can be addressed over the weeks that follow. It was noted however that this was more challenging to

do during the pandemic, with the consequence that many students were expected to study and create content that they had very limited real-world experience of, if any.

In pre-pandemic times, educators have a range of ways in which they try to ameliorate the impacts of digital inequalities, including:

- introducing debates about accessibility, usability and digital inequalities at an early stage so as to centre consideration of these in design and build processes, and promote an open dialogue about the issues.
- making sure all students have access to computers on campus.
- encouraging group work so as to accommodate different skillsets.
- supporting remote working via already familiar platforms such as WhatsApp.
- placing emphasis on storytelling rather than '*gadgetry*'.
- using virtual tools designed with the broadest user base in mind, and giving students time to navigate them in person at their own pace, recognizing that they may well feel awkward at first.[7]
- avoiding '*walled garden ecosystems*' and high-end HMDs, and even (referred to by one respondent) avoiding video sharing sites like YouTube which might not be available in all locations.
- in some instances, educators have been in a position to give students personal access to a piece of kit to take home (an Oculus headset for example, or a Google Cardboard or similar).

Expecting students to purchase their own equipment was broadly seen as problematic, not least because "*students will purchase the least powerful and cheapest headset, allowing them to participate, but potentially limiting their experience*".

Most of our respondents noted that in 'normal' times their courses would have been experienced by students through face-to-face delivery, although there were three courses referenced that would typically run in a hybrid or distance model given their predominantly international and dispersed cohorts. During the pandemic all respondents had switched to remote or hybrid delivery, however, which clearly had implications for equality of access to kit, digital infrastructure and support, as had been the case on our own module. In all but one case, there is direct reference in responses to '*industry-led*' or '*practice-based*' teaching on programmes. This is not unexpected and sheds some light on why students on these courses may have been at a disadvantage during the pandemic, particularly in comparison to those on courses which are research focused or that do not require practical components.

Some of our respondents had been in dialogue with students about these issues during the pandemic and were able to be responsive to issues raised where possible:

This last year these in person sessions fell during a period of lockdown and we were aware that this digital divide was likely to deepen as well-funded students effectively had their own lab set up at home, where others had very little to work with. We undertook a 'Digital Capacity survey' to understand what, if any provision the students had in home to engage with the curriculum (computers, phones, headsets, data etc). In response to this information we altered much of the curriculum during lockdown to enable all to participate fully.

But for others these issues presented ongoing challenges, and led to inequality of experience:

we were aware that this digital divide was likely to deepen as well funded students effectively had their own lab set up at home, where others had very little to work with.

Expanding on these observations, respondents noted that the pandemic had created the circumstances for an *'exacerbation'* of already evident divides between students who start a course with access to hardware and knowledge of the software/games engines that underpin experiences, and those that do not. In our first question about digital inequalities, one of our respondents began simply by noting *"This has been a hard year for this"*.

Some of our respondents professed to have had quite profound realisations on these issues as a result of the pandemic that would inform their approach to teaching the subject going forwards:

I am much more tightly tuned in to the capacity students have to work independently in home. Before this I was quite focussed on the facilities and expertise we made available on campus, but I realise now this is only one part of the picture. The greater insight into this gained during the pandemic will certainly impact on my planning, teaching and support in the years ahead. I will also be much more aware of the myriad calls on students time, from caring and professional responsibilities, to the challenge of finding workspace that is conducive to postgraduate level research, practice and writing.

I have also learnt how to adapt my teaching style ... We should definitely carry these lessons forward after we return to in-person teaching. We should be fighting (sometimes our universities) for all students to be able to borrow the necessary kit for them to learn at home and in their own time. An MA is mostly self-directed learning; we must do all we can for them to learn at home and on campus.

Educators talked about the need to allow time within teaching and assessments for interventions that can support students who are not engaged,

or who are struggling to fully participate. This is critical in order to *"demystify and democratize the creation of content"* and with any luck, in time, to diversify the sector; its workforce, audiences, content and priorities.[8] This is something a number of our respondents highlight as a crucial related factor.

Closing Thoughts

We would encourage all educators in this space to think more about digital inequalities and associated implications for their programmes and those who study them. Most of the respondents in our small study indicated that accessibility, in terms of both the technology and the tools, needed to develop content continues to be a key issue for their cohorts. These 'first-level' disparities combine with 'second-level' inequalities in ways we are only now beginning to understand, and that no doubt impact student experience, including their propensity to sign up for these courses in the first instance. This is not good news for anyone interested in increasing diversity within the immersive sector.

These issues should not only be a consideration for educators, however, but for developers also. One of our respondents was hopeful that on that front at least, we might be seeing progress:

> *developers are waking up to the fact that accessibility must be included for differently-abled individuals as well as higher performance, faster bandwidth capabilities to ensure a good experience for everyone no matter their VR headset or 2D desktop or laptop and internet bandwidth. It's a slow process, but change is coming.*

We are able to propose some emergent recommendations from the responses we received, and from our own experiences as educators, particularly in the context of the pandemic. Wherever possible, educators should consider placing emphasis in their teaching on storytelling and connections rather than on technology per se. Real-world communities remain hugely important pedagogically, and educators should consider how they can build, and build on, social connections rather than being purely task focused. Working in such a way can help us better understand student capabilities, their level of adaptability and their capacity to work independently outside of academic settings.

The pandemic was an interesting moment in terms of digital inequalities and debates about them. We should not be fooled by any claims that the 'pivot' has created a generation of learners more comfortable with or adept at online learning. As one of our respondents noted:

> *While some people may cite the pandemic for allowing students to upskill in learning software, for some students without access to the necessary kit at home, the inequalities have deepened.*

In our own module, as we have noted, there were very few cases of students unable to access the basic kit needed to participate in the module, but plenty of students who struggled with connectivity, processing power and digital confidence, and it was a hugely varied picture when it came to their having someone at home who might be able to support them as they experimented with the technology. Digital inequalities were in many ways made more visible to us during this period, but we are aware this is something we need to remain attuned to. In the coming years, and as we emerge from the pandemic, it will continue to be important to consider not only students' needs in relation to access, but in relation to a series of other factors too; what Rowsell and Morrell call "lived digital divide inequities" (2020: 1).

Notes

1 Educators from different higher education courses in different countries, identified through a small desk study, contributed to the discussion here through participation in a questionnaire, July–August 2021.
2 This structure is similar to courses that cover similar topics, an example of which can be seen in Çamcı (2020).
3 Hugely important according to Gharehbaghi (2015).
4 The 'design sprint' was developed by Jake Knapp, Braden Kowitz and John Zeratsky for Google Ventures (see Knapp *et al.*, 2016).
5 A press release, a storyboard, a user profile, a burndown development document and a personal reflection on the process.
6 All quotations from survey responses are italicised to distinguish them from citations from the scholarly literature.
7 One respondent noted how challenging it can be for some students when they first encounter an HMD if, for example, they are wearing religious headwear or glasses, or if they find it off-putting encountering another person's make-up or sweat on a device. This *'can be de-motivating and even potentially humiliating for students when they first start to engage'*.
8 The 'mechanisms of exclusion' from cultural occupations are varied and now well-documented (Brook *et al.*, 2020).

References

Biggs, J. and Tang, C. (2007). *Teaching for quality learning at university* (Vol. 3rd Edition). Berkshire: Open University Press.
Brook, O., O'Brien, D. and Taylor, M. (2020). *Culture is bad for you: Inequality in the cultural and creative industries*. Manchester: Manchester University Press.
Çamcı, A. (2020). Teaching Immersive Media at the 'Dawn of the New Everything'. *Proceedings of the 15th International Audio Mostly Conference (AM'20)* (pp. 15–17). New York: ACM.
Castellanos, S. (2021). Augmented Reality Gets Pandemic Boost in *Wall Street Journal* 28/01/21. Available at https://www.wsj.com/articles/augmented-reality-gets-pandemic-boost-11611866795 [Accessed 5 September 2021].
Eynon, R. and Helsper, E. (2010). Adults learning online: Digital choice and/or digital exclusion? *New Media and Society, 13*(4), 534–551.

Gharehbaghi, K. (2015). The importance of industry links in teaching pedagogy: A higher education prospective. *American International Journal of Contemporary Research*, *5*(1), 17–23.

Gourley, L. (2015). 'Student engagement' and the tyranny of participation. *Teaching in Higher Education*, 20(4), 402–411.

Helsper, E. (2021). *The digital disconnect: The social causes and consequences of digital inequalities.* SAGE.

Immerse UK & Digital Catapult. (2019). *The Immersive Economy in the UK 2019.* Immerse UK. Retrieved from Immerse UK: https://www.immerseuk.org/wp-content/uploads/2019/11/The-Immersive-Economy-in-the-UK-Report-2019.pdf [Accessed 28 August 2021].

Knapp, J. with Kowitz, B. and Zeratsky, J. (2016). *Sprint: How to solve big problems and test new ideas in just five days.* Bantam Press.

Lai, J. and Widman, N.O. (2021). Revisiting the digital divide in the COVID-19 Era. *Applied Economic Perspectives and Policy*, *43*(1), 458–464.

MarketsAndMarkets. (2021). *Extended Reality Market with COVID-19 Impact Analysis by Technology (AR, VR, MR), Application (Consumer, Commercial, Enterprises, Healthcare, Aerospace and Defense), Offering, Device Type, and Region (North America, Europe, APAC) – Global Forecast to 2026.* Retrieved July 2021, from MarketsAndMarkets: https://www.marketsandmarkets.com/Market-Reports/extended-reality-market-147143592.html [Accessed 28 August 2021].

Mintzes, J., Wandersee, J. and Novak, J. (2005). *Teaching science for understanding: A human constructivist view.* Elsevier.

Perkins Coie. (2021). *XR Industry Insider Survey.* Available at https://www.perkinscoie.com/content/designinteractive/xr2021/ [Accessed 5 September 2021].

Ragnedda, M. and Muschert, G.W. (2018). *Theorizing digital divides.* Routledge.

Reilly, J. Gallagher-Lepak, S. and Killion, C. (2017). 'e-Learning in Higher Education: The Digital Divide and Culture'. Craig S. Landers (ed.). *The Digital Divide: Issues, Recommendations and Research.* Nova.

Robinson, L., Cotton, S.R., Ono, H., Quan-Haase, A., Mesch, G., Chen, W., Schulz, J., Hale, T.M. and Stern, M.J. (2015). Digital inequalities and why they matter, Information. *Communication & Society*, *18*(5), 569–582, DOI: 10.1080/1369118X.2015.1012532

Rowsell, J. and Morrell, E. (2020). 'Introduction: Moving Stories of Inequity to Stories of Justice'. Morrell and Rowsell (ed.). *Stories from Inequality to Justice in Literacy Education: Confronting Digital Divides.* New York and London: Routledge.

Rowsell, J., Morrell, E. and Alvermann, D.E. (2017). Confronting the digital divide: Debunking brave new world discourses. *The Reading Teacher*, *71*(2), 157–165.

Rubinstein-Avila, E., and Sartori, A. (2018). Diversification and Nuanced Inequities in Digital Media Use in the United States. In *Digital Multimedia: Concepts, Methodologies, Tools, and Applications.* IGI Global: 1216–1237.

Uskali, T. and Ikonen, P. (2021). 'Teaching Immersive Journalism'. Uskali, T., Gynnild, A., Jones, S. and Sirkkunen, E. (eds.). *Immersive Journalism as Storytelling: Ethics, Production and Design.* Taylor & Francis: 163–175.

van Dijk, J. (2005). *The deepening divide: Inequality in the information society.* SAGE.

van Dijk, J. (2020). *The digital divide.* Polity.

Vygotsky, L. (1980). *Mind in society: The development of higher psychological processes.* Harvard University Press.

Watkins, S.C. (2018). *The digital edge: How black and Latino youth navigate digital inequality.* New York: New York University Press.

Wenger, E. (2010). Communities of Practice and Social Learning Systems: The Career Of A Concept. C. Blackmore (ed.). *Social Learning Systems and Communities of Practice.* London: Springer.

Wersényi, G., Csapó, Á., Budai, T. and Baranyi, P. (2021). Internet of digital reality: Infrastructural background–Part II. *Acta Polytechnica Hungarica, 18*(8), 91–104.

Wilkin, S., Davies, H. and Eynon, R. (2017). Addressing digital inequalities amongst young people: Conflicting discourses and complex outcomes. *Oxford Review of Education, 43*(3), 332–347, DOI: 10.1080/03054985.2017.1305058

8 How to Use Social VR in Higher Education: Case Study of the JYUXR Campus in Finland

Turo Uskali, Matti Rautiainen,
Merja Juntunen, Riitta Tallavaara,
and Mikko Hiljanen

Introduction: Virtual Reality in Education

We are already at the beginning of the third wave of adopting virtual reality (VR) in education.

The first wave occurred at the dawn of the new era of VR in the 1960s and focused on flight simulator training (Christou, 2010). Originally, VR training was developed for military purposes. Later, medical, firefighting and first responder training have all benefited from VR simulators, and training is still the most studied use of VR (Jacobson, 2017).

The second wave can be traced back to the end of the 1980s and early 1990s (Alhalabi, 2016, 921). During that time, many educators and researchers still paid attention to simulator models. For example, Christopher D. Wickens (1992), representing Aviation Research Laboratory at the University of Illinois at Urbana-Champaign, argued that good interface design was important for the learner. Sarah Hensel (1992, 38) moved a bit further by asking, "Will virtual reality allow educators to act as gods – creating new realities and magical worlds with educational Utopias where all students learn?" Hensel believed that VR had the potential to move education from textbooks to experiential learning (ibid., 41).

The third wave in VR education started in the 2010s as VR technology advanced. New forms of VR experiences emerged like the first stories of immersive journalism (de la Peña et al., 2010). At that stage, more empirical testing of virtual environments in education was possible, and it was seen in the research literature. In summary, many studies from the third wave indicated positive feedback from tests of VR in education. For example, Alhalabi (2016, 925) concluded, "Using any VR system dramatically improves the students' performance".

Today, the common premise is indeed that immersive environments (IEs) offer an active approach to learning and may, therefore, enable deeper learning experiences (Shuteet al., 2017, 72). According to the research literature, many barriers exist in terms of adopting IEs in education.

DOI: 10.4324/9780367337032-11

For example, McGovern et al. (2020) argued that two main obstacles could be found in higher education: One is at the university level, and the other relates to the individual level of educators. At the university level, the lack of investment in a digital infrastructure is a common bottleneck. Another problem is a general hesitancy or even aversion among professors and lecturers toward adopting new technologies.

Furthermore, Richards (2017, 89) argued that integrating new technologies with existing classroom systems and with existing and emerging pedagogical practices has proved to be difficult. In addition, special health-related issues such as VR-based motion sickness, a basic sensory conflict when brains are getting mixed signals from the environment, are still valid concerns. However, motion sickness could be avoided if continuous movement is minimised, and by using, for example, "teleporting" instead (ibid., 101).

Although research on VR education has been conducted for nearly 30 years, many scholars are still pessimistic about the adoption of the new tools, especially for K-12 classrooms. For example, Richards (2017, 102) argued, "We have not seen large-scale successful applications of immersive learning technologies in the classroom".

Editors Dede and Richards (2017, 238) concluded the following in their book:

> *Immersive media have great potential to promote enriched curricular content, active forms of learning, performance assessments with high validity, and the application of academic learning to real world situations. However, much work remains to be done before these educational technologies will be truly practical, affordable, and scalable.*

Despite these problems, by 2015, the immersive technology market for global education was larger than the industrial training market, and it was expected to grow from 1 billion dollars in 2015 to about 16 billion by the year 2020 (Richards, 2017, 90–91).

Next, we will shift our focus to higher education. The first experiments using VR in higher education included, for example, engineering students (Alhalabi, 2016), psychology and communications students (Bailenson, 2018), journalism students (Uskali and Ikonen, 2020) and business students (McGovern et al., 2020). Although research into VR has increased dramatically in recent years (Makransky and Petersen, 2021), we still lack knowledge about how VR has been used in teacher education. If VR is to ever be widely adopted in education, then higher education, and especially teacher education, play an essential role in the diffusion of VR skills. As Torro (2020, 24) argued, "Educating the educators about VR and its potential is critical".

But, before presenting our case study of JYUXR Campus focusing on teacher education, we still need to introduce a new term that is important for understanding the recent evolution of immersive VR: social VR.

Social Virtual Reality

Without high-quality real-time communication and social interaction, VR experiences are in danger of staying in solitude and marginality. Torro (2020) listed five important prerequisites for the success of VR in higher education: stand-alone head-mounted displays, quality over quantity, recognition of the complexity, educating the educators and social VR.

It has been widely believed that as soon as the social element could be implemented in VR experiences, it would become the "killer application" that is needed before new technology can become mainstream and in everyday use. The imminent upcoming era of social VR has been predicted since at least the year 2011 (Perry, 2015). The engineering magazine Spectrum IEEE (Ibid., 57) stated that "social virtual reality allows two geographically separated people, in the form of fairly realistic avatars, to communicate as if they were face-to-face".

In recent years, many new social VR applications have been published, enabling social VR to enter a new phase. The user bases of AltspaceVR, Facebook Spaces, Rec Room and VR Chat are already in the millions. In August 2021, there were about 170 million VR users worldwide (Petrov, 2021).

Maloney and Freeman (2020) pondered the meaningfulness of social VR for users. For their study, social VR referred to "3D virtual spaces where multiple users can interact with one another through VR head-mounted displays (HMDs)" (Ibid., 510). Their results identified five forms of activities that users find meaningful: full body mirroring activities, doing mundane and essential everyday activities in new ways, activities for social and mental self-improvement, immersive cultural appreciation and educational activities, and engaging in immersive events. It seems that social VR applications have already passed some milestones as some have even used the applications for getting sleep. Although their study did not focus on social VR in education, the interviewees mentioned that social VR platforms motivated them to learn, for example, to learn new languages and cultures. Also, new methods for self-improvement such as meditation were learned.

Even if social VR is clearly offering new immersive affordances to education, openly accessed applications also include the potential for misbehaviour and harassment, especially through real-time voice chat and avatar movements. A team of Facebook's Oculus VR representatives agreed, saying "Embodiment and presence make harassment feel more intense". As a solution, they proposed a bottom-up, community-led governance that should be based on "responsive regulation" (Blackwell et al., 2019, 23). Of course, this has often been the main strategy for social media platform companies: crowd-sourcing the handling of ethical problems for the users. However, social VR companies should also be responsible for creating safety features like enabling personal spaces and quickly responding to any cases of misbehaviour and harassment in timely manner. After years of news reports of harassment in social VR, Microsoft's AltspaceVR, for example, has created

its own community standards, including instructions for how to report any violations of the community standards (Docs.microsoft.com, 2021).

All this reinforces the notion that social VR is maturing as a new technological platform that needs to be tested in the field of education. One of the first examples of how to use social VR in teacher education is the case of the Finnish JYUXR Campus.

Designing and Constructing the JYUXR Campus

Due to the COVID-19 pandemic, distance teaching and learning has been used by most universities around the world as a substitute for on-campus education since the spring of 2020. Videoconferencing tools and platforms like Zoom and Teams were in a key position when professors and lecturers rushed higher education from the campus into the home. Enter Zoom fatigue as a new term in educational vocabulary. This overload of constant streams of video-conferencing was one of the starting points for creating a new VR teaching and learning environment at the University of Jyväskylä. JYUXR Campus was officially opened on December 14, 2020, via AltspaceVR, making it one of the first higher education institutions to test an open social VR platform for its teachers' education.

Of course, a few other VR platforms had already been tested around the world in some schools and universities, such as in the United Kingdom, and Australia via special VR environments designed for education; for example, EngageVR or VictoryXR. But these educational VR platforms are chargeable and closed systems, and therefore, they are less open for innovative testing and development of new teaching methods.

JYUXR Campus arose from the need of the university's teacher educators to safely organise a mass learning event for about 100 teacher students during the COVID-19 pandemic. A virtual learning environment was required where students could meet each other and the teachers, chat together, learn together and laugh together. All of this should preferably be carried out in a space that would create the feeling that all participants were together on their familiar university campus. Collaborative learning, interaction and collaborative knowledge building were the key pedagogical cornerstones. To implement such pedagogies, new kinds of learning spaces needed to be designed and constructed.

AltspaceVR is a scalable multiplayer operating environment where you can move and communicate freely as an avatar and build your own spaces. It is a free environment for both users and virtual world administrators. All virtual modes/worlds are first built with Blender and Unity and then loaded into AltspaceVR, which provides a lot of ready-made functionality for the worlds.

A Unity 3D modeller was hired to create unique learning spaces for VR. One of the starting design principles was that facilities on the JYUXR Campus must be available for download to the most used social VR ready-made services because they have versatile functionalities ready in a

multiplayer environment. JYUXR Campus was ready to be used only two months after the first planning meeting.

The JYUXR Campus consists of four different learning spaces: the outdoor space of the campus (lobby/navigation space with portals to all other campus facilities), the lobby of the main campus building, 11 small identical group spaces placed in different parts of the real University of Jyväskylä campus and the Finnish Summer Cottage Island. All 11 small group virtual spaces show 360-degree images of the real university campus. They are designed for communal learning, but they are also well suited for various events, such as exhibitions, parties, academic events, meetings and professional and free-form meetings.

The opening ceremonies of the JYUXR Campus offered a glimpse of a new kind of a hybrid event, mixing old traditions and new technologies. When the President of the university and the Dean of the Faculty of Education and Psychology gave their opening speeches, an audience in the form of avatars were using emoticons. Also, a local musician played some of his greatest hits acoustically in real time, which again caused a wave of animated reactions. Social interaction and communication were key parts of the event and were enabled by moving avatars, emoticons and audio channels (see www.jyu.fi, 2021).

In designing the premises, special attention was paid to a manageable size, visuality and the aesthetics of the spaces. In addition, functionality and suitability for the joint activities of large groups were also important to apply, as was the possibility of dividing a group into smaller groups working peacefully in the same space. There is also a large screen in the learning space that everyone can access to share content stored on YouTube. In order to enrich learning experiences, for example, 3D models or image files (including 360 images) as learning objects could be brought to the space.

But of course, there is still a lot that can be developed better; in particular, logging in and deploying requires a lot of time and know-how. Currently, one cannot use AltspaceVR on mobile devices, and one faces a lot of challenges trying to use it on an Apple computer. The new update and collaboration with Microsoft's Mesh environment will be released in October 2021. Hopefully, that will bring numerous new opportunities for learning as well as virtual and real worlds merged into a common operating environment. It could be participated in both as an avatar from the virtual world and as a physical self from the real world.

JYUXR Campus was created as an open test bed for anyone interested in VR education. It is not limited to use by only the faculty and students at the Finnish university; on the contrary, JYUXR Campus is accessible to the whole world. Of course, this has already caused a phenomenon of passersby, where individual avatars from around the world pay short visits to the virtual campus as part of their global travelling tour, teleporting from one destination to another without any means other than curiosity. At least so far, these virtual globetrotters have been well-behaved.

Aims and Implementation of Experiment

The first teaching experiments of JYUXR Campus at the University of Jyväskylä were implemented in 2020–2021 as two fair-type events, which were part of mandatory courses in the subject teacher education program (pedagogical studies for subject teachers, 60 ECTC). The first group consisted of students who started their university studies in the autumn of 2020; the other group of students was finishing pedagogical studies (master's studies). Pedagogical studies give students the necessary qualifications to teach basic education and upper secondary school subjects they have studied at university for at least 60 ECTS.

Over a hundred students representing 13 different major subjects and five faculties participated for both fairs. Thus, both student groups were very heterogeneous. However, students share with each other much of the same. Although the autonomy of teachers in Finland is very broad, especially when compared internationally, the social cohesion of teachers (e.g. values and perceptions of what constitutes good teaching) is very strong. Subject teacher students typically look at their future work strongly from the perspective of their own subject (Veijola, 2013; Yrjänäinen, 2011). In addition, the nature of a subject teacher's work represents continuity and stability more than radicality and change. In teaching experiments, when facing something new, students are often polarised into three groups. First, a small group is immediately ready for change. Second, and the biggest one, consists of students basically open-minded, but a step in a new direction requires practical examples to follow. The third group is small and against the new (Rautiainen, 2008; Rautiainen and Veijola, 2020). From these perspectives, JYUXR Campus offered excellent spaces for subject teacher students to challenge concepts and practices of teaching and learning.

At both fairs, students made a project in groups, and the projects were presented for others on the JYUXR Campus. In practice, each group had their own space and exhibition point on the JYUXR Campus where they planned and implemented their presentation to others. The first fair was characterised by the transfer of the real world to VR reality. Groups presented their work via text-based presentations that visitors had to open using QR codes placed on media screens. This hampered interaction because it took a long time to not only open QR codes but also to read long text-based materials. Interaction and activity were marginal compared with the expectations we had before the fair. Based on this experience, interaction and activity were emphasised in the second fair for students during the planning period. In addition, QR codes were not allowed to be used in a similar way as they were used during the first fair. Instead, students were encouraged to use either pictures/photos or videos on media screens and, in particular, plan activities for interaction. As a result, groups implemented more diverse solutions in their own spaces. Some of the teachers had their own group in both fairs, which had a

significant role in the developmental work: positive experiences from the first fair transferred towards stronger pedagogical development of the environment during the second fair.

AltspaceVR was familiar to only a few educators and students before the fairs. In addition, experiences in VR realities were more occasional than regular. Thus, special attention was paid to the use of AltspaceVR. For the first fair, educators were oriented together to the use of AltspaceVR, and educators then trained their students in their own groups. The same was repeated for the second fair, but now educators who had participated in the first fair shared their own experiences with others. At both fairs, educators were supported by an expert in the pedagogical use of VR realities and the developer of JYUXR Campus.

From Experiences Toward Developmental Work

In this section, we present key findings from our VR experiment in university education. We used collaborative autoethnography as an approach to understand our experiences. In collaborative autoethnography, the research data are researchers' own experiences and the material created about those experiences, like research diaries and discussions between researchers about experiences (Chang et al., 2012). The four authors of this article participated in the fairs as teacher educators and pedagogical experts. In addition, we used course feedback collected by the university administration. The administration services at the University of Jyväskylä collect formal feedback for all courses by a questionnaire that is voluntary for students. Through the questionnaire, students have the opportunity to give feedback on teaching and working methods, as well as learning in the course. The questionnaire consisted of both Likert-based and open-ended questions. Thus, feedback did not focus on students' views and experiences of the VR as part of the course. However, students could give feedback about the fairs via open-ended questions. In all, 11 out of 61 students who filled out the questionnaire highlighted the fair experience in the AltspaceVR environment in their answers.

The polarisation that is typical for students and educators participating in experiments in education was also realised in this experiment.

The nearer the fairs are, the stronger uncertainty and critique against VR environment strengthen. I know it reflects more broader perceptions and understanding of learning, teaching and studying, but why these voices cannot be said at the beginning of the course? At this stage, "critical" voices are more or less signs of frustration of individuals.
(Researcher A's research diary, 1.3.2021)

I was wandering in XR-Campus and heard two students talking together and complaining how horrible JYUXR Campus is. I was

confused first, but then I thought, yes – environment works, because students found themselves a peaceful place to talk.
(Researcher C's research diary, 14.12.2020)

The polarisation was visible also in student feedback gathered after courses: "The virtual fair in Altspace was also nice" and "Task in Altspace did not work at all" describe opposite experiences, but the reasons behind students' experiences may vary. As noted earlier, a subject student teacher's orientation towards pedagogical studies is strongly defined by the perceptions in the sub-culture of their major and teaching subject. In addition, students' orientations toward their studies differ generally (see, e.g. Beaty *et al.*, 1997; Jeffrey, 2009). These different orientations to learning and teaching especially come to the fore when education is based on new and previously unexperienced elements, such as studying on XR-Campus. In general, discussion on the use of technological and digital learning environments in education has been focused on the question of whether technology should be used in education rather than considering the possibilities of different learning environments (e.g. Jalkanen, 2015).

Although COVID-19 has radically changed this setup, during the experiment, we faced the question of why the fair could not be held in environments already in use, such as Zoom. This is the same phenomenon that Jalkanen (2015) describes in his research, but now it has moved into the discussion about technologies because educational institutions have been forced to use technology in education. We are now debating whether new and less familiar technologies should be used in education, and the XR technology and XR environments representing "new" opportunities are part of this debate.

In our experiments, the change in the pedagogical nature of fairs was remarkable between fairs. After initial technological uncertainty, teacher educators could focus more on pedagogical uses of AltspaceVR. Thus, the second fair offered more variety and different kinds of activities than the first fair, including games, action-based debates, discussions and physical exercises related to well-being. In other words, pedagogical processes were more communal in the second fair than in the first one.

Once it became clear that videos cannot be used because of new updates, I could concentrate on students' work and go around XR-Campus. After seeing all 11 points, I said "WOW" to myself. Some groups were implementing skillful, interactive and immersive pedagogical solutions that took advantage of the Altspace environment. My personal favorite was a point where participants had to express their opinion for certain claims via selecting a space in exhibition point. This was followed by discussion and short presentations of research findings concerning the claim.
(Researcher A's research diary, 18.3.2021)

The use of new technologies in education usually involves technical problems, especially in the early experiments also faced in our Altspace experiments. Because of the complex technology of Altspace, a technical expert was an essential part of the team in our experiment. In addition, one of the educators was an expert in the pedagogical use of VR realities. Without their input, it would not have been possible to implement the fairs' unique experience.

Experience was unique because we all were at the front of something new, never experienced. All we needed, was open mind towards experiment. Together – supporting each other!
(Researcher B's research diary, 15.12.2020)

The Altspace environment is at its best when organising interactive events, -and the experience is immersive when using a VR headset. This was possible for only a few participants, and most students used computers. It reminded many students of their childhood virtual environment at Habbo Hotel (see more at habbo.com).

I'm sure Altspace will offer a lot of possibilities in education when it will be developed.
(Student 6, course feedback, spring 2021)

The above-described experiments were the first ones for JYUXR Campus at the University of Jyväskylä. Based on our collaborative experiences and reflections, the following four elements were successfully implemented in our experiments and constructed a basis for the use of Altspace in university education.

JYUXR Campus Environment

The campus offered a lot of possibilities for interaction and different pedagogical solutions from the beginning. After first experiments, more Utopian spaces have been constructed.

Support

The technical and pedagogical support of two experts was essential for the use of the JYUXR Campus. Support enabled educators to focus on teaching in the new environment.

Educated Staff

A common orientation, as well as peer learning, strengthened the activities of educators.

Confidence of Students

The Altspace environment was new for most of the students. However, students' preparedness to use technology and adapt to new environments was high, and they could implement their activity autonomously after instruction and training in the use of the environment.

The following four elements require special attention when developing uses of Altspace in university education.

More and Earlier Is Better

Activity in the Altspace environment was placed at the end of both courses, partly because JYUXR Campus was launched at the same time as our first fair. However, the use should start at the beginning of the course when critical views could be discussed before planning and activity. In addition, JYUXR Campus should be part of other courses as well, when the use would not be a unique, one-time experience but, rather, a normal environment among others.

VR Environment's Specificity

All students were slightly confused about why the fairs were organised in JYUXR Campus, not in environments mostly used in university education. Thus, JYUXR Campus special features should be stressed more for students and there should be an emphasis on activities not possible in real life.

Immersion

Only a few students had the possibility to use a VR headset at the fair, and because of COVID-19, the university could not support students having an experience on the JYUXR Campus via VR headset. Even if the university does not have the possibility to offer VR headsets for all students during fairs, all students should experience the environment of JYUXR Campus via VR headsets.

Focus on Individual Learners

At both fairs, our resources were mostly focused on organising the new event as itself and groups as a unit implementing exhibition points. However, resources should focus also on individuals to encourage their activity in VR environments.

Next Steps

The first phase of the JYUXR Campus building process ended in the summer of 2021. After the first experiments described in this chapter, new spaces were constructed in spring 2021. During the academic year 2021–2022, JYULearn is implementing JYUXR Campus inside the

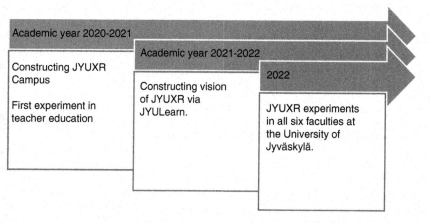

Figure 8.1 Implementation of JYUXR campus inside the University of Jyväskylä.

university and supporting experiments in all faculties. JYULearn is part of JYU's strategy work that promotes, via experiments, for example, pedagogically and digitally appropriate teaching practices.

The developmental work in coming years will focus on different activities for strengthening collaborative learning in JYUXR Campus. As noted earlier, AltspaceVR is at its best in activities emphasising interaction. Own environments in VR environments e.g. for students, programs and faculties could be possible solutions as well. In addition, own content production, such as 3D models, are part of long-term developmental work as well as strong infrastructure (VR labs) at the university. In autumn 2021, the university will open several rooms where it is possible for all staff and students to use VR headsets. Thus, the most important goal is to get university staff and students to JYUXR Campus and use it in different, innovative ways. Alongside this goal, co-operation among other stakeholders using VR environments is essential. The University of Jyväskylä is part of the regional ecosystem, where educational institutions and companies develop a shared environment together that contains existing VR environments such as JYUXR Campus.

Conclusion

As Dede and Richards (2017: 242) acknowledged with regard to VR education, "It's crucial to see experiments that are 'informative failure' as a success in advancing knowledge". They also assert that it is still rare to find educational test beds that include risk-taking and experimentation. Clearly, JYUXR Campus is operating as one of these early test beds for immersive learning in teacher education.

We argue that VR indeed offers new opportunities for immersive teaching and learning, but many bottlenecks still exist. Our leading premise for this

chapter was that new immersive technologies should be first tested and adopted in teacher education, and only after that should it be implemented in schools. We add that without proper and functional VR learning environments, nothing noticeable will ever happen. As the current VR technologies already support platforms that offer real-time immersive 360-degree social experiences, we trust that social VR could finally enter into every level of education. However, more risk-taking, experiments and investments, especially on the newest models of stand-alone head-mounted displays, should be done in higher education before social VR will be a reality for every student and teacher.

References

Alhalabi, W. (2016). Virtual reality systems enhance students' achievements in engineering education. *Behaviour & Information Technology*, 35(11), 919–925. 10.1080/0144929X.2016.1212931

Bailenson, J. (2018). *Experience on demand: What virtual reality is, how it works, and what it can do.* New York: W.W. Norton & Company.

Beaty, L., Gibbs, G. and Morgan, A. (1997). 'Learning Orientations and Study Contracts'. Marton, F., Hounsell, D.J. and Entwistle, N.J. (eds.). *The experience of learning.* Edinburgh: Scottish Academic Press: 72–86.

Blackwell, L., Ellison, N., Elliott-Deflo, N. and Schwartz, R. (2019). Harassment in social virtual reality: Challenges for platform governance. *Proceedings of the ACM Human-Computer Interaction*, Vol. 3, No. CSCW, Article 100 (November 2019), 25 pages. 10.1145/3359202

Chang, H., Ngunjiri, F. and Hernandez, K-A. (2012). *Collaborative auto-ethnography.* New York: Routledge.

Christou, C. (2010). 'Virtual Reality in Education'. Tzanavari, A. and Tsapatsoulis, N. (eds.). *Affective, interactive and cognitive methods for e-learning design: Creating an optimal education experience.* Hershey, PA, United States: IGI Global: 228–243. 10.4018/978-1-60566-940-3.ch012

Dede, C.J. and Richards, J. (2017). 'Conclusion—Strategic Planning for R&D on Immersive Learning'. Liu, D., Dede, C.J., Huang, R. and Richards, J. (eds.). *Virtual, augmented, and mixed realities in education.* Singapore: Springer: 237–243.

de la Peña, N., Weil, P., Llobera, J., Giannopoulos, E., Pomés, A., Spanlang, B. and Slater, M. (2010). Immersive journalism: Immersive virtual reality for the first-person experience of news. *Presence: Teleoperators and Virtual Environments*, 19(4), 291–301.

Docs.microsoft.org. (2021). *AltspaceVR Community Standards.* Available from: https://docs.microsoft.com/en-us/windows/mixed-reality/altspace-vr/community/community-standards [Accessed 21 August 2021].

Hensel, S. (1992). Virtual reality and education. *Educational Technology*, 32(5), 38–42.

Jacobson, J. (2017). Authenticity in immersive design for education. Liu, D., Dede, C.J., Huang, R. and Richards, J. (eds.). *Virtual, augmented, and mixed realities in education.* Singapore: Springer: 35–54.

Jalkanen, J. (2015). *Development of pedagogical design in technology-rich environments for language teaching and learning.* Jyväskylä studies in humanities 265. University of Jyväskylä, Jyväskylä.

Jeffrey, L.M. (2009). Learning orientations: Diversity in higher education. *Learning and Individual Differences*, 19(2), 195–208.

Makransky, G. and Petersen, G.P. (2021). The cognitive affective model of immersive learning (Camil): A theoretical research-based model of learning in immersive virtual reality. *Educational Psychology Review*. Available from: https://doi-org.ezproxy.jyu.fi/10.1007/s10648-020-09586-2

Maloney, D. and Freeman, G. (2020). Falling asleep together: What makes activities in social virtual reality meaningful to users. In *Proceedings of the Annual Symposium on Computer–Human Interaction in Play (CHI PLAY'20)*, November 2–4, 2020 Virtual Event, *Canada*. New York: ACM. 10.1145/3410404.3414266

McGovern, E., Moreira, G. and Luna-Nevarez, C. (2020). An application of virtual reality in education: Can this technology enhance the quality of students' learning experience? *Journal of Education for Business*, 95(7), 490–496. 10.1080/08832323.2019.1703096

Perry, T. S. (2015). Virtual reality goes social. *IEEE Spectrum*, 53(1), 56–57.

Petrov, C. (2021). 45 Virtual reality statistics that will rock the market in 2021. Techjury.net. Available from: https://techjury.net/blog/virtual-reality-statistics/# gref [Accessed 21 August 2021].

Rautiainen, M. (2008). *Keiden koulu? Aineenopettajaksi opiskelevien käsityksiä koulukulttuurin yhteisöllisyydestä*. Jyväskylä Studies in Education, Psychology and Social Research 350. Jyväskylä: University of Jyväskylä.

Rautiainen, M. and Veijola, A. (2020). 'Alakulttuurin tuho ja uuden synty eli kuinka historia synnytettiin uudelleen'. Tarnanen, M. and Kostiainen, E. (eds.). *Ilmiömäistä! Ilmiölähtöinen lähestymistapa uudistamassa opettajuutta ja oppimista*. Jyväskylä: University of Jyväskylä: 181–196.

Richards, J. (2017). 'Infrastructures for Immersive Media in the Classroom'. Liu, D., Dede, C.J., Huang, R. and Richards, J. (eds.). *Virtual, augmented, and mixed realities in education*. Singapore: Springer: 89–103.

Shute, V., Rahimi, S. and Emihovich, B. (2017). 'Assessment for Learning In Immersive Environments'. Liu, D., Dede, C.J., Huang, R. and Richards, J. (eds.). *Virtual, augmented, and mixed realities in education*. Singapore: Springer: 71–87.

Torro, O. (2020). 'Five Key Insights for Successful VR Adoption in HEIs'. Schwaiger, M. (ed.), *Boosting virtual reality in learning*. Focus Europe Special Edition. Graz: E.N.T.E.R GmbH: 23–24.

Uskali, T. and Ikonen, P. (2020). 'Teaching Immersive Journalism'. Uskali, T., Gynnild, A., Jones, S. and Sirkkunen, E. *Immersive journalism as storytelling: Ethics, production, and design*. Oxon: Routledge.

Veijola, A. (2013). *Pedagogisen Ajattelun Kehittyminen Aineenopettajakoulutuksessa. Tutkimus Suoravalituista Historian Opettajaopiskelijoista*. Jyväskylä studies in education, psychology and social research 478. Jyväskylä: University of Jyväskylä.

Wickens, C.D. (1992). Virtual reality and education. IEEE Conference Publication: 18–21. 10.1109/ICSMC.1992.271688

Www.jyu.fi. (2021). *Opening the JYUXR Campus*. Available from: https://www.jyu.fi/fi/ajankohtaista/arkisto/2020/12/vr-kampuksen-avajaiset [Accessed 27 August 2021].

Yrjänäinen, S. (2011). *"Onks meistä tähän?" Aineenopettajakoulutus ja opettajaopiskelijan toiminnallisen osaamisen palapeli*. Acta Universitatis Tamperensis 1586, Tampere: Tampere University Press.

9 The Moral Metaverse: Establishing an Ethical Foundation for XR Design

Professor Andy Miah

Introduction

In October 2020, the IEEE convened a Global Initiative on Ethics of Extended Reality to address critical concerns in the emerging XR environment (IEEE, 2020). The initiative was born out of a concern that new forms of reality, made possible by the design of alternate worlds and the growing amount of time people spend within them, calls for urgent action to articulate the obligations and responsibilities of technology designers to the public. The initiative is the latest manifestation of an ethical foundation to computer culture, which has been a central feature of its creation since the early days of computer science. From the creation of the first computers (Bynum, 2017) to the most recent advances in artificial intelligence, ethical debates about our networked society have focused on a variety of concerns pertaining to humanity's quality of life, questions of inequality (Tavani, 2003) along with discussions about how computer-mediated experiences affect people's sense of being in the world (Mäkinen et al., 2020).

In the first computer age, debates focused on the impact of automation on working lives, expanding the trajectory of alienation from the mode of production, exacerbating feelings of a loss of ownership over the process of creation (Kellner, 2006). As the Internet era emerged, moral concern turned to the proliferation of virtual interactions and the prospect that people might lose touch with the physical, social world, or fail to operate as fully human (Turkle, 2011). The cyborg and posthuman futures imagined over this brave new era also turned attention to the growing integration of technology within biological systems, where the prospects of dehumanisation through technological barriers being broken down by genetics and artificial life were also the cause of anxiety about our digital future (Miah, 2008).

Today, in an era of artificial intelligence, companion robots or cobots, and an already data-driven society, the need for ethical limits on technological change have never felt more urgent. This is true, especially, in the context of those technologies that disrupt the boundaries between reality and unreality and, in particular, the need to operate within the former. Alongside this, public ethical debate has shifted towards designing technologies that are in

DOI: 10.4324/9780367337032-12

support of ecosystemic health, thus minimising the impact of the human species on other forms of life, and designing new technological solutions that cohere with a prudential culture of care for life on earth.

In this sense, whether it is the transformation of our interpersonal communication or the facilitation of services that underpin societies, the ethics of digital design have become prominent features of public debate (Cuttica, 2020)), but with little resolve. The rise of digital extended realities – what I collectively call here XR – is an important component of these discussions, as their potential to disrupt the fabric of lived biological embodiment becomes even greater. Indeed, disruption to reality is a key feature of ethical debates surrounding alternate realities, where scholars have enquired into the implications of creating alternate spaces, particularly in terms of its impact on the existing realities that people experience outside of such systems.

What's more, while discussions about ethics often focus on how human lives are lived, XR has a non-human animal component too. This is especially important as we get closer to embodied virtual reality experiences, such as the imposition of digital personas onto robotic or even biotic physical entities. We know little about how non-human animals may respond to the presence of embodied digital artefacts that are perceived by their distinct sensorial capabilities. Yet, it would be remiss to ignore such eventualities, especially when digital twins of species begin to blur the boundaries between the origin and the copy. Imagine the possibility of leaving a dog at home with an embodied digital twin of its owner. Might this become a moral expectation of pet ownership, as the ultimate form of enrichment for a domestic animal, or the source of considerable confusion for it? These fanciful ideas become realistic considerations in a world where disruption to reality is possible through XR. For example, in November 2021 research outlines how dogs might use video call technology to contact their owners, as a way of providing further opportunities for socialisation when left home alone (Hirskyj- Douglas et al., 2021).

Ethical discussions about new forms of digital reality often centre on the eventual user experience and investigations into the consequences of deployment for different communities. For example, how does a new XR experience affect personal and interpersonal communications, or how does it transform our sense of being in the world? These debates have far-reaching origins, where the current debates about experiencing life through virtual reality headsets are conceptually aligned with discussions about a wider variety of world-remaking innovations and experiences, from daydreaming and reading to television, music and social media. In each case, at different points in history, these forms of world making have been subject to criticism over their tendency to relocate people from some presumed notion of a true (and more important) reality in which people should predominantly reside, to an, often, lesser or ephemeral reality where lives are more like a "hallucination", to quote William Gibson (1984).

These discussions have reached heightened levels with the emerging discourse on the prospects of an imminent *metaverse*, a concept with roots in the early years of our digital imaginary, which appeared first in Neal Stephenson's 1992 science novel *Snow Crash* (Stephenson, 1992). More recently, the metaverse has become a focal point for large technology companies such as Facebook which, in November 2021 announced a transformation to its parent company, which would become known as *Meta*, signalling a shift into designing for the metaverse (Meta, 2021). Many of the reactions to this new metaverse centred on the moral content of the transformation, located particularly in a concern that the new company name sought to distance itself from its previous, controversial history, as a data-driven organisation whose policies and practices have been challenged in legal courts and in the media. In this sense, Meta seeks a new image for Facebook, which draws highly on a narrative of hope that the metaverse seeks to embody in its pursuit of unifying a fragmented digital world where software and hardware often fail to operate seamlessly across platforms.

The public discourse around the launch of *Meta* highlights the growing importance of ethical considerations in technological design, particularly where this concerns the disruption of existing modes of determining what is real and what is not. This is because the creation of alternate realities is accompanied by the risk that they relocate human experience outside of conventional forms of securing moral responsibility, environments where there is not often an understanding of how else social norms may operate, if at all. A simplified example of this is found in the proposition that playing computer games leads to children spending less time playing sports, an idea that is not born out of the scientific evidence, but which is interwoven with what Kember (1998) describes as a "virtual anxiety", a deep-seated ideological concern about the "loss of the real" (p. 10).

Such concerns are more appropriately described as moral concerns, rather than ethical, since they are features of uncodified modes of existence, to which one must appeal to norms and principles in order to resolve. In this sense, they are enquiries which seek to identify characteristics of the good life. As Lee and Hu-Au (2021) describe, XR requires ethical scrutiny so as to understand "whether it supports or hinders human flourishing" (p. 2) and, in this sense, it is about more than just ensuring good practice. Yet, there are also ethical concerns which pertain to the kinds of responsibilities that people face, through the conduct of their professional lives; the kinds of moral concerns that underpin the practises of designers, technologists, creators, medics and scientists. It is these, subsequent concerns that I want to address predominantly in this chapter.

Of course, morality and ethics are closely related subjects and a considerable amount of scholarship has investigated their differences. Here, I consider that morality describes those principles that govern the kinds of lives we ought to live, while ethics is the process by which those principles

are critically interrogated through philosophical reasoning and which, then, describes the formalisation of those conclusions into codes of conduct or the accepted and expected norms of a practice. For example, a virtual reality system that specifies a minimum age use of 13 years may determine such limits on the basis of a concern of legal liability, a fear that, should any health issues arise from use, then this may lead to a legal claim against the manufacturer and potential financial, civil, or even criminal sanctions. Yet, the legal liability is born from the prior moral concern that people should be protected from harms which arise from using a product or, at least, should be able to consent freely to accept the risks of that interaction before participating. To this end, the underlying moral premise of the principle is the belief that societies should optimise opportunities for their citizens to exert personal agency over their lives, especially where such actions do not harm others. Furthermore, the ethical principle consists in the codes of conduct that govern such design, either through its instantiation of a legal framework or a set of agreed principles that govern best practice. Admittedly, there is more complexity to the principles that govern the regulation of products and services than is described in this simple explanation, but it is helpful to identify that such processes of formulating these principles transcend the ethical codes of conduct that underpin their deployment. Rather, the ethical codes are intimately connected to a deeper moral conviction over what sorts of societies we seek to create.

This deeper engagement with moral concerns is also of interest to this chapter, which seeks to identify critical ethical principles that should inform the design of XR. Crucially, I want to specify fundamental ethical considerations when designing XR environments to ensure that the design sector fulfils its obligations, responsibilities and duties that apply to designing alternate worlds, especially when these become dominant parts of people's lived reality.

The starting point here is to examine the present culture of XR design and to establish what may be some of these considerations apparent within the sector. From here, the chapter critically interrogates these principles and considers further issues that may yet to have been fully resolved in the design of XR systems and experiences. However, initially, I outline the principles that underpin this methodological approach.

Developing an Ethical Framework of Reasoning About XR

Historically, modern western philosophy has developed two distinct theoretical approaches to applied ethics, which may be broadly described as rule-based versus consequence-based approaches. The first of these has sought to identify rules or principles that best serve the optimisation of good practice, either across a broad societal population or within a specific practice community. For example, one might ask "what are the ethical obligations of XR designers to their users?" and then seek to elaborate on

these obligations before identifying rules which permit their adherence. This approach, which is predominant in medical and scientific ethics, now pervades many aspects of social life and has been shaped by the influential work of bioethicists Beauchamp and Childress (2001) Their four fundamental principles of bioethics: respect for autonomy, beneficence, nonmaleficence, and justice, have become central pillars of best practice within a variety of applied settings, transcending their initial bioethical context.

This principled approach to thinking about morality has been defined in a variety of ways by different traditions within moral philosophy and applied ethics, from virtue theory to deontological approaches. For example, virtue theory involves identifying and specifying the principles by which one should live which follow from the rightness of a rule, rather than the rightness of its consequences. The overarching premise is that the consequences do not determine the merit of the rule. Instead, its rightness is born out of a conviction that some things are right or wrong by virtue of how they reflect moral character, rather than for the consequence they provoke. For example, Coeckelbergh (2021) discusses the example of robot ethics, specifically the case of abuse to robots. They describe how such behaviour is not morally wrong because of the harm to the robot – since speaking of harm to an object would be misconstrue what harm entails – but to the manner in which such harm would evidence the flawed moral character of the person inflicting the harm. So, somebody who is given a social robot with which they develop a relationship over time and then proceeds to destroy it without due reason, is, rightly, not harming the robot. Rather, their destructive act is evidence of failure to care and reveals a moral inadequacy in their character to treat things with respect, regardless of the harm they may experience.

Alternatively, a *deontological* approach seeks to identify an individual's obligations to others within any given setting, so as to determine which forms of right action should follow. For example, a physician's need to adhere to patient confidentiality is born out of their special relationship and this feature of their professional identity is what determines the moral principle. In design ethics, one might describe obligations to assess safety risks, which might arise from utilising a product or service.

The second approach is described as *utilitarianism* and focuses on identifying the potential or actual consequences that follow from the implementation of specific ethical principles – or which are retrospectively identified as lacking – and then ascertain whether these can be justified or reduced by following an alternative course of action. For example, consider a virtual reality experience that involves high levels of flashing lights and dynamic content which may provoke epileptic seizures or other health risks. When designing such an experience, it would be reasonably expected that participants would be warned of such content, in advance of their choosing to engage with it and this principle is very well established in the development of consumer goods. It is underpinned by a commitment to

maximising the pursuit of autonomy, by ensuring that the participant is able to consent knowingly into the experience they are choosing. The underpinning rationale for adopting and optimising this principle of autonomy is born out of the belief that societies are better off when people are able to exercise consent and control over their decisions. Moreover, one can evidence the value of this principle in terms of how people feel about their lives and what other harms may follow from choosing a competing principle, such as not warning people.

Countless philosophical works have sought to mediate these different approaches to establishing ethical frameworks for resolving complex problems about what sorts of lives we want to live, but a helpful way of understanding their complexity is provided through the consideration of specific cases and this approach is described as "casuistry", which seeks to mediate consequentialism and principlism, by providing rich detail about the lived reality of social practises to evidence more clearly what they require of us to act in morally good ways. A good example of this is found by considering a specific case.

For example, consider an artificially intelligent fitness mobile app, which develops a training programme for its subject based on a variety of personalised indicators, such as fitness levels, lifestyle (sleeping times, work life, family obligations), personal goals, and exercise preferences. Such systems are broadly indicative of present-day technology, which is found in a variety of tracking applications. Consider further that the user of this app has developed a 5-year history of data tracking within it, which has developed a highly bespoke system of insights that are gradually allowing the user to reach their fitness goals. Consider now that the developer creates an update to the app, which means that all of this insight and learning is lost or, perhaps more perniciously, that it is now infused with hidden designs which seek to sell the user a particular fitness product. Imagine that the intelligent update gradually and subtly leads the participant to eventually – and perhaps without their awareness – to make certain exercise purchases that they now believe will be essential to their progress.

In each of these cases, we might reasonably argue that the updates would be evidence of failure of responsibility to the user, which both undermines their autonomy and is contrary to fairness. Furthermore, through casuistry, an ethicist might engage with the members of this user community to test out their sense of moral concern about the update and use this to inform an understanding of which principles may have been violated or which may be of no concern. This process is described in applied ethics as the process of "reflective equilibrium", where the specifics of a practice may test its top-down moral principles against the bottom-up, lived reality of the practitioners, to find some agreement on the optimal approach to regulating moral conduct within a practice.

Broadly speaking, while principlism may describe the emergence of modern ethical codes, contemporary practices of ethical enquiry look also

to a more detailed, accurate appreciation of the lived experiences of a user community to re-define such principles and, often, this involves a good understanding of social scientific methodologies to adequately reflect the key concerns of any given user community. This appreciation for nuance and specificity in ethical conduct is also why it is critical to interrogate XR ethics today, as these are still communities of practice that are in development with still scope to clarify what might be the range of ethical concerns that are pertinent to their use and future applications. A good example here may be found in the shift towards virtual exercise experiences, which are found in a variety of contexts.

To further elaborate on these various methodological approaches to deriving ethical frameworks, it is instructive to consider some examples pertinent to our context of XR design, not least because they also helpfully describe the transition towards the kind of realities described by the most immersive of worlds, namely, the metaverse. To do so, it is useful to examine a variety of XR experiences, which reflect different degrees of immersion, as is outlined in Table 9.1.

In this typology, a number of claims are implied about each experience and their relationality so as to differentiate forms of XR. First, as we shift from Type I to Type VIII, there are increasing levels of insulation from the

Table 9.1 A Typology of XR Experiences

Type	Description	Examples and Release Date
I	User watches TV/device flat screen and interacts with CGI/video content	Joe Wicks YouTube (2010) Second Life (2010)
II	User inhabits a simulator in a CAVE-like environment with an instructor leading.	Les Mills The Trip (2016)
III	User inhabits a simulator, which translates physical output into a CGI social world, which they can see on a flat screen.	Zwift cycling (2014)
IV	User interfaces with an AR display to interact with physical world	Google Glass (2013) Pokemon Go (2016)
IV	User wears a VR headset and interacts with digital content while stationary (head-only movement).	Beat Saber (2018)
V	User wears a VR headset and interacts with digital content while moving in limited space	Thrill of the Fight (2016)
VI	User wears VR headset and moves across physical space interacting with other	HADO Sport (2017) Treehugger (2018)
VII	User in Headset with fully, multi-digital object world in AR, moving in physical space.	Arcadia.tv (2021)
VIII	Seamless connectivity between the digital and physical reality	Metaverse (2021)

physical world, where one might also claim there to be greater levels of immersion. Each of them is also chosen on the basis of their having some degree of full-bodied immersion, so as to engage physicality as a crucial criterion of an immersive experience. This is important as one might reasonably describe a number of other experiences as also immersive, even though they are unrelated to the kinds of XRs under discussion. For example, everything from daydreaming to reading or watching a theatre play has immersive qualities and has, historically, been said to remove us from reality (Walser, 1991), but it is not these kinds of experiences that are under discussion. Rather, it is the digitally mediated immersive experience that is under interrogation, particularly as they tend towards achieving a seamless connection between the virtual and the physical.

As noted above, contemporary approaches to applied ethics often begin with examining a particular case to, then, identify and develop a sense of the range of moral concerns it engages. For example, in the case of identifying the ethical principles to govern the use of frozen eggs and sperm, the discussion may begin by appealing to a general sense of obligations or existing ethical rules which may be upheld by the state, the medical or research profession, or the individuals concerned. However, as a culture of practice becomes established around the case, the conversation may then seek to reflect the experiences of the potential user community within that practice to refine the rules. Indeed, this may be said of the recent UK decision to extend the maximum storage time of such biological materials from 10 years to 55 years, where the transformation to the principles of governance was based on the results of a public consultation (British Government, 2021).

For XR design, these structures of ethical oversight are much harder to identify, not least because the practices of XR design are varied, each with different cultures of ethical concerns attached to them. For instance, in Type I, the kinds of ethical expectations of this virtual gym session may be informed by principles deriving from broadcasting or gymnasia standards. A good example here is the emergence of the Joe Wicks Physical Education YouTube sessions, which took place over the 2020 COVID-19 pandemic lockdowns in the United Kingdom, interesting particularly because the target audience was young people. Within the delivery of these 25-min workouts, a number of ethical concerns and moral considerations were apparent from the design of these experiences and in their delivery. First, Joe Wicks designed workouts that could be undertaken within limited physical space, which reflects a moral awareness that many people watching may not have much space in their homes to take part in certain kinds of workouts. As such, many of the exercises could be adapted to the spatial limitations of the participant and this was expressed in each of the sessions. Participants were told they could adapt the exercise to the space available.

In this case, we can identify a moral consideration of the particular needs of all potential participants, which is informed by an appreciation for

equality, diversity and inclusivity. While it is unclear whether Joe Wicks implemented such a principle on the basis of an ethical code of conduct for online physical trainers, it is a principle that may, nevertheless, be argued as a critical principle in an ethical code to promote inclusivity. In this sense, it may be described as a bottom-up principle that emerges out of the moral considerations of the practitioner, which may, indeed, form the basis for an online Physical Trainer's code of conduct – the rule being "make your workouts accessible to people of varying needs".

This is a useful example in our present discussion, as it alerts us to the importance of certain moral principles which may determine the effectiveness of any XR system, namely, its capacity to work for people of varying abilities and social conditions. Where such an absence exists, it also draws attention to the need for re-design, informed by the knowledge that certain systems do not take into account such variations. Indeed, it is reasonable to determine that the design of products should seek to maximise the range of people who are able to use them, in order to ensure an environment that was fair to all. Indeed, such interests are why certain innovations have developed, such as spatial audio or immersive experiences that prioritise acoustic innovation, rather than just the visual experience. In this sense, design for audio and visual immersion allows engaging people who may have varying abilities in each of these categories. For instance, those who have limited sight can still experience the innovative qualities of immersive VR using binaural design.

The specific qualities of each immersive experience will also dictate the ways in which best practice in ethical design will be measured and evaluated. A YouTube workout session – whether live or pre-recorded – is quite different from cutting edge XR fitness experiences and so each requires precise explanation. Yet, this is not to say that there is no utility in looking across immersive experiences (from Type I to VIII) to develop an appreciation for ethical concerns in XR design. Even the Joe Wicks YouTube workout is instructive to XR designers because it reveals how, even in relatively primitive immersive encounters, a lot has yet to be determined in terms of the codes of conduct for the user experience. For Joe Wicks, this may also involve addressing the PT's absence of knowledge about their audience. The participants' age, their physical abilities, and the circumstances in which they train will all impact the experience they have when immersing themselves within the workout and tailoring a session to ensure people are aware of the risks associated with participation and designing it to accommodate different limitations or needs is a crucial principle to take into account. It is for this reason that Joe Wicks P.E. sessions were described as being possible with very small or reasonably sized rooms. Failing to accommodate the spatial limitations of some participants would have been to exclude people from certain demographics where not much space was available.

In this respect, an ethical code of conduct for online PTs – as live, immersive choreographers – should encompass their developing data insights into their participant audience and adjusting content in response to this information. This type of immersive experience allows us to appreciate that developing a moral foundation to XR design does not require starting from scratch. Rather, looking towards existing immersive experiences for compelling principles that can inform ethical XR design is helpful and likely to come from different sectors. In this sense, the XR ethical context is a multisectoral context, where insights need to be derived from more than one industrial setting, from device design, content experience, wider physical culture and perhaps others too.

Within the typology described above, as we move closer to the metaverse, the range of moral concerns also expands, as there is a growing disruption between the physical and the digital realities. Some of these concerns have been apparent from the early days of digital communities where, for instance, questions arose around the moral status of virtual beings or, indeed, their collective architecture (REF). After all, the creation of a second life or even progress within digital games is a manifestation of time, care and concern around what has taken place within such spaces, warranting some degree of moral consideration. While live debates took place around whether damage to such places was damage to person or property (REF), the salience of the moral consideration was never in doubt. Respect for people requires respect for the things that they care about and digital artefacts were among such categories.

So, what should be the moral foundation for XR design? Part of the answer must be located in determining some agreement over the mechanisms by which moral principles are derived. As discussed earlier, there are different approaches to moral reasoning and the development of ethical principles, with considerable disagreement over which is most effective approach. Do we adopt the principles found in medical ethics and are more widely located now in technological ethics, environmental ethics and bioethics? Alternatively, do we seek to examine cases of moral concern within XR practices and develop an ethical framework from these examples? Critical scholarship in applied ethics reflects a willingness to adopt the best parts of both approaches – to examine the application of principles in practice and to refine them through discursive interactions with the practice community.

To help develop a moral framework, it is useful to examine how different approaches to theorising XR ethics have been articulated thus far. Lee and Hu-Au (2021) summarise recent theoretical approaches to XR ethics as focused on the "broad categories" of: "negative psychological effects", "issues of autonomy" and "privacy" (p. 3), subsequently invoking their 3EXR framework for assessing the ethical credibility of XR design. Importantly, their emphasis is on educational settings and what might be the obligations of XR designers to design with a wider range of

interests in mind than just harm avoidance. Rather, they present a hierarchy of interests, which transcend harm and focus, instead, on inspiring designers to consider how their experience can promote education and human flourishing, not simply avoid wrongdoing. While their focus is on pedagogy, a generous interpretation of their aims would invoke the idea that any textual narrative experience has pedagogic value, even if it is not designed with education in mind. For example, the VR experience called "The Key" may be first seen as a narrative experience – designed to explain the story of what it is like to be a refugee. While it may not have been designed with pedagogy in mind, it can be treated as a pedagogic text by an educator, in the same way, that literature may be used pedagogically, even if books are not written as educational texts. Nevertheless, it may not be desirable to treat XR design as a pedagogic device or subject creativity to a pedagogical process in a way that may interfere with creative responsibilities.

For this reason, it is critical to distinguish how an ethical framework for XR design can interface with creative or "eudaimonic" aspirations, without compromising the underpinning artistic expression. Indeed, such a framework must accommodate the pursuit of moral engagement through practices which may not be capable of upholding ethical obligations to users. There are countless examples of such activity from the history of media culture, which are instructive here. For instance, in 2007, a Dutch reality show purported to host a competition for a contestant to receive a life-saving kidney. It was later revealed as a hoax, but sought to highlight the problems of organ donation in the Netherlands and was subsequently celebrated for its impact. Alternatively, in 2004 the Yes Men appeared on television as representatives of Dow Chemical, making a public apology for what took place in the Bhopal gas leak of 1984, which affected the lives of many people in the region. In these cases, the orchestration of the mediated experience would likely fail to meet ethical benchmarks – should they have been subject to them before deployment – but the ends may be argued to have justified the means, by drawing attention to greater moral concerns. In the case of the Dutch reality show, the concern was the shortage of organs and the programme was a critique of the present system or organ donation in the Netherlands. The mechanism of public deception was a critical feature of this message, but it unavoidably meant that there were acts of deception which may be considered unethical from a broadcasting standard. And indeed complaints were made about the programme.

It is also useful to consider the E3XR framework by Lee and Hu-An (2021) in the context of existing ethical frameworks, which are more widely applied elsewhere, so as to establish where nuance occurs. To do so, the following table outlines the top-down foundational principles in bioethics and articulates these using examples from XR.

Table 9.2 Ethical Framework for XR Design

General Principle	Specific Principle	Example	
Autonomy	The experience should optimise and respect autonomy	1	Promote user ownership of data and responsible data legacy policies
		2	Design transparency into data usage
		3	Regularly engage the user community in understanding their key values and concerns
Beneficence	The experience should act to benefit the participant	4	Integrate personalised digital well-being functions
		5	Establish a data dividend for the public good
		6	Promote socialisation as a supportive structure
		7	Promote a sharing economy
		8	Design with respect for context in mind
Non-maleficence	The experience should do no harm to the participant	9	Use biometric monitoring for safety
		10	Deploy effective measures for data integrity, monitoring third-party access to user data, moderation of toxic behaviour
		11	Design indicators of unreality and allow users to self-assess
Justice	The experience should be designed with accessibility in mind and the potential for design to further social inequalities.	12	Establish diversity within design teams
		13	Provide modified experience for differing abilities
		14	Promote access to legal services, applicable to the experience
Realism	*The experience should elevate a critical awareness of and appreciation for what is real and what is fictional*	15	Make clear distinctions between narrative and factual representations
		16	Provide opportunities to express and confirm knowledge that the participant is in a simulation

One might argue that these principles adequately capture the general sense of the 3EXR framework and, thus, requires further consideration in the development of an XR Ethical Design framework. This is useful partly because there exists a historical context to such reasoning and scrutiny from a range of the industries that surround – and which are engaged by – XR

designers. For instance, if one seeks to design an XR experience for medical care, then it will be crucial to reflect upon these existing principles and the ethical norms of medical practice. Yet, the table also adds a fifth principle for consideration, described as "realism" and my remaining section focuses on explaining and justifying the integration of a fifth principle within an XR ethical framework.

Realism – The Fifth Principle

What may also be described as the metaverse principle, the fifth principle outlined here to underpin ethical XR design arises from the novel ethical issues presented by the disruption to reality, which is provoked by people spending increasing amounts of time in increasingly realistic digital space. Importantly, this principle does not emerge only in the context of the metaverse but is intimately connected to the growing disruption to reality that is apparent in the growing digital society that advanced digital nations have become. Its assertion claims that there are novel sets of concerns that arise from this new condition of lived reality, which warrant further and distinct ethical oversight and which are not adequately catered for by the other four principles.

In its simplest form, the fifth principle describes a concern for ensuring that people are able to critically scrutinise and distinguish reality from unreality when immersed in XR and that designers have an obligation to elevate and expose the reality status of their participants are in when designing their system. Importantly, this principle does not require that designers must prioritise reality over unreality or truth over falsity or fiction. Indeed, to require this level of prescription would be to preclude a great deal of human creative works which have, undoubtedly, enriched human societies, but which have absolutely involved bringing people out of their daily reality and into an imaginary space. Instead, rather than seek to prescribe the forms of realities people should experience, the fifth principle seeks to provide mechanisms for participants to check and monitor the consequences of their lives within XR to avoid what Chatfield and Nixon (2021) describe as "getting stuck" into a "rigidly held self-image" (p. 8) that has become excessively fixed and informed by the distorted realities presented in digital worlds.

While this may sound like a principle that is essentially cloaking a deeper foundational concept of elevating autonomy, it also extends beyond this. To illustrate this difference, consider an XR experience which seeks to cultivate an emotional relationship with a character, which then leads the participant to determine that their interaction with the XR character is real, rather than a narrative construction. Leaving aside the debate over whether all relationships are merely narrative constructions, one may reasonably distinguish between a relationship with an entirely fictitious persona and one that belongs to a human whose existence is authenticated through being in the

world. In this case, the ethical concern around establishing a relationship with a narrative construction is not simply a loss of autonomy, although this may be some degree of concern. Instead, the ethical concern is that the person's interaction with the XR persona leads them to create a misplaced sense of expectations and appreciation of value that is simply not there.

A good example of this is found within the film *Her* (Jonze, 2014), which describes a protagonist who falls deeply in love with an AI operating system. The disembodied voice behind the system meets the protagonist's every expectation of a relationship and he is ready to end his pursuit of any other love at this point, reconciled with the idea that a relationship with an operating system may be even better than a real human. Our protagonist is fully aware that the object of his affections is an intelligent system, not a real person at all, but software, but this does not deter him. In this case, we might conclude that the user is entirely aware of the unreality of their situation and makes the informed choice to accept these conditions. As such, there is no loss of autonomy that takes place here, no violation of the first principle. However, the point at which the relationship breaks down is the moment when the AI system reveals that it is also having relationships with countless other people who it also claims to love equally and it is this loss of expectations and sense of what is happening that describes the harm that is done. While some aspects of this engage concerns about autonomy, doing good, not doing harm, and justice, these principles would have been more adequately accommodated with first attending to the reality of the circumstances in which the person finds themselves – by elevating an appreciation for what is real and what is not. In this case, one might claim that the protagonist's appreciation of what love entails is flawed and this misconception is what leads to the harm he experiences.

In establishing this ethical principle to governing XR design, it is also important to consider what may be described as the ultimate objection to elevating realism, which I call the Neo-Matrix Objection. This objection intends to make direct reference to the proposition described in movie, The Matrix (Wachowski and Wachowski, 1999), but also offers a counter-narrative by modifying the underlying premise of the story. Thus, rather than locate the human subjects in the Matrix as objects of exploitation – as they exist as pods within "Power Plants" which provide power to the Matrix – we, instead, present the idea that humanity's relocation into such pods becomes a matter of practical necessity, in the face of species extinction brought by climatic conditions which make life on earth impossible. In other words, the Neo-Matrix is a place where our consciousness takes a digital form in order to safeguard any kind of existence at all, where the alternative is non-existence. This hypothetical is helpful to our further interrogation of the fifth principle because it asks us to consider whether in fact a life that is perpetually and exclusively lived in digital space would, in fact, be a life that is worth living at all.

Such an idea takes the concept of the metaverse to its logical extreme and imagines whether such existence would be tolerable. The hypothetical is quite close to the circumstances described in the movie Reader Player One (Speilberg, 2018), but without the luxury of imagining there is an alternative reality – what has historically been treated as the true reality – which we could occupy. As is often the case in stories that depict the prospects of living in an exclusively digital world, such conditions are often treated as, ultimately, inferior to a physical world, the world which we claim to know and have always known. In the Neo-Matrix hypothesis, the comparison is not possible, unless one concludes that non-existence is, indeed, preferable to being a disembodied digital consciousness.

Yet, while I think there are reasons to prefer living within the Neo-Matrix rather than choosing non-existence, the salient point here is that the fifth principle requires that those who live within the Neo-Matrix are given opportunities to engage with the reality that they are, indeed, part of within this digital configuration. One of the problems with The Matrix and other simulation hypotheses is that people within such circumstances are living lives that are, in fact, other than what they expect them to be. By not having awareness that one is living in a simulation we suffer a great number of losses and harms, which would be alleviated by having awareness of these conditions of our lived experience. It is this expectation that should be met in order to safeguard the ethical status of XR. Failing to provide opportunities for participants to critically assess and come to terms with the real or unreal characteristics of their experiences is to fail in one's obligation as a designer.

Conclusion

This chapter has sought to present a moral foundation for XR design which is mindful of the growing complexity of the relationship between the real and the unreal, or the physical and the digital, as is evidenced by the emerging metaverse. It has been argued that our characterisation of ethical principles to design XR environments should look towards established principles and discourses that are found within allied fields of enquiry and seek to determine their precise characterisation in consultation with the existing practice communities who a) design and b) deploy XR experiences. Furthermore, it has argued that the elevation of critical scrutiny of the real is a fifth principle which should govern XR design ethics and that this principle is connected to a growing concern that there is a loss of reality born out of the design principles of highly utilised digital media environments.

Indeed, we see evidence of such concern in existing digital media platforms such as Instagram, where, in November 2021, UK retailer Lush suspended its social media accounts due to its concern that the algorithms of such platforms were delivering progressively damaging content to users who were already in a position of vulnerability (BBC, 2021). It was stated that, for example, Instagram users who are experiencing self-harm are likely

to be shown increasing amounts of content related to self-harm which may have the impact of exacerbating the degree of harm that they experience. In this case, it is reasonable to consider that the lived reality of the physical experience, accompanied by engagement with the digital environment constitutes a profoundly connected world in which digital and physical are consequentially seamless. In this sense, it is not required that immersion involves physical relocation into a sensorial virtual world. Rather, it is sufficient that these two worlds are connected. Such examples reveal the importance of avoiding what may be called immersive exceptionalism as if the concerns associated with immersive worlds are tied essentially to sensorial relocations into digital spaces. Indeed, it is quite likely that the trajectory towards the metaverse is underpinned by the incremental encroachment of cyborgian interfaces of which the handheld or wearable mobile device is a crucial intermediary. The mobile phone both manages to secure its presence upon our body almost permanently, while also habituating us into a technological co-dependency.

The specific ethical frameworks applied to XR design are likely to be best informed by the specific codes that underpin the context of its application. So, a VR system designed for paediatric care, to alleviate anxiety among patients should be scrutinised with this lens and ethical framework in mind. It should be assessed against the specific obligations and responsibilities of practitioners in this setting and design should, first, focus on understanding this context in the design of such work. In cases where content design is appropriated from one setting into another, the obligations focus particularly on the delivery community involved with making this application. For example, the VR system used to reduce the stress of a child patient in advance of surgery may best be a VR experience of their favourite cartoon, or a compelling storytelling experience, rather than a bespoke narrative designed for that setting. In this case, it would be unreasonable to expect the XR designer to have considered all potential uses of their content and so, instead, the clinicians involved will need to scrutinise and assess the merit of that content before delivery. Nevertheless, the creation of any XR experience would be advised to consider its use in a variety of settings, not just the one where it is initially intended. In conclusion, by elevating the fifth principle of ethical concern and testing it against the lived reality of XR participants, designers can more fully attend to their ethical obligations to their users and avoid a variety of harms that may follow by failing to do so and this should be the focus of the design philosophy that underpins such work.

References

Beauchamp, T.L. and Childress, J.F. (2001). *Principles of biomedical ethics*. USA: Oxford University Press.

BC (2021, Nov 23). Lush to Stop Some Social Media Until It's 'Safer'. Available from: https://www.bbc.co.uk/news/business-59380458

Bynum, T.W. (2017). Ethical challenges to citizens of 'The automatic Age': Norbert Wiener on the information society. *Computer Ethics*. Routledge: 3–12.

Chatfield, T. and Nixon, D. (2021) Introducing the Digital Ego Project, Perspectiva. Available from: https://systems-souls-society.com/wp-content/uploads/2021/02/Introducing-The-Digital-Ego-Project-3.pdf

Coeckelbergh, M. (2021). How to use virtue ethics for thinking about the moral standing of social robots: A relational interpretation in terms of practices, habits, and performance. *International Journal of Social Robotics*, 13(1), 31–40.

Cuttica, F. (2020, Dec 11). Meaningful Data, Critical Thought & Futures Thinking: Our Recipe for 'Ethical Experiences'. *BBC*. Available from: https://www.bbc.co.uk/gel/articles/our-recipe-for-ethical-experiences

Gibson, W. (1984) *The Neuromancer*. London: Orion.

Hirskyj-Douglas, I., Piitulainen, R. and Lucero, A. (2021). Forming the dog internet: Prototyping a dog-to-human video call device. *Proceedings of the ACM on Human-Computer Interaction*, 5(ISS), 1–20.

IEEE (2020). https://standards.ieee.org/content/dam/ieee-standards/standards/web/governance/iccom/IC20-016-Global_Initiative_Ethics_Extended_Reality.pdf

Jonze, S. (2014). *Her*. 2013. [DVD] Spike Jonze.

Kember, S. (1998). *Virtual anxiety: Photography, new technologies and subjectivity*. Manchester: Manchester University Press.

Kellner, D. (2006). New technologies and alienation: Some critical reflections. *The Evolution of Alienation: Trauma, Promise, and the Millennium*. 47–68.

Lee, J.J. and Hu-Au, E. (2021). E3XR: An analytical framework for ethical, educational and eudaimonic XR design. *Frontiers in Virtual Reality*, 2, 697667. 10.3389/frvir

Mäkinen, H., Haavisto, E., Havola, S. and Koivisto, J.M. (2020). User experiences of virtual reality technologies for healthcare in learning: An integrative review. *Behaviour & Information Technology*, 41(1), 1–17.

Meta (2021). The Metaverse and How We'll Build It Together-Connect 2021, YouTube https://www.youtube.com/watch?v=Uvufun6xer8

Miah, A. (2008). A critical history of posthumanism. *Medical enhancement and posthumanity*. Dordrecht: Springer: 71–94.

Speilberg, S. (2018). Ready Player One.

Stephenson, N. (1992). *Snowcrash*. London: Penguin.

Tavani, H.T. (2003). Ethical reflections on the digital divide' in *Journal of Information. Communication and Ethics in Society*, 1(2), 99–108.

Turkle, S. (2011). *Alone together: Why we expect more from technology and less from each other*. New York: Basic Books.

Wachowski and Wachowski (1999). The Matrix

Walser, R. (1991). The emerging technology of cyberspace. *Virtual Reality: Theory, Practice, and Promise*. Chicago.

10 "Unruly Encounters": Literacies of Error in Immersive Virtual Environments

Vicki Williams

I want to begin this chapter by asking you to imagine you are trying VR for the first time. Your knowledge of VR is wholly shaped by the language and literacies others have used to describe it: "you feel like you're actually there"; "it feels super weird"; "I went underwater!" You place the headset on and the simulation starts. Let's say that the simulation begins on a boat. You look around and see vast oceans and blue skies. You're taken aback. After some time taking in your surroundings, a dialogue box appears in front of your eyes asking you to pick up the fishing net in front of you. "I can pick things up?!" – you say to yourself. Excited by this sense of agency, you step forward to pick up the fishing net with the simulated hand that extends out in front of you.

Except the hand doesn't grab the fishing net – instead it passes through it.

Following this, the wall of the boat starts distorting erratically, and the virtual hand that once calibrated to your own movement now appears to be fifty metres out into the ocean, not corresponding to anything you do, but floating aimlessly away in simulated seawater.

This rather mundane example illustrates the micro-encounters that I want to focus on in this chapter, forms of encounter I will refer to as "unruly encounters", where an immersive technology, for a short moment, doesn't do what you want it to – a moment where immersion momentarily breaks, but in a somewhat playfully disruptive way. In these moments, we see a form of "intra-active agency"[1] where the user's embodiment and the technological infrastructure co-emerge and project outwardly within a simulation. It is with these unruly encounters that we might have a starting point for opening up literacies of Virtual Reality (VR) and virtual environments beyond "immersion" – a word that has become quite overpowering in the space which tells us little about the intricacies of experiencing simulations that, to some degree, always resist us.

In this chapter, I want to toy with established terminologies surrounding VR and virtual environments, exploring alternative experiences, representations and theoretical approaches to seamless forms of immersion. Experiences of VR are difficult to narrate; there is not yet a prevalent literacy which allows users to wholly capture the unique, and sometimes ambivalent,

DOI: 10.4324/9780367337032-13

affects that VR produces. This is perhaps why neat representations, and the overuse of terms like immersion, have become commonplace. This chapter will attempt to forge new affective literacies of VR interaction by narrating paths that veer away from perfect immersivity towards *immersion in worlds of error*. That is to say that I am making the case for a form of immersion which is not all-encompassing (as we will come to see many define it as) not governed solely by human action, and is not a comfortable err towards realism; rather, we should reconsider a form of immersion that is unruly, disorientating, and *weird*. Such encounters, as with the sensation of a virtual hand passing through a fishing net, are weird because they break expectations and invite us to consider realms where the ontological rules of "reality" go out of the experiential window. Such forms of glitch and error in virtual environments do not necessarily "break" immersion. In fact, they produce a new opportunity for a certain kind of immersion in worlds that are not created just for the user, or with user empowerment at the forefront.

I want to make the case that momentary glitches can cooperatively work with the ambitions of immersion, that being to surround the entirety of the user's bodily and perceptual apparatus, providing them with access to the unexplored parameters of the hardware's infrastructure. In order to produce a novel literacy of unruly encounters, I will look closely at the literary landscapes of weird fiction, and the conceptual alliances the genre has with forms of mediated error. Overall, this chapter wants to utilise the literacies of *weirdness* to develop a taxonomy of error in immersive virtual environments. The weird, both as a literary and theoretical genre, illustrates and narrates unruly forms of immersion through affective encounters with *worlds not for us*.[2] To offer a brief definition, which will be developed further within the chapter, the weird might be considered as that which marks the interaction of the human with an unknown Outside, a place or being that is completely other than the human/world. Oftentimes, weird fiction relays the affective and phenomenological (human) responses to encounters with worlds and other-than-human beings that defy the coded logics of the human world.

At this stage of VR development, the novel feelings produced by entering a virtual world and interacting with virtual entities, are wholly weird. Disorientation, loss of agency, and awe are common phenomenological and affective experiences in VR, yet they are not oppositional to the experience of being immersed – we just don't quite have the language to describe immersive experiences that are not seamless and neat. This chapter will argue that weird fiction, and theoretical approaches to the weird, can provide us with some of this language. The weird might offer us ways of narrating immersion not as a totalising phenomenon, but one that in reality is made up of more subtle affective encounters with otherworldly landscapes, beings and objects. Blackman notes that affect studies seek to consider the body's "immersion in the world".[3] Weird fiction, and studies of the weird, however, oftentimes illustrate affective encounters where one

does not feel comfortably immersed in, or integrated within the world; rather, the world seems to resist and pull away from human subjects. The weird categorically resists "submersion" as a concept. Rather, interactions in works of weird fiction are more subtly affective than totalising. The weird, I argue below, might provide us with some experiential examples of immersive worlds which co-emerge with error.

Existing discussions of weird affectivity and error in VR are very limited, though Susan Kozel has recently explored the affective implications of VR from a somatic point of view. Kozel's work in somatic materialist studies provides rigorous discussions of what she calls the "phenomenology of affect", and she conceptualises affect in VR as what she refers to as a "shimmer". The passage of intensities associated with VR affect, she argues:

> *is like a vibration or a shimmering, in the sense that shimmering is based on change and is not a static state. Viewed this way, affect might travel through familiar states of feeling, but it may also participate in the creation of something that did not exist previously.*[4]

Any embodied action within a virtual environment ultimately affects the user, the virtual realm, and the system which produces it; the VR user is not simply an observer, but affective, affecting, and affected by the encounters. Kozel defines affect as "bleed[ing] across the borders of a single body", describing it as "more like a cloud: it is as likely to be creepy as it is euphoric and it does not just come from bodies, but encompasses objects, structures, animals, systems, and all things environmental".[5] She describes affect as being part of an ecological essence which extends beyond the human subject, considering the ways affect flows amongst all things within a given environment. It is through this ecological essence of affect that I associate VR with the genre of the weird and the manifestation of weird affect: the weird challenges human agency and access in the narration of that which exists outside of human comprehension. Weird entities challenge understandings of the world as it is framed for, and by, human beings.

Redefining Immersion

Immersion has become the totalising definition of virtual reality itself. Yet, there is little nuanced understanding, particularly in its popular expressions, about what the term means, and the wide array of feelings that can be associated with "being immersed". Aside from the idea that one *feels part of a world* presented by a medium, whether a book, a TV screen, a videogame, or a VR experience, immersion itself remains relatively obscure. In the realm of contemporary virtual environments, it appears that the "realism" of a mediated world has become the predominant factor in determining its immersive potential.

As one example of the contemporary reliance on the term "immersion" to convey lifelikeness, a review for Rockstar's 2018 game *Red Dead Redemption 2* described the experience of playing the game as "total immersion in an astonishingly lifelike world".[6] The review continued to write of the game's determination to immerse its players in "the obsessive detail on show" – arguing that the overall effect of the game's level of detail was "nothing less than total immersion, the sensation of a lived experience".[7] In contemporary discourse, immersion has come closer and closer to being synonymous with recreating the experience of reality. This has the potential to stilt the exciting potentials VR offers if it simply becomes the endless pursuit of the recreation of the perception of the real world. The framing of immersion-as-realism is seductive because it is comfortable. However, a world's detail doesn't necessarily make it welcoming; enticing worlds, as we will come to see, can still resist us in ways that are not lifelike, but fundamentally *weird*.

Mel Slater's work is often cited in academic work exploring definitions of immersion in regards to VR experiences specifically. In an article written in 2009, Slater reflects on his earlier definitions of immersion, stating:

> by definition, one system would be more 'immersive' than another if it were superior on at least one characteristic above—for example, higher display resolution or more extensive tracking, other things being equal.[8]

In this regard, Slater suggests that superior systems allow for increased immersivity. With better hardware, Slater suggests, immersion emerges through "the valid actions that are possible within a system".[9] Slater's definitions of immersion place emphasis on the quantifiable elements of the experience and on the capabilities of the hardware's capacity to mimic real-world perceptual experiences. This chapter argues that mediated error and the weird can provide gateways into further understanding immersion in worlds we *do not* always feel we have a full grasp of, instead embracing unruly interactions that emerge between the body and hardware; we might learn more about immersion if we also learn to embrace error.

We might instead draw inspiration from immersion's etymological roots of "being submerged in water".[10] The fluidity of immersion is tied to its association with watery metaphors, of entering new landscapes which require users to adapt their embodied actions to the sensory possibilities they enable. We could consider it not as an all-encompassing experience, but one that instead ebbs and flows in real-time. It is here that I turn to weirdness to suggest that, as opposed to submersion, immersion entails more subtle affective encounters with other worlds. The language used to describe interactions with weird entities, I argue, enables more nuanced ways of articulating the affects of coming- into-contact with virtual environments, and the entities within them, in ways that are not wholly encompassing. As

prefaced in the introduction to this chapter, I refer to the weird as that which marks the interaction of the human with an unknown Outside that resists enframing and instead brings with it the narration of affective encounters with worlds- not-for-us. The weird's narrates embodiment through unfurling affects, resisting the urge towards totalising bodily sensations.

The weird finds its roots in a literary movement which emerged in the late 1800s. This movement didn't find its place in the literary landscape of gothic fiction; as opposed to descriptions of eerie atmospheres where the human is seemingly absent, the weird was more invested in encounters with an absolute Outside – a hint at worlds beyond human perception. The weird pushes at the borders of other known genres, including horror and science fiction, but resists generic classification.[11] In both works of fiction and philosophical thought, the weird is invested in the narration of things that are inherently difficult to narrate. As such, the genre appeals to its audiences' reliance, instead, on the narration of embodied sensations of those things in order to try and cognise them. Take, for example, the narration of one of Walter Gilman's dreams in H. P. Lovecraft's short story "The Dreams in the Witch House" (1933):

Gilman's dreams consisted largely in plunges through limitless abysses of inexplicably coloured twilight and bafflingly disordered sound; abysses whose material and gravitational properties, and whose relation to his own entity, he could not begin to explain. He did not walk or climb, fly or swim, crawl or wriggle; yet always experienced a mode of motion partly voluntary and partly involuntary. Of his own condition he could not well judge, for sight of his arms, legs, and torso seemed always cut off by some odd disarrangement of perspective; but he felt that his physical organization and faculties were somehow marvellously transmuted and obliquely projected—though not without a certain grotesque relationship to his normal proportions and properties.[12]

The story tells of the experiences of Gilman, a student who moves to the fictional town of Arkham Massachusetts to pursue his studies in Mathematics at Miskatonic University. Whilst lodging in "the Witch House", he experiences strange dreams and hallucinations of "organic and inorganic" entities – most of which are instigated by his obsessions with the architecture, geometrical patterns, and "unearthly symmetry" of the house. In the excerpt above, we see the narrator describing Gilman's incapacity to explain the worlds conjured within his dreams. Rather, the narrator describes the ways the space enacts certain affects upon his body – a "disarrangement of perspective" where his body felt "obliquely projected".[13] The weird logics of his dream space remain somewhat elusive to description, but are made understandable to the reader by their imagining of the feelings the space produces on Gilmore's human body.

It is worth noting that Lovecraft's narration almost reads as the glitching projection of a body in another environment: when in the dream space, Gilmore feels othered from his own body, yet immersed within the "limitless abysses" of his dream space. This tale, along with the majority of works within Lovecraft's oeuvre, narrate a coming-into-contact with "the boundaries of the world of space".[14] In the same way, Lovecraftian narration often references the limitations of human comprehension, as well as the compromising of agency and access. If we interpret the example above as a narration of Gilmore's immersion in an unknown space, we can see that this is not a clean and comfortable form of realism. Rather, it turns to the body as the locus of feeling immersed in strange sensations and affects of the space beyond the familiar world. Weird fiction provides an avenue through which to interpret immersion in worlds not-for-us, for those that pull away from us. We could liken Gilmore's dream encounter with the encountering of an unruly virtual environment, where our bodies seem to pull away from us, and the world pulls away from us too.

Influential cultural theorist Mark Fisher describes the weird as a hint at the conflicts and ruptures between this world and others though the "encroaching" of an experiential outside onto the human subject.[15] He alludes to the genre of the weird as being simultaneously tied to coming-into-contact with worlds beyond, but that it is also concerned with the very limits of human cognition, arguing that the weird does not function as an opportunity to lose sight of the world we know, but to acknowledge the weird as an Outside, which is beyond anything we can comprehend. He states

> *Worlds may be entirely foreign to ours, both in terms of location and even in terms of the physical laws which govern them, without being weird. It is the interruption onto this world of something from Outside which is the marker of the weird.*[16]

The weird, then, is premised upon interplay and exchange: as opposed to being submerged in a world, as is suggested by the etymology of immersion, weird encounters mark a complex entanglement between here and there, the familiar and unfamiliar.

We can look back at the original example of the glitch given at the beginning of this chapter anew in the context of the weird and understand it differently; I used this as an example of the unruly interactions that can occur between bodies and virtual environments and how these kinds of experiences might illustrate that immersion and error might be able to simultaneously co-emerge. The weird, as a mode of theoretical enquiry and fictional genre with an established set of tropes, is premised on the essence of human immersion in worlds of error; humans come into contact with weird entities that reveal the underlying contours of the "realities" they perceive. This is not dissimilar to the potentials of the technological glitch, both in the ways that they reveal something about the underlying

functioning of the technology, but also in the ways that they signal the unruly and unanticipated emergence of the other-than-human.

Taxonomies of Immersive Error

We can experience glitches in VR that we never anticipate will happen; we can suddenly apprehend a distortion without understanding what has caused it, or be taken aback by the sudden jolting of the display. In VR, glitches cause visceral bodily reactions because they are so proximal to our bodies and point of view. These instances mimic the evocative moments within weird fiction where humans come into contact with beings and entities from worlds beyond this one. These moments feel wrong, disorientating, and strange – and part of this is because they are never anticipated by their experiencers. Recent scholarship that explores glitches in contemporary culture emphasises their occurrence as "dysfunctional event[s]" within a system,[17] their capacity to uncover obfuscated protocols,[18] and as events which inspire breaks away "from the hegemony of a social system".[19] VR enables a multitude of new glitches to emerge that have a truly affective and intimate impact on the body of the user. Such affects, I argue, are weird because they break anticipated logical systems, and reveal what lies beyond normative human perception.

I want to spend some time here establishing a new taxonomy of glitches that reveals their unique affective potential in the realm of immersive and haptic virtual environments. The weird and unruly elements of glitch are experientially pushed further in VR simulations; the human-computer assemblage is perhaps the most proximal and felt, where the mediated world replaces the whole of the user's immediate perception. Thus, when a virtual world does something unanticipated, the user's proprioceptive vision is essentially momentarily disrupted via random machinic error. Glitches are experienced, more so than ever, as wholly affective and immersive realms of new understanding: the user, in a sense, perceptually encounters the emergence of the nonhuman system in an affective and embodied manner. It remains that glitches in VR, and the feelings they produce, cannot be completely captured by or through language; indeed, there is a tendency to anthropomorphise machinic agencies in order to try and understand them.

My attempt to generate a taxonomy of glitches, then, is not to produce further anthropomorphised visions of the glitch. Rather, it is an attempt to capture the unique affects of proximal VR glitches, and the ways technological error more broadly encompasses moments where human and non-human actors interact in a variety of different ways. I thus refer to my taxonomy as a "glitch ecology", the ways that glitches and their interwoven affects co-emerge to produce new embodied encounters which bridge between ontological planes. I use the term "ecology" as inspired by affect theory; Marie-Louise Angerer[20] and Tonya Davidson et al.[21] regard ecologies as micro-geographies through which affects emerge. Affective ecologies mark

the generative encounters between organisms and things external to them, resulting in a change in condition: ecologies of affect capture and allow the examination of the production of change or modifications that take place through encounters with other bodies. Such a taxonomy or ecology of glitches can never be exhaustive and will continue to develop as more people begin to use and interact with immersive technologies as they become more integrated into everyday digital use.

This taxonomy originates in a provisional mapping of glitches that I myself have experienced in VR, but it also incorporates the types of glitches that are emerging in reports of VR experiences more broadly. The glitches within the taxonomy are not antagonistic to one another, but come together in a cooperative ecology through their relationship to the body of the user. This is where glitches in VR differ from more well-theorised interfaces, in that their errors are proximal to the body and surround the perceptual field of vision; VR glitches are immersive. Different kinds of error in VR can occupy multiple areas of the taxonomy at once; this initial mapping brings together the various kinds of affects that certain forms of error can produce in virtual environments. Such errors are particularly close to the body and implicate embodiment in their unruly infrastructures. In capturing some of the specific instances of immersive glitches as they emerge as particular affective encounters in VR, we are able to understand the disruptive potentials of the body and technology coming together via unruly encounters. Such encounters, I argue, ultimately challenge the façade of absolute user agency; immersive glitches fundamentally alter intended experiences to create sometimes destabilising and/or revelatory responses which can highlight the potentials of VR for challenging user and producer (human) agency and access.

Emergent Glitches

The first modality of glitch I refer to is "emergent". An emergent glitch is unintentional and occurs randomly during the use of technology, triggering an unanticipated affective response. The affective implications might be confusion, frustration, humour or stasis. The emergent glitch could be associated with a specific cause, or there could be a logical reason as to why the glitch occurred. In other instances, emergence can be seen through the exploitation of a game's system. That is to say that the player breaks into the coded system of a game and changes it so that the game does something the developer could not have predicted. An example might be that of a calibration disruption in a VR headset, where a sudden movement of the body meant that the virtual environment suddenly *pulls away* from the body of the user. The abrupt movement of the body and its concurrent movement of the hardware causes a glitch to emerge. The term "emergence" is regarded as the capacity for variation outside the embedded rules of a system,[22] and is oftentimes associated

with gameplay and the multiple outcomes based on player choice. Emergent glitches in VR do not valorise the player or their disruption of the rules. This is because the body functions as part of the VR system, and in this way, the body and proprioception of the user is automatically implicated in the uncomfortable affective space of the glitch. But what is unique about these glitches is that they are fundamentally immersive, not because they make us feel part of a world, but because they surprise us and pull us into worlds not-for-us. Imagine being within a virtual environment, and it suddenly jolting, moving away unexpectedly, or devolving into a blank void of darkness. This is not the immersion we might have presupposed from the technology, but it is still nonetheless a form of immersion: our bodies are, for that emergent moment, fully drawn into what Peter Krapp calls the "experiential crevice"[23] of the glitch-space. In the case of VR, emergence will continually "emerge", so to speak, as users continue to test the boundaries of its systems.

Intentional Glitches

The second version of the glitch is the "Intentional" glitch or those glitches which are intentionally built into a narrative or an experience to elicit a specific kind of affect. Intentional glitches are commonly found in works of the horror genre and can include visual allusions to mediated error like white noise, or the machine acting on its own accord, signalling the presence of a likely supernatural entity which provokes ruptures in the more ruly working of the medium. Though in the diegetic world these glitches may appear to be unruly and emergent, they have been included by the producer to give the viewer or player information about something they couldn't otherwise see, like a ghost. There is no "logical explanation" for why the glitch occurred in the realm of the story world, but it functions as an ontological capturing of something otherwise ephemeral. As such, the glitch signals the presence of something, or someone, else. It gives our bodies information to read, and as such, pulls us in.

Intentional glitches oftentimes bridge the line between the intra-diegetic and the diegetic—where affective responses to the emergence of error are mirrored by both viewer/player and character (shock, fear, unease). In this sense, intentional glitches allow awareness on behalf of the viewers of the artwork that another agent is present within the space, signalling the loss of agency from the human character. But this is the intent of the producer of the artwork. Thus, the glitch becomes an artistic indicator of compromised human agency, making our bodies feel vulnerable to the entities that have disrupted seamless technological flow. These kinds of glitches require responsibility from their makers, and the ethics of the intentional glitch, and their popular use in horror simulations, will be explored in depth in the following chapter.

Ruly Glitches

The third glitch within the proposed ecology might be referred to as the "Ruly" glitch. Ruly glitches are those that a user would accept as being part of the story world they experience, or the environment that they are within. The formulation of the "ruly glitch" suggests that these kinds of glitches are not disruptive, because they form part of the linearity or feel of the world, whether or not they are part of the programmed system and events that emerge within it. Yet, ruly glitches can still be unintended like emergent glitches, but they can also be built into a narrative like intentional glitches. For example, in a virtual environment, I could encounter an object bouncing up and down; though it hadn't been the intention of the producer for this object to bounce, it may make sense for it to do so. Ruly glitches might produce strange affects, but are accepted as being part of the story world/ environment. This might include the weird movement of the goats within the game *Goat Simulator*,[24] for example, where the world inherently glitches for the purposes of humour. Thus, the affective implications of the ruly glitch are oftentimes not uncomfortable or unsettling but add to the intended feelings of the producer of the artwork.

Unruly Glitches

The last glitch I cite within my preliminary taxonomy is the "Unruly" glitch. An unruly glitch has the potential to completely alter the user's experience of a virtual environment by modifying their anticipated experience and exposing the inner workings of the technology. The unruly glitch is, in effect, the weirdest glitch, precisely because the emerging error marks a unique and wholly unpredictable interaction between the body and the environment, such that it exceeds both the user and the producer's comprehension. It is not programmed to occur by the producer, nor is it anticipated by the user. Rather, it emerges out of an instantaneous random interaction between body and hardware, or processing action. In VR, an example of an unruly glitch might be when the user's hand moves *through* an object as opposed to picking it up, where a rupture in the programmed logic interrupts the intended interaction. Another example might be the walls of a world breaking apart, code appearing within the headset interface, or the environment glitching away from the user's body. All of these examples of the unruly glitch absolutely challenge the autonomy of both the player and the producer alike, in that they solely emerge in a unique temporaneous moment where the body and technology in a specific way.

As previously mentioned, this taxonomy is not all-encompassing, and will continue to develop and grow as more people engage with immersive technologies – a greater number of new experiences will require a language to describe them. The most notable uniting factor of all of the instances of glitch described above, however, is that the body forms part of the glitch

ecology in each instance. It is during unruly interactions that the experience mutates beyond common practice and anticipated action. Within the VR space explicitly, both in development for the medium and use of it, such instances provide chasms of experience where user agency is challenged. This does not only encompass glitches that the user can visually see, but touch, hear and engage with on a deeply multisensory level.

This chapter has argued for the co-emergence of error, glitch and immersion as they are united through bodily affect. It began by looking at the neat definitions of immersion that has become embedded in the VR space. Such definitions do little to account for the nuanced affects that VR produces, including disorientation and compromised agency. Rather, immersion is often conflated with realism, or the capacity for VR to produce worlds that are as real as the world we move through every day. VR is a weird machine. It remains unnerving to look at, to experience, to feel. It remains a difficult task to leave an experience in virtual reality and have the language and grammar to describe it. The human body's pairing with VR is a strange assemblage. I have linked VR to the realm of the weird here because of the unique affects and ontological collisions it produces. The genre of the weird initiates new insights into collisions with other worlds, offering rich discourses that extend beyond individuals entering new realities and maintaining a sense of unlimited access to them; there is always an embodied limit. VR highlights the weird contours of this reality by affectively evoking the weirdness of entering another. By untangling VR from predetermined expectations of absolute immersion, there can be more active awareness of the unravelling sensations of interacting with virtual worlds. Its "dualistic" ontological model must be reconsidered: the chaotic, messy and material potential of VR persists. The affordances and dis-affordances of the medium should be utilised by developers to do something different than simply looking at the world-for-us; the advantage of an interface is that it can function as a nonhuman layering which alters perception, creating something wholly different to looking at the world through human eyes.

Notes

1 Karen Barad, whose work will be explored further in Chapter 3, refers to the dispersal of agency between human and nonhuman as "intra-active agency" in *Meeting the Universe Half Way: Quantum Physics and the Entanglement of Matter and Meaning* (NC: Duke University Press, 2007).
2 The *world not for us* is an idea taken from Thacker's work on *The Horror of Philosophy*.
3 Lisa Blackman, *Immaterial Bodies: Affect, Embodiment, Mediation* (New York: Sage, 2012).
4 Susan Kozel, 'Somatic Materialism or "Is It Possible to do a Phenomenology of Affect"?', *Site*, 33 (2013) p. 159.
5 Ibid.
6 Keza MacDonald, 'Red Dead Redemption 2 Review – Gripping Western Is a Near Miracle', *The Guardian* (2018).

7 Ibid.

8 Slater, 'Place illusion and plausibility can lead to realistic behaviour in immersive virtual environments,' *Philosophical Transactions B*, 12 (2009).

9 Ibid.

10 Janet H. Murray, *Hamlet on the Holodeck: The Future of Narrative in Cyberspace* (Cambridge MS: MIT Press, 1998).

11 Roger Luckhurst discusses the weird's resistance to generic classification in his essay 'The weird: a dis/orientation.' In this essay, Luckhurst argues that 'it is better to think of the weird as an inflection or tone, a *mode* rather than a *genre*' (p. 1045).

12 H.P. Lovecraft, 'The Dreams in the Witch House,' in *The Complete Fiction of H.P. Lovecraft* (ReadOn Classics, Kindle E-Book, 2015) p. 3371.

13 Ibid.

14 Ibid, p. 3344.

15 Mark Fisher, *The Weird and the Eerie* (London: Repeater Books, 2016) p. 20.

16 Ibid.

17 Olga Goriunova and Alexei Shulgin, 'Glitch' in *Software Studies: A Lexicon*, edited by Matthew Fuller (Cambridge, MA: MIT Press, 2008) p. 114.

18 Rosa Menkman, 2011.

19 Legacy Russell, 'Digital Dualism And The Glitch Feminism Manifesto', *The Society Pages* (2012). Available from: https://thesocietypages.org/cyborgology/2012/12/10/digital-dualism-and-the-glitch-feminism- manifesto/ [Accessed November 2018].

20 Marie-Luise Angerer, *Ecology of Affect: Intensive Milieus and Contingent Encounters* (Lüneberg: Meson Press, 2017).

21 Davidson et al., *Ecologies of Affect: Placing Nostalgia Desire, and Hope.*

22 See, for example, Jesper Juul 'The Open and the Closed: Game of emergence and games of progression,' in *Computer Games and Digital Cultures Conference Proceedings*, edited by Frans Mäyrä (Tampere: Tampere University Press, 2002). Juul states "there is more to playing games than simply memorising the rules. So we need a framework for understanding how something interesting and complex (the actual gameplay) can arise from something simple (the game rules). How can something made from simple rules present challenges that extend beyond the rules?

23 Peter Krapp, 'Gaming the Glitch: Room for Error,' *Error: Glitch, Noise and Jam in New Media Cultures*, edited by Mark Nunes (London, Bloomsbury, 2010) p. 114.

24 *Goat Simulator*, Skövde: Coffee Stain Studios (2014).

11 A Virtual Journey Towards New Literacies

Sarah Jones, Steve Dawkins, and Julian McDougall

In the introduction to this book, we posed the central question that we are seeking to answer: *how can all users best understand immersive media so we can become engaged users of the technology and utilise it to its full potential?*

The previous chapters in this section have given us some clues as to some of the key issues surrounding, problems with and opportunities provided by VR.

- Verity Macintosh's chapter highlights the uneasy relationship that VR has in relation to notions of "the audience" that are accepted within "traditional" media
- Jenny Kidd and James Taylor's explore different strategies through which VR can be used in education to teach about and disrupt the existing digital divide
- Turo Uskali et al. go further in exploring the opportunities in, and problems with, using social VR as the space for teaching and learning using a case study to illustrate.
- Andy Miah proposes an ethical framework to help us understand designing immersive worlds. It reinforces the need to retain valuable components of the physical world which underpin social experiences with the design principles within a variety of XR environments.
- Vicki Williams explores moments of micro-encounters, described as unruly encounters which are the point where immersion can break momentarily in an almost glitch-like fashion. This provides a starting point for opening up the literacies of VR and virtual environments beyond immersion.

To explore some of these key issues, problems and opportunities within VR around our five key areas of access, awareness, engagement, creativity and action, we conducted a series of interviews – individual and round table – with educators and creators of VR experiences, both before and during the writing of the book. As with most activities during 2020–2021,

DOI: 10.4324/9780367337032-14

these interviews were conducted over Zoom. In order to more fully explore and understand what could be seen as theoretical or philosophical issues around each of these areas. To enable a more grounded sense of the experiences made possible by VR, we also decided to include both first-person accounts of VR experiences in this section through the chapter Virtual Encounters and, towards the end of the writing, we invited three previous interviewees to a round table discussion.

Dr. Angela Dayton is an educator known as the VR lady in the United States and on most virtual platforms. She is the Senior Virtual Reality Research Scientist at the Virtual World Society and an Aspen Institute Tech Policy Fellow. She is a virtual reality researcher, user experience designer, speaker, consultant and trainer. As she states: "if you see somebody with the VR lady above their head as an avatar, that's probably me, or one of my students have got in". By her own estimates, she has put over 20,000 first time users into headsets that "are not tech people, they're not engineers. They're people in Middle America, we usually don't have access to technology". She works as the Senior Virtual Reality research scientist for the Virtual World Society and has a number of projects that she is currently working on to close the digital divide: mostly with Native American communities within reservations. She started Students in VR as part of Educators in VR and in her free time is a children's magician. She has seven children but has "more headsets in my house than I have children or heads".

Dr. Jamie Cohen is an educator in the USA. The focus of his PhD dissertation was on the history of virtual reality from 1987 to 1992, specifically in the way that Silicon Valley developed and excluded those who may or may not have been part of its development. He founded a degree in New Media in a college on Long Island, the focus of which was on digital media literacy, civic engagement and social good. The degree enables students to explore issues of access and inclusion and, beyond that, the "misuse, the creative misuse of virtual reality, and how we could use it to do different things, use the technology to experiment with new ways of interactivity. relationship swapping, gender swapping and so on".

Dr. Michael Loizou is an Associate Professor in Health Technology and Life Sciences at UWE Bristol and Visiting Professor at the Research Institute of Health & Wellbeing, Coventry University. He started working on using immersive technologies for digital libraries but has since led projects using Virtual Reality (VR), Augmented Reality (AR) and other technologies for education and in the area of healthcare. He has currently completed a project using art through immersive technologies for people with dementia. His work also extends to projects that are using VR to with carers of people with long term conditions to help them work more effectively with people with dementia, cancer and other mental and somatic health conditions.

We began our discussion by highlighting the idea that there is a long history of media literacy being taught in colleges and schools, especially in the United Kingdom and the United States, but that VR literacy may need to be different. The starting question is then framed as: Is VR literacy the same as media literacy or should we recognise its distinct experiential nature and employ different tools to understand it fully?

Jamie: *Personally, I do think it has to be an extension of media literacy. I don't think it's the same as media literacy. Traditional media literacy is a two-dimensional construct on a screen, whereas VR media literacy would be very much immersive. The way I describe it to my students often is when we watch screens, we watch the outcome of what was delivered to us from front of us. Whereas, if you were here in this and an immersive media literacy, your eyes might be wandering to the lights or who's running the camera or who's in the seat next to you. Therefore, the storytelling aspect is where did the designer of the story want to focus the central point, but what else was included in the immersive screen so in a three-dimensional space or 360-degree space, recognizing it in terms of direction, may take on some of the traditional media literacy terms like cutting or transitions, but, because of its immersivity or first-person perspective, has to take on much more of a new media literacy, a completely new media literacy and the more we engage with VR, the more I think new media literacy is going to be necessary to understand it.*

Michael: *I would totally agree with that. You're adding a different dimension. In our case from the projects we've run here, we also include storytelling, we include gamification where your actions can also change the course of the route of the learning. So, in a way, you're an actor within the media that is presented to you. We found that to be very important, not only for changing the course of your learning, but also to get people more involved, and more interested in what's happening and in that way to make sure that the learner, if it's a student or whoever else, is, is going to be more likely to complete the course, or the quest as we sometimes call it, and try to reach the conclusion that we expect them to reach in their own way.*

Angelina: *I'd like to frame it just slightly differently. I agree with both of the things that you said. I think there's a paradigmatic change that's occurred with the new media.*

You can't use the same frames now, mainly because old media was static, it was something that was a content that we consumed and this is more generative, it's more creative. What I tell people is that students create the world in which they live in

*and so if you're not consuming media but creating the media
and therefore creating the reality that you're then teaching
yourself or reflecting back into yourself, then teaching media
becomes different because it's moving from a static medium of
consumption to a dynamic one. The framing has to be different
and so it just includes and transcends what Jamie and Michael
said. When you teach it, you cannot teach it in the same way as
you would a static medium, because it's just paradigmatically
different. Our questions are going to be different and our
answers are going to be different as we approach media literacy
in this new way.*

The second part of the question about recognising the experiential nature
and the idea of employing different tools, asked the contributors to explore
this further. If we acknowledge a paradigm shift, what are the new tools
that have not been mentioned?

Angelina: *... storytelling, a generation of story. I think the end part of
that, at least for me, is that we're creating the world that we live
in, because we're generating the media that we are then
reflecting upon.*

*What does it mean if you make the world that you live in
instead of consuming that which is given to us in a static
medium, which is the way that the world used to be given to us:
as something that is? But it's not that way now: the youth
create and then reflect, create and then reflect within their
media and so it requires a different set of tools to evaluate that.*

This response suggests that these tools need to be developed to include a set
of *core* skills one needs to be able to be a critically- engaged user of the tech
now: skills that are profoundly different to those needed to critically engage
with other media. The questioning then turned to the skills that are cur-
rently unconsidered or neglected in discussions around VR. Acknowledging
the discussions in academic conferences, articles and books around, for
example, presence and immersion, we probed a little deeper to find out
what our participants thought was still unconsidered or neglected.

Jamie: *I think one of the currently unconsidered discussions that often
happens, even in the most recent release of Horizons with
Facebook, is access and disability issues or anybody who doesn't
have the monetary way of access to it. I think there's an exclusion
that's currently unconsidered in the discussions, although it does
come up in almost every article which is really nice that there is a
responsibility of most journalists who do approach it and say this
But when it comes to equality and diversity, it is one of those*

technological 'have and have-nots' issues that is still considered in the expensive nature of it. Like even if you were to go back to that Lanier and Biocca article about the price, originally it was like $10,092, which I thought was funny. And today, it's $300, which is cheaper than a phone, sure, but it still doesn't give us the tech that gives access to everybody and if we're going to create new worlds inside of an immersive space, I think we should find a way to maybe do that.

When we come to just to answer the skills, I think we need to talk about what Angelina said is education. [...] When we're talking about media studies or media education, these skills have to be engaged with on the forefront. It can't be like, oh, it's chapter nine, we're going to talk about VR: it's got to be up front.

The conversation naturally moves into the notion of the digital divide and the kind of world, or worlds, being created in and by VR. Because of the divide in terms of awareness of, or access to, VR experiences, are the worlds created within them a world of privilege?

Angelina: When they talk about diversity, a lot of times they'll do markers like, "Are you a female?", "Are you a person of colour?" but really diversity is the ability to ask different questions. If you ask different questions, you get different answers. The idea is that accessibility allows for the other voices or the passing of the mic and because the spaces, at least that I inhabit most of the time, have the people who can afford it, people who have the leisure, people who can work for free. How many of us have done stuff, and not gotten paid for it but we still have to pay our bills? That kind of privilege doesn't give the voice. That's why I put headsets on my hairdresser and the lady at the bank, get their feedback and then try and give them a voice or get them into the space because of equitability. Equity really starts there.

But to answer your question about what's not being taught, what I teach is that there are three types of consumers and three types of VR users: there's a consumer, that only takes in what's given to them, the contributor and then the creator, and then the levels of responsibility I have as a consumer to be educated in any media about how I'm being influenced and what they're doing to get me to buy type soap or a whopper at Burger King which they're very good at because look I already went there this morning. Or, and as a contributor, how I choose to partner with people and contribute to their worlds, and which ones I choose to contribute to, which ones I don't, which ones I think I can edify. Then as a creator, when I create that world or that space, or that advertisement, what responsibility do I have to the contributors,

*the content, consumers. That responsibility can't be in chapter
five as I've already done the damage so it's got to be in the first
chapter when it's ' I'm powerful now because I'm not the thing
that's receiving: I'm the thing that's creating'. I think that is
missing from media studies: what influence am I going to have
accidentally and what do I need to be aware of at the beginning.*

The issue of first-time users of the technology and the 'onboarding' they
need to fully engage with it was explored further. It is well recorded that
there is often a "wow" moment when a person first experiences VR through
a head-mounted display. This can be a profound moment for people but
can often lead to people "ticking off" VR from their experience list.
Establishing new behaviours and modes of experience are critical so what
do people, who are used to a two-dimensional, "flat" environment of tra-
ditional media, need to take the next steps in moving beyond that "wow"
moment?

Angelina: *The reason why I do it is twofold: one, to show them that the
next form of media is going to be something that's wearable
technology, and that it's coming. I used to tell people we're going
to start banking online and they'd say, "Angelina, you're crazy"
and I said, "so you're gonna think I'm crazy, but you're going to
be wearing your technology soon". The second thing that I tell
them, and most of the areas that I work in are those in which
people don't have access to technology, that think that Facebook
is the same as Google and they get their medical information
from Facebook, is to say, you need to be in this space. If you
could go back and be on a computer in 1983 instead of waiting to
get the internet in your house in 2005 which some of these people
I work with don't. So, what would you do if you could be in the
space and start helping to make the decisions of the world that
we're creating with this next immersive technology?
 That's what I tell them you need to do: this doesn't exclude
you just because you don't understand it, it's easier than you
think and we need you in the space.*

The discussion then turned to the notion of activity within the space of VR
and, implicitly, the notion of co-creation of that space. Is there a require-
ment for a person in a VR experience to be more active than they would be
with traditional media?

Angelina: *I like Michael's work because I think that you can really see it
in Alzheimer's patients because I've worked with some of them
too. You give them a new life when you can help them and their
caregivers.*

Michael: In my case, from my experience, there's a lot of different dimensions when you use virtual reality. You've got the people that want to use it and know how to use it and they have the technology; you've got the people that might want to use it but they come and say, "I don't have the technology. My phone's too old. I haven't used it before, I don't have, you know, a virtual reality headset". You've got people that want to use it but they don't have the knowledge on how to use it. But when you explain how to give them the technology, it doesn't matter how old they are, or what they did in the past, their education. It doesn't matter. If they have the willingness to use it I think the fact is to be quite versatile and easy to use.

Then you have the other people that just don't want to use it. You try to explain the advantages, how it can help them and they say, "No, I'm not interested", or if it's part of their job, they say, "No, I mean, if I do this, in the job that I love, the robots are going to take over the world and I'm not going to have a job so I don't want to use new technology". This came out from a report I did last year on the use of technology for healthcare and the digital skills gap within the UK, the NHS and so on. There were so many people that said, I don't want to use it. Then you've got people I work with, for example children with autism or other mental disabilities, and you find out that they're actually much better in using VR and being immersed than interacting with any other technology, or talking to somebody else because they don't like the close interaction with a person, for example, and we found that using that can actually help them evolve much more quickly, learn and also improve their lives.

There is so much that you can do and use VR for, you just have to find the right way to immerse people in it.

The idea of "old" media and new, immersive forms of media are central to this book. Returning to the ideas of existing models of media literacy, we asked the participants to reflect upon the fact that central to those models and the debates around them was the idea that one needed to understand the construction process of the media being analysed to more critically engage with it. *If a key part of the teaching around media is understanding the workflow and production process, as creators, do you think that we need to be aware of the creation tools within VR and their possibilities and is that going to be one of the kinds of pillars of a new model of literacy?*

Jamie: I can answer this quickly, in a very strange way because I had the privilege of developing a new media degree, and I had the ability to build that type of context in but I think in traditional

schools or traditional media curricula, or traditional media literacy, the translation is a little different. Access to cameras is a bit different than access to the technology that develops in VR spaces. When I think about how we develop VR spaces, I think of it in terms of space. 3D printing is more similar to VR space than television production in some ways because it's coded, it's structured, it has three dimensionality. It has different ways of making something immersive. Social media is similar too, but then, that question is similar to that age-old question you need to know how to make the car to make the car work. When it comes to programmes like Unity or the development of these spaces. I think it's important to see them. I think students should have access in one way or another to see how the structures are actually built in the same way they should know how algorithms are running on social media because if they don't, they don't have the skills to think about it, at least its ability to give them the insight. I do think it does come to schools that have access to either the tech that can develop VR spaces or at least a knowledge of how to talk about it and I think that's really, really important because the more and more VR spaces and immersive spaces are developed, not just from the camera perspective, not just from 360 cameras but from the actual technology, I don't think we should do just speaking about cameras, we should be speaking about the tech that does that as well.

Michael: *Well, I was going to say that the understanding of the creation tools is important but on the other hand, it is creating those tools that help me most. We just finished an [European Union] Erasmus project just last week, where we created our own tools for teaching entrepreneurship to students at university, and other educational institutions. So, we decided to try to recreate from scratch what the tools can achieve for the creation of the VR tools instead of using software that was already in the market. We went back and we looked at different [...] theoretical models that allowed us to create something more unique.*

On one hand, it is good to be able to understand what you can achieve with what's out there, on the other hand, by looking at theoretical models, you can possibly recreate, or even improve, some of them instead of just staying and using what somebody else created in the past because VR is a bit different. It hasn't been there for that long so there's always improvements to be made to different tools for creating VR experiences.

Angelina: *I think Michael makes a good point that there's plenty of horrible VR developers out there. And I think Jamie makes a good case for the "Do I want to know how to build a car, how to fix it?".*

I'll tell the story that my son is a virtual reality content creator so he creates worlds. He's 15 years old and he's asleep right now because he works with people in Bangladesh and they did a build last night and so he's off schedule. But he's 15 and, because he creates and he uses tools, he's a better HCI researcher than I am because he creates the world and then he sees what the human interaction is with it and then he can modify it, and he can do the iterations. That speaks to what Michael was saying and what Jamie was saying about having enough of an understanding of the tools or at least having very competent people around you that understand it, that you listened to, so that you can do the iterations because one of the things about this medium is, it's iterative. You don't ever finish, you're always creating and so you have to be able to: one be very comfortable failing ... often (which I am) and you have to be very comfortable, understanding that you're never finished and so you have to understand the tools well enough to make those modifications.

The other thing I would say because your question really asked "How well do you have to know the tools?" I say that the most interesting part of human–computer interaction is the human part. We miss a lot of the development issues because we focus on the interface and not on the human. And so we talk about how we protect people's privacy on this platform, when the problem with the privacy is the person. The person is sharing the information not, you can't make something secure and so I think that while you have to know the tools of the trade, you also have to know if this person is driving the car and not getting an oil change, and all of the human part of it to really get a good product at the end.

Jamie: *... and it is about privacy and she brings up an incredible point here which is about that which is: if you have no literacy, about vehicles, you have to trust the mechanic. Now we were talking about that liminal space between use, and somebody else's taking advantage of you and that is, there is a certain middle point that has to be acknowledged which is that that level and privacy is in that which is how much do you want to give that? Privacy is about how much you keep and how much you give, and I think a lot of VR conversations aren't engaging with that as much as we should be and that is a big part of media literacy. That is the biggest thing, so I think that I was just so excited that she brought that up.*

Angelina: *I would just add that that also goes into things like hardware. [...] When I go out to schools, I say "I am going to teach you everything about VR but the one thing I want you to go away with is: "Bestbuy Salesmen are not your friends". They're salesmen". Because, even the idea of media literacy and understanding that if I'm giving them personal information, or*

> *if I'm letting I'm giving away power for them to choose my hardware or to choose my software or to get me locked in and some system that later on [because] that's what all the medical schools are using, but it doesn't really work, all of that comes back to media literacy: understanding how much I'm giving up in my privacy, how much am I giving up in my heart which was, what am I giving up because I'm not educated in my decision making.*

This critically informed access to the full range of experiences that were mentioned previously were returned to: *How do we ensure that kind of access? What are the ways that we do that?*

Michael: *You have the opportunity to let people use VR. Last year, we set up at the Shakespeare Birthplace Trust in Stratford, a headset that was a combination of VR and AR, where we recreated how the birthplace would look based on material that was published in the past. So people that visited the birthplace, they could go and use the headset to have a more immersive experience that included AR and VR, and that gave them the opportunity to see how things like that work, showed them how important it is, if you have the opportunity to do something like that and I'm sure allow them in the future to go get their own headset and do something similar.*

Jamie: *From the perspective of access, when the Cardboard came out, the first person to show that to me was my Dean who brought it in and went "That's incredible" but who I never figured would pick up a mask. One of the things too is also bringing this conversation into media literacy spaces, so if there is a traditional conference of any type or traditional conversation, it is to inform or to bring in or de-stigmatise the fear of the HMDs. "Oh my gosh. It's a headset and I don't want to put that on it's too much", is to say you know this is this is a form of media we have to have a conversation about and that I think is part of it too that gives us access so if you have access to that community already, we should be bringing in VR and media literacy into that community as well.*

These comments suggest, or explicitly highlight, the importance of the VR experience being "offered" to people in a wide range of places and spaces. Angelina, though, went further.

Angelina: *I want to go back to the idea that I said earlier, which is that access to emerging tech is not a space. That divide is not spatial. It's not about getting the internet into my house. It's temporal. You can put it in or near my house but if I've only had it for five weeks, I'm not using it the same way as somebody else who's*

had the internet since the 90s, and so you have to bring up literacy. I have to have read a few novels before I consider myself literate. Most of the things that keep that digital divide wide are class issues, more than anything else. We teach students in poor schools that you're supposed to limit their use of the computer to something like a half an hour a day after school but why would you do that? Even if they have it, they're not supposed to be on it, because too much computer use is bad for them and what if they game and then they leave schools in these poor rural communities, having had no time on computers, having had no time on the internet, because it's bad, they have these huge firewalls. When I go in, none of the teachers can access the internet because they don't know how to get through the firewall, but every student does so I just have to grab a student random from the hallway and say how do you use a proxy server to get through so that I can set up my VR stuff and they all know how to do it. So there's this weird classist idea where in the richer neighbourhoods, they have full access to HMDs whenever they want. My kid is coding at 2 am, and I'm closing the digital divide by just giving access and the people who are restricting the access to other people who are supposed to be educating our children on how to use emerging tech.

So if that's an issue then the last thing I would like because we would never restrict access to a book which is another form of media, we wouldn't restrict access to a headset. When we talk about accessibility or we talk about the digital divide, it's self-induced and, and I think Michael says something true about "give me a reason to be on there", and then Jamie, I'm just reiterating with what you guys said, and give me a reason to feel like it's safe, and then they'll, then they'll come. Then everybody will have a smartphone.

The points made here start to relate the notion of access to VR experiences to the kind of potential moral panics discussed in Chapter 2 around the fear of technology and the fear of unfettered access to certain types of technology or a certain type of content. As Angelina wryly noted though, when people say to her that if she gives access to the internet, people, especially children, might look at pornography, she replies: *"did you know porn used to be in books?"*

Whereas social class is often highlighted as a key factor in the digital divide, it is critical to explore further the other factors alluded to, especially age. Is it the case that young people have probably already got more of an understanding of what some of these tools of critical literacy are and, as a result, we need to worry less (not more), about them?

Angelina: They use filters all the time they don't need. They're using AR.
In our spaces, I find that what I tell people is because I'm a
children's magician just in my spare time, there's a type of
person that's a little bit more courageous and a little bit more
crazy and we step into those spaces regardless of our age where
we kind of are more risk-taking. And so, in a lot of the areas
where people are running VR programmes, they're philosophy
majors, or from these weird backgrounds and it's because
they're willing to take a risk. Young people are very willing to
take a risk and that's why they step into that space of the
unknown emerging tech. It's a type of person that's not afraid,
that's not risk averse and they're the ones that are going to say,
"I'm okay putting it in my job, even if it means I might lose my
job". I'm okay with doing online banking first. It's that type of
person. [...] Not age, it's your, your willingness to fail or your
fearlessness I think.

But how, as an educator, does one encourage that fearlessness that Angelina
is talking about, and that willingness to go and play and try?

Jamie: Maybe I have a different perspective on it because when I'm doing
VR, my students want to put it on, and they don't have access at
home. I teach in a school that doesn't really have access
traditionally so they do come to school to use VR. Oftentimes
their excitement leads out to their parents and relatives and
connectors and they actually want to try it. We do give them the
opportunity to borrow headsets. We somehow convinced the
school to purchase a handful of Samsung devices so we handed
those out as rentals and it's also part of the 360 cameras. We have
a handful of GoPro 360 cameras. And when we do field trips, we
went to Rome to shoot media archaeology projects using 360, and
the only way to experience it was with the headset so it's the
excitement kind of rides with the output so when they see it, [...]
it's just a new experience and it's beyond the wow factor. It's just a
matter of experience.

Earlier in the conversation, Jamie made a point about "renting [VR] stuff
out to people" and we felt that this had been underexplored. Technologies
like television are in many people's houses in many countries and are part of
that domestic environment. Despite, as we mentioned in the Preface to this
book, the number of people adding headsets to their Christmas lists, VR is
not yet that kind of domestic technology for most people and so we asked
*to what extent do you think that ability of people to take something that is
unknown into the domestic space of the home to play with is important?*

Jamie: *Believe it or not, they love borrowing the cameras. The problem wasn't the cameras but the acquisition of the storytelling. It was processing. It was the machine that enabled them to post-produce the video. They often have to bring it back and use our MSI machines, because their machines would take two and a half days to process something. They enjoyed taking it out as a camera or taking the headsets out as a viewer and the only drawbacks for our workflow was processing and the terrible keyboard inside of VR spaces to find their content. Aside from that, I think that was an exciting factor. Very often towards the end of semester they were taking 360 cameras out more than traditional media cameras because it did give them the option to shoot a different way.*

Angelina: *I just want to note that the trend is Nokia and other places that do 5G technology and looking at 6G technology, are predicting that they will have 1 billion wearable technology devices by 2026. [...] So, wearable technology they're thinking is going to hit 1 billion, so we're right on the cusp of it, mostly because they need the ROI, the return on investment, for all the 5G tech that they've already invested in. It goes back to Michael's point, you have to have content. You have to have a place to go. What they're trying to do is move it into that social space, so that instead of getting on Facebook I get my headset and I go hang out with somebody. It's not quite there yet, but the projection is 1 billion by 2026:2030 at the latest. That's within the decade.*

These responses give a sense of the excitement that VR technologies of production and consumption can engender but also raise the issues of the commercial imperatives, especially of "Big Tech" companies, to develop content. We have seen in previous chapters the "utopian" visions for VR but this apparent dichotomy – between artistic creativity and the demands of commercial enterprises to data mine for profit – starts to raise issues around VR technology and content. This leads naturally to the field of ethical implications and concerns: *what are the ethical issues that have arisen, or that you foresee arising, in VR as an educator or creator and are they different for different types of VR content?*

Jamie: *The genres of content are very different in that it's storytelling in that way; it's the content of that, how you acquire that footage, and then what we consider art, and what we consider immersive interactive spaces so they're all different. What's really fascinating about this medium is it's far different than two-dimensional mediums, especially its liveness or first-person perspective, so there are ethical considerations. I always, always think about that moment in the VR chat when that poor user had a seizure, and all*

of the different users had no idea how to interact at that moment. They circled virtually as an avatar around this seizing, unfortunate victim, but they were in many different places all over the earth and dressed as their avatars. While we might not be able to directly answer the ethical dimension, I might want to consider that as a place to start a conversation. That's a good place to start a conversation about avatars, first-person perspective, third-person perspectives, immersive spaces, liveness and media consumption all in one because there's so many ways to be in that scenario.

The development has to consider that. Those are the people who have to be in the room, it cannot just be the traditional stodgy Silicon Valley bros that do this. It has to include people with disabilities, it has to include women and people of colour and queer people and anybody who hasn't a voice, that has been typically excluded because while we may not prevent somebody from having an unconsidered incident inside of a VR space. These are conversations that have to be in the development of it and talking about ethics in general.

Jamie: *We could go back to the 90s, or back to even the 60s and you're going into these massive spaces where you were developing this. Just like television, it was developed from a very esoteric way where we're a very privileged class. It's almost like you'd have to go back and reinforce that but I do think we're in an era now, a very good time now, where we're allowed to consider this and maybe what I think is in the stalls of VR I've written about how VR missed its pandemic moment because it depends on that ability that really we should have jumped in at that moment but because of that gap, we're having this conversation now and maybe we could start up these things right now, rather than think back to its origin space, and have these conversations as we move forward into the next generation of VR immersive.*

Michael: *It's very multidimensional and we learnt from the things we did because they include things in education but also things in healthcare. First of all, you have to see how you use what you're going to use, how do you then create your story. How can that story affect somebody because it's so real? Some people might compare it to reading a book, in that they might have some information, there's some pictures but if the book upsets you, you can skip the chapter and close the book more easily than removing the headset when you're immersed in something. By the time you do that, it might be too late.*

The material can include how you're going to create your story. And then you've got questions like, who's going to use it? Are you going to have kids using the VR? Are you going to have

people with disabilities immersed in the VR scenarios? Are you going to have people, like we did, with dementia, that may not be able to quickly express their dissatisfaction? They might just, you know, start shouting and become very upset. It might affect them in the future. The more immersive something becomes the more ethical considerations you will have to have, and more ways to jump out of it and, you know, fix things if something goes wrong.

I'm not saying that we shouldn't let people have this, I'm exactly the opposite. I want people to use VR and AR, but you have to think about things more carefully than you would when you create something, using a different technology.

This phrase – "more carefully than you would with another technology" – felt important and has been considered throughout these conversations: *What do you mean by that? What care do you need to take with VR that you're not with another technology for example?*

Michael: *If you're going to give the VR scenarios to somebody to sell, or somebody to use, it is, I think, even more imperative to see what disabilities they might have, what mental condition issues, what age they are, what they can use at any other time so they should be more ways to lock out passive experience. I know that for books, you've got ages. You wouldn't give a book for adults to someone who is 9 years old but this is a bit different. It's not as easy as just locking out, as not allowing somebody to use something at all, but you can adapt parts of it, based on their circumstances, their age and so on. It's not like a movie you won't allow them to watch at all, because you have to be of a certain age. But you can still adapt the virtual experience to work with everyone, based on the input they can give you about their circumstances at the beginning.*

Angelina: *One time, we were in school during the summer. It was super-hot. I put some kids in Antarctica and they started saying, "Dr Dayton: it's getting cold in here", and I know, and we all know, that when we remember things in VR, it's much more similar to something we've truly experienced, even if we're not truly experiencing it. Once that memory is implanted in you and you think you have experienced it, the damage is done. So, ethically, I think there are considerations. I'm going to interact and I'm going to feel as if that's real and I'm going to remember it as if it's real. So, what am I considering in this interaction?*

The suggestion that the old distinction between production and consumption is being elided by VR led us to the last question in the discussion.

Manifestos have in the past been important at the key moments of the development of new creative or artistic movements or practices, so we wanted to finish with a playful question: *If you were developing a manifesto for VR what would be the most important thing that you would have in there?*

Jamie: *Everything is interaction, and I think if we, we make that the thing. And then, when Michael said about who's going to use it, you know I think those are those are what I would say.*

Michael: *I would add personalization. The ability to personalise experience like you did with [...] those old interactive books where you could make a choice in the book and then jump to a different page and see what would happen. I started playing these, you know Dungeons and Dragons and also the first online Dungeons and Dragons games. Even before the formality that was out there, I was using the bulletin boards and was an operator for a bulletin. That allows you to personalise it, to change things and to make your own choices. I think that's important. It shouldn't be something that we feed to people: this should be something they choose to do, and in their own way and choose their own concepts and what they're going to do and what they're going to get out of it.*

Angelina: *That made me really think about the possibilities of virtual reality and how we can create any world we want to, if we're brave enough to create the world that we want to live in and not recreate the world that we're trying to escape from.*

Part III
An Immersive Literacy

12 Presenting New Literacies

Sarah Jones, Steve Dawkins, and
Julian McDougall

Chapter 3 set out this provisional framework for understanding virtual reality as and for literacies and promised to return to it here to fill in the blanks.

Media Literacies	The Uses of Media Literacy	The Uses of Media Literacy in VR	The Uses of VR for Media Literacy
Access	Using access to media to challenge access barriers and inequities.	Socio-material, pedagogic and social access points	
Awareness	Critical, meta-reflection on everyday mediated practices.	Reading presence and immersion. Interpreting choice	
Engagement	Dynamic Agency in Media Spaces	Perspective, degrees of empathy and adapting the text	
Creativity	Curative and maker literacies	Creative media practice in and of VR	
Action	Counter-script media, capability for positive change	From virtual empathy to positive action in space and place	

This chapter works with ideas about "unsettling literacies" (Lee et al., 2022) to extract themes, to do with ways of being in VR and ways of seeing it (conceptually) from the collection of perspectives and experiences collected, collated and curated in this book. The purpose is to, if not straightforwardly convert, then at least *motivate* the work generated here on understanding virtual reality, towards a sense of how, in both theory and practice, we can think about, in more educational spaces, this dynamic and purposely precarious relationship between virtual reality and (media) literacy, most explicitly with regard to critical meta-reflection on experience.

When we talk about "unsettling literacies" we are both concerned with, but also more enthusiastically working with opportunities provided by seismic changes. These are changes to our ways of being in the world, during a pandemic, with all of the attendant repurposing of what we mean

DOI: 10.4324/9780367337032-16

by real and virtual, or being social or being in particular spaces, hitherto more clearly insulated from one another. We are also living through profound changes in space and place, through migration and displacement, but also through the unforeseen benefits of the virtual during covid, as we worked across time and space with less barriers to engagement associated with funding and travel or access. In other words, and at the risk of too convenient a convergence, perhaps, the relationship between literacy as living and situated and the blurring of real and virtual is both unsettling and exciting, as these developments "*open up new spaces for examining ways that literacy has come to matter in the world*" (Lee et al., 2022).

In the very troubled times in which we have edited this collection, the public has come to accept this "unsettling" of claims to truth, our handle on reality and the credibility of expertise. The way that covid forced us into ethical decision-making and scientific interpretation in real time, wading through conspiracy and the erosion of trust in experts and leaders, followed by a "hybrid war" in Europe – both profoundly unsettling, not just for obvious reasons, but also existentially. If our means to distinguish between information and its distorted variants is challenged, as a seemingly permanent state, then this could be described as a kind of Baudrillardian nightmare, or at best a "vertigo of interpretation".

Jean-Francois Lyotard (1988) offered a reading of Herzog's *Where the Green Ants Dream* as an example of a philosophical "differend". This is where two completely irreconcilable language games clash. A differend cannot be assessed without interpreting one language game with recourse to the idioms of the other which makes any "democratic" judicial judgement impossible. In Herzog's film, an Australian mining company intend to excavate land occupied by Aborigines who believe, without doubt, that the dreaming of the green they co-inhabit with maintains the balance of the universe. In Lyotard's reading, this can be invoked as a case in point for how western rationalism, founded on colonial epistemologies, should give way to truth claims from the other. This allows us to de-centre justice, truth and knowledge, locally situating these in a postmodern "micropolitics".

Can we now say that this *differend* has come to prominence, but in ways that are very far indeed from the decolonising politics that may have been assumed to be the inheritors of Lyotard's theoretical ideas, along with others in the poststructuralist school such as Judith Butler and Luce Irigaray? If so, then for protectors of the green ants, now look to Q Anon and Putin. A feature of these unsettled times which is no longer theoretical, but up close and personal and in the lived experience of pretty much everyone with a smartphone is that it is not only possible, but required, for philosophers to try to help us understand the conditions of possibility for our existential working through of "Reality+" (Chalmers, 2022). Are we at a moment where trying to distinguish between real and simulation, even for the purpose of arguing that we cannot, is an oxymoron? If Facebook's "Meta" turns out not to be *the* shift, Chalmers observes that we are *already*

in a state of "extended reality", beyond any useful relation of virtual/ simulation/reality to be simulated through the virtual, which requires a relation with what it simulates.

The kind of critical media literacy we will need will move beyond "this is not a pipe" analyses of media representation (of reality, people, places, ideas and events) to the practice of reading reality itself as textual, as a genre (Ahn and Pena, 2021). This will need to go further also towards a deconstruction of the architecture of the "deceitful media" (Natale, 2021) we live our lives with. As we co-exist with artificial intelligence, with these virtual and augmented, *extended* realities, we will need to be critically "in the affordance". Couldry offers another angle:

> *There is a paradox here. Once, the imaginative power of media – for example, the nineteenth century novel – was used to reduce the opacity of the social world, to make its vast complexity more manageable by uncovering patterns. But today the newly unleashed imaginative power of algorithmic processes is increasing the social world's opacity, at least to human beings on the receiving end of algorithmic decision-making.*
>
> (Couldry, 2019: 79)

As Andrews (2021) puts it, we must be awake to the fact that "*a cottage industry has developed around imagining salvation in the form of western technological development*" (p. 164), so it would be an act of "strategic ignorance" (McGoey, 2019) to see virtual reality's affordances as a neutral project of "ontological redistribution". At the risk of sounding glib, to think about how poststructuralist politics, such as the work of Judith Butler, could be reclaimed for good things, we can think about how gender exists in its performance and is thus something we can "trouble"; and see how "futuring techniques" at work in projections of virtual work, education and civic society, reveal the interplay of genre, narrative and staging in the *performance* of future, as "*the politics of the future revolve around who can make their imagined futures authoritative in the scenes and stages that matter*" (Oomen et al., 2021: 15).

Returning to binaries is out of the question, since any "return to the real" is obviously a retreat to nowhere, since the conditions of possibility for "post-truth" were clearly in the symbolic violence that centred epistemologies enacted, regardless of how we feel about where the centre not holding has taken us, at this point in history. In the complex interplay of medium and message at the time of putting this collection together for a series on media literacy, the extent to which humans care about "objective truth" is raised. As the West rightly worried about Russian citizens' media and information access during the bombing of Ukraine, Peter Pomerantsev reminds us of the sobering fact that "*there will always be ways to reach the Russian people, from virtual private networks to satellite TV. The question is what to talk to them about*" (2022: 17).

In these perspectives and evasions of false binaries, in these more nuanced and complex positions, we can return to the uses of media literacy *in* VR and then turn our thinking to the uses of VR *for* media literacy. As asserted in Chapter 3, this is about a "model" of media literacy that works for virtual reality but also loops back to media literacy better.

The Uses of Media Literacy *in* VR

This book grapples with what it means to be a critical, engaged user of immersive technologies such as virtual reality and, in this sense, media literacy has much to offer. Media literacy is "just literacy", expanded to include the reading (viewing, listening, playing) and writing (making) of new textual forms, but as new technologies brought with them new problems and challenges, media literacy has found itself in a perennial, problematic solutionism. Whether in response to moral panics over music videos, violence in video games, "fake news" or online safety, there is a strange assumption that media literacy in itself will provide citizens with not only resilience to these potential harms but also a positive mindset to either make different media choices or to think before sharing misinformation on Facebook. When we consider that most "harm" in the media and information ecosystem is done by people who are very media literate, we can see that this assumption is at least something of a leap of faith.

This is important because if we acknowledge this, then we start out from the right place, thinking about media literacy through a theory of change, where we move from critical awareness in and of virtual immersion through to positive action in virtual spaces, and we won't assume the latter to be a product of the former.

In this section, "classic" approaches of this kind of agentive, more "dynamic" media literacy are put to work with the ideas articulated in this collection about VR.

"Classic" media literacy enables people to understand the role of media in society and the impact of media access on their lives and their communities; critically evaluate the health of their media ecosystems and reflect on the choices they make about media access and, where required, commit to making different choices about what to access and what to access less or engage with differently. A healthy media ecosystem gives people access to information which can be trusted; provides people with the information they need to be fully involved in society; offers a healthy range of media choice and media from a variety of perspectives on the world; represents all groups of people fairly and equally and enables all people to see themselves represented in media and to represent themselves through media. Of course for many people on the planet, media access is restricted in various ways out of their control. But people also make personal choices about what media to engage with and what information to receive and share with others. We can make choices which narrow or restrict our access to the

media ecosystem by only using information from people whose opinions we already agree with, for example on social media.

In virtual reality, we start out from a much more complicated place, but in a good way. For the switch from reader to viewer, listener, player, scroller, which media literacy has dealt with in the progression from page to screen, in this moment we are thinking about enabling a critical mindset in the visitor, actor/actant and the immersant/interactant. We need a media literacy for presence, for embodied cognition and for "dual consciousness", and yet actually, this is perhaps the best example of how virtual reality offers a kind of critical awakening to the dual consciousness that was already happening, in our engagements with all media, we are in "living literacies" (Pahl and Rowsell, 2020). We can see this also in the work shared in this collection on "social VR" and the notion of developmental behaviours in immersive learning, choices and "diverse solutions".

All media content represents the world, people and ideas in particular ways. Media often carry persuasive messages. In these times, there is much new anxiety about a long-standing problem, of misinformation. Whilst it is not a simple case of a "single shot" inoculation, more a case of developing critical "antibodies" over time, media literacy does offer protection from misinformation, and like a public health campaign such as a vaccine programme or mask-wearing, we can say reasonably that the more people who are media literate, the healthier the media ecosystem becomes.

However, this is longitudinal, as people need to be able to apply textual analysis skills to media texts and digital information sources at the "micro" level but also relate their own media access to awareness by critically assessing how media representations impact on their lives at the "macro" ecosystem level. Once people develop this media awareness as a "habit of mind", once they become mindful media and information users, then all this "micro" level awareness builds up to "macro", critical thinking about media and information as a whole in their lives and in their society and their country. They can question which people and ideas are more powerful in their media ecosystem; which people or ideas are left out or kept in the margins and then have higher expectations for a diverse media. This isn't, any more, simply about public interest media versus commercial imperatives, as much as how, if people are getting more information from their Facebook friends and social media influencers than they are from journalists, whether this might be a problem. And it won't be only about film, television and newspapers, but about video games, data, algorithms, virtual reality and "deep fakes". Even taking a seemingly contemporary media literacy approach such as lateral reading of online media requires a shift in perception for virtual, immersive mediation.

In virtual reality, there is a consensus that media literacy must involve both understanding how things are made, and how to make them and, indeed, that it is more simple to make things in VR than it seems. At the same time, learning how to create a sense of immersion does present ethical

questions that are apparently different, or at least more pronounced, than previous iterations of "learning by making" in media literacy. It might not be that the "ethics of production" are different to previous forms, but more that they are so clearly laid bare. The *consequences* are never neutral, but also always-already at the surface. The writers and respondents in this book often, indeed almost always, talk about using the tools of VR production responsibly, ethically, for "better use". In this way the *uses* of media literacy are more front of stage in virtual reality than they were in the past, we can argue. In the case of XR design, world-remaking cannot be detached from ethical scrutiny and the extent to which this form of media promotes human flourishing. Utilitarian and eudaimonic questions are not, in this application of media literacy, either separated from or a later extension to, "just" critically understanding the media experience and its representational imperatives. Justice is included in the conceptual frame, next to realism. This has the potential to be a significant shift for media literacy, but at this point, we will observe that this inclusion is doing what media literacy always "wanted to", but was often impeded from by the need to work with the frames of reference for "schooled" literacy.

As media literacy moves into more active and experiential "maker spaces", we typically require people to first audit their own digital literacy skills and gaps, pool resources to work together in creative contexts and then – and this is the leap of faith – understand the benefts of using media literacy for active engagement in communities and society for *positive consequences*. When people can use their access to media and information and their mindful media awareness of sources, representation and trust for particular, active purposes in their lives, then they are converting their media literacy into capability. So we move from critical decision-making when engaging with media, more mindful attitudes to sharing media content changes in our expectations of media *and* getting involved in the media ecosystem as a creator of positive media content – using your media literacy with whatever tools people have access to, or in Henry Jenkins' words *"By Any Media Necessary"* (2016): representing people or social issues differently, to produce a counter-script, campaigning for change. This is about using media to develop a civic imagination, using the media tools we have access to and our media literacy skills to "push back" against social injustice.

But, of course, when we are involved in teaching media literacy or training in media literacy projects, people need a "safe space" for discussing these issues, so we are not imposing a morality or even an unintentionally colonial view of social justice, for example. This involves working hard to design a "third space" where peoples' lived experiences of media engagement come into play with critical thinking and radical pedagogies, where and if possible.

In virtual reality, this is helpful to the kinds of "digital futuring" we have encountered in this collection, where authors have advocated for utilising emerging media tools for community empowerment. In mobilising

"progressivism", the pedagogic practices shared in these pages favour process, activity and interaction and explicitly work to create communities of practice which can both do this futuring work for positive consequences and social justice but also work through digital inequalities as experienced by community members, in the moment. In this sense, partly due to its "beta" status, media literacy in VR is something of a real-time case study in co-creation, since the educational constraints of institutionalised, formal knowledge transfer are stretched by immersive media as much as they are enhanced by it. Without wanting to make light of, or understate, the anxiety this can cause for educators and students who need to make sense of all this at the same time as operating in a fee-paying, commodified environment, the practice of working what together what it means to learn about virtual reality from both inside it and with it as a thing to "know" about both critically and as a creator, is something of a perfect storm (in a good way) for the kind of media literacy we are talking about when we talk about the dynamic "third space". Going further, and moving closer now to the shift from the uses of media literacy in VR to the uses of VR for media literacy, but still, just holding the line for the former, the notion of unsettling literacies meets the "unruly encounters" with VR, echoing Mark Fisher's critique of capitalism realism from within itself, with complex entanglements. This is what media literacy "as it is" should be about – our complex entanglements with media in our living, mediated experiences, not with subject/object dualism. So whilst the focus here on glitches and moments of revelatory rupture *of* media is very fertile ground for moving into an assessment of what VR does, in these ways, to media literacy, we must also bear witness to how the more ambitious work of "unsettling" media literacy, of unravelling the assumed insulation of "the media" from "us" was and is not so different. "The media" is constructed out of a need to preserve a status outside of it, to maintain it as other, to be looked upon with the pedagogic gaze through judgements which – in the case of media literacy – are conservative in their preservation of the idea that there exists "the media" to be critical about. This was our observation over a decade (Bennett et al., 2011). We were advocating then for a critical media literacy pedagogy for reflexive engagement with textual fields, the choices people make as they negotiate "myriad texts", to facilitate more ethnographic approaches to living in the world with others and with media. It might just be that VR can bring this into being.

The Uses of VR *for* Media Literacy

Composing ourselves in virtual spaces is "a thing" which is new and emergent, but our mediated lives are always about negotiating our identities and the pull and push of representation, in which we are situated as more or less other. Blevins (2017) returns us once again to this important focus on the *uses* of VR:

Our use of VR, AR, and MR is connected to human existence, small—in individual lives—and large—in the existence of whole peoples. Our media usage is how we understand and discuss humanity's historical, contemporary, and future existence. Through Virtual, Augmented, and Mixed Reality, as we compose our past, present, and futures, we compose ourselves.

(Blevins, 2017: 269)

In Tunisia, the alternative media platform Boubli is the focus of interest for media literacy activists as a case study for theory of change:

In Tunisian slang, boubli means a hubbub, a kerfuffle or a bangarang ... in other words, a commotion often caused by conflicting views. Among young people, the term has taken quite a positive connotation which encapsulates the spirit of the project: "to make a boubli" is to disrupt norms and conventions. Boubli's mission is to empower young people, especially the most marginalised, to disrupt the media landscape and to challenge dominant narratives and stereotypical representations of youth through innovative content.

(Sayah, 2022)

The composition of self, for young Tunisians, is very much at the heart of this intentional disruption. Likewise, the paradox of absence–presence is not the gift of virtual reality but an enduring feature of our textual lives, as ALL media texts are both material and immaterial and we engage with them physically and mentally. But developing a critical literacy for articulating what artificial intelligence is doing whilst being in an artificial intelligence-generated "system-driven narrative" (Travis, 2017) is a bit more "immersively socio-material" than the kind of media literacy needed to view a film more critically whilst still enjoying it. But it's really just a next level in the boundary-crossing and border-dwelling kind of media literacy *praxis* that we've always needed to "critique the cultural world we inhabit" (Bacalja, 2021: 186).

Back in 2004, James Paul Gee wrote *What Video Games Have to Teach us about Learning and Literacy.* This text was highly influential for educators and researchers keen to understand the complex place of gaming in literacy, given that *"the relationship between reader and text (player/game) is differently mediated so that the 'player as reader' of the 'game as text' is positioned as an agent in knowledge making practice rather than a recipient of 'knowledge'"* (Kendall, 2008: 18) and also that studying games might constitute a challenge to the "figured world" of literacy as framed by education and its attendant "relations of power and domination" (Freebody, 2006; Street, 1995). Gee's application of broader theories of critical literacy, figured worlds and affinity spaces gaming presented the medium and experience as distinct, in the terms of reference for literacy, as

the player is "licensed" within practice of gaming to take up a position as "expert" and play at the margins of what is already knowable to produce new meanings. The meaning of the game as "text" becomes shape-able as well as knowable and the reader/player is re-situated to learn in relation to this "reframed" expertise. Gee observed that gaming reflects how humans "scenario build" through our own simulations in response to given situations in lived experience and posits the rich environment offered by gaming for learning, in cultivating layers of identity and systems thinking through experience, as opposed to the more detached epistemology imposed by formal education. O'Brien (2021), in a recent return to Gee's thinking, suggests

> *In terms of understanding interdependency and how intricate and complex globalised systems have become, the Covid-19 era has shone a powerful light on such globalised systems - both in terms of infection transmission and control but also in the tools to combat it's spread. In such a moment, Gee's statement "Citizens with such limited understanding are going to be dangers to themselves and others in the future." has never rang truer than right now (Gee, 2015: p. 35). In the offline campaign modes particularly, the Call of Duty games have excellent potential for providing a total view of a world in chaos and identifying the role and purpose of one individual - the player and the characters she or he will inhabit throughout the duration of the game. Educators need to harness ways of being able to present total pictures but also spell out the individual's capacity for agency and change is within that grander system - games do this routinely.*
>
> (O-Brien, 2021: 76)

Meaning-making in play as it intersects physical and virtual experiences is also of established import to the study of literacy and its own intersection with digital media cultures. The "makerspace mindset" is a possibility in physical play spaces, virtual worlds and "third spaces" across and between them. If play is meaning-making, across hybrid sites of experience and cultural mediation, then how does this work within virtual reality? In a study of children's meaning-making in physical playgrounds in the era of digital and virtual/hybrid popular culture, research which has much to offer to media literacy, Potter and Cowan observed play as "laminating" layers of meaning, remixed and remediated from media culture, folklore and everyday lived experiences, with four emerging domains – "Lifeworlds, folkloric imagination, media remix, community and belonging" (2020).

When we think about reading, whatever kind of reading it is, whatever the text or the textual experience being read, the reader decodes signs, interprets the meaning and makes meaning, within an interplay of personal and cultural contexts. Writing from a media literacy perspective when the *Occulus Rift* was still in development, Steph Hendry offered this thinking:

The rational response to the visual messages provided is to recognise them as representations but the fact that the representations are presented to the brain in a way that effectively emulates the 'real world', means the fiction is more easily adopted and adapted to whilst playing Texts do not have an 'inherent' meaning that needs to be learned by the reader but analysis skills can be taught and developed through practice. In the contemporary media age where audiences are fragmented and the definition of text is in a state of flux, teaching students what to read/think becomes futile when how to read and interpret texts in context has become a daily necessity.

(Hendry, 2016: 31)

This early intervention in "making sense" of virtual reality from a media literacy educator was actually, looking back now, more about the uses of virtual reality *for* media literacy. This is about a shift in praxis to account for what is undoubtedly a huge challenge for institutionalised "autonomous" model of schooled literacy – the need to enable "transcendental critique" of immersive, virtual media experiences in the moment of immersion.

Nick Hayes explorative polemic about the ways in which land ownership and notions of trespass are "baked in" to inequality through the cartography of "the lines that divide us" was published during this project. This is a book about fields and paths, forests and stately homes, it has little, seemingly, to offer an academic and educational account of virtual reality for media literacy. And yet, Hayes returns to many of the more "radical" theories of space and power. He turns to Foucault, bell hooks and ideas about Third Space, which I have worked with a lot myself with regard to media literacy, with John Potter, cited above, as well as those who cross the borders between academic research and activism, such as my own colleague Anna Feigenbaum and her work on protest camps. Why is this significant? What Hayes does is similar to how we are trying to work through this duality of "in and for". In unpacking relations of space, architecture and power, Hayes talks about the commons as "the oldest use of space in history" (2020: 279) and claims the internet for/as such, as many others have, but not in quite this way:

The philosophy of communing has thrived on the internet just as it has died on the land. It encourages a system of social interaction that foregrounds co-operative, inclusive values, sharing, over the ideology of privatised profiteering Though modern commons can still include areas of land or water whose rights and duties belong to the locals, their core philosophy has now transferred to the virtual world.

(2020: 182–183

In their calling for a sensitivity to "Living Literacies" for social change, Pahl and Rowsell (2020) offer much to the media literacy project which this analysis is situated by and for, towards positive consequences in media ecosystems, as opposed to "neutral" capabilities. This is a way of seeing literacy that is embodied within the particular and the felt. Like what is intended here, this is a call to action for an approach to literacy, and is very much about the moment-by-moment unfolding of literacy, *"attending to the sociality and sensoriality of place first and to it materialities after, to analyse the lived nature of literacies"* (2020: 164).

When space and place is virtual, not material, these aspects – sociality and sensoriality are still prominent and, as the writers and contributors in this book have walked us through, maybe more so. The first person accounts, the unruly encounters, the otherworldly landscapes, beings and objects, locating presence, these are all living literacies, and so virtual reality can reasonably be said to offer a return home for media literacy to this view of literacy which is disruptive and unsettling but, like Nick Hayes' activist trespass, in its insistence on the dynamic, "in the moment" becoming of media literacy, really constitutes a radical acceptance of media literacy in motion.

For David Buckingham, often and justifiably cited as a key scholar in this field, reminds us that in the ever-changing media environment, the work of media education is always to understand cultural forms and critique *practices* within a framework that combines reading, writing and contextual analysis. Our model here, and informed by our broader theory of change for media literacy is in synch with this, as we move from awareness through to action. Buckingham describes himself as having always shifted between problematising and proselytising (see Butler, 2021). This is true of the field itself, at the moment when media literacy is understood to have paused on a conceptual frame, it must proselytise the textual object of study and its own theoretical frame, but this is a constant – always, we are arguing here, in the pursuit of *living* media literacies. In virtual reality, we can even argue that this proselytising is enacted by participants in real time:

> *Even when a task seemingly calls for a simple reproduction of declarative knowledge learned through reading, listening, drawing, and writing, the process of shifting this knowledge into a new mode, such as virtual painting, is never a simple reproduction of content. Rather, the lack of equivalence between the modes invites learners to engage in a generative process of adaption and knowledge transformation.*
>
> (Mills and Brown, 2021: 20)

Vicki Williams' chapter in this collection takes us the closest to the gift VR gives media literacy in the pursuit of the unsettling this chapter set out as a goal, or indeed our obligation. In analysing the body's relation to VR as a

"strange assemblage" and situating this in the genre of the weird, Williams unsettles categories of immersion, ontology and disrupts our ways of seeing, both seeing VR and seeing in VR.

All this said, nothing here loses sight of the need for media literacy *in* VR to navigate the interplay of affordance, for all of these benefits, and algorithmic "onto-platforming", the axes of inclusivity, community and data sharing that Sarah Hayes describes as the "virtual airing cupboard" (2021: 2). Every virtual reality "user" who is also a media literacy student or teacher or researcher has their own unique positionality, but one which is now subject to much fragmentation due to blurs in what is considered natural or organic, digital, engineered or synthetic (Hayes, S, 2021: 5). And yet, again, and at the risk of repetition at this point, this unique positionality of socio-material, human/post-human, engagement and critique, this was always the messy stuff of the sticky field. It's the way that VR lays this bare – in trans-mediating literacy *praxis* – this is the affordance it gives *to* media literacy.

So, what are the uses of virtual reality for media literacy? I think we can see here the need for media literacy to find new ways of "doing text" with VR, to develop a pedagogy for the "border-crossing" between immersive experience and critical praxis (Bacalja, 2021) within the "modern commons" of the virtual space. This looks like both a shift *and* a sharpening of focus on the transboundary we were always-already traversing. It looks something like this.

Media Literacies	The Uses of Media Literacy	The Uses of Media Literacy in VR	The Uses of VR for Media Literacy
Access	Using access to media to challenge access barriers and inequities.	Socio-material, pedagogic and social access points.	Meaning-making with and in media at *the margins of knowing*.
Awareness	Critical, meta-reflection on everyday mediated practices.	Reading presence and immersion. Interpreting choice.	*Laminating* media meaning in the composition of self.
Engagement	Dynamic Agency in Media Spaces	Perspective, degrees of empathy, adapting the text.	Media literacy an unruly encounter. Media literacy as productively *weird*.
Creativity	Curative and maker literacies.	Creative media practice in and of VR.	Generative adaption: trans-mediating media literacy *praxis*
Action	Counter-script media, capability for positive change.	From virtual empathy to positive action in space and place.	Enacting the commons through media literacy: media literacy as *trespass*.

References

Ahn, C. and Pena, E. (2021). 'Reality as Genre'. JuliAnna Avila (ed.). *Critical digital literacies: Boundary-crossing practices*. Leiden: Brill.

Andrews, K. (2021). *The new age of empire: How racism and colonialism still rule the world*. London: Allen Lane.

Bacalja, A. (2021). "There's More Going On": Critical Digital Game Literacies and the Imperative of Praxis. JuliAnna Avila (ed.). *Critical digital literacies: Boundary-crossing practices*. Leiden: Brill.

Bennett, P., Kendall, A. and McDougall, J. (2011). *After the media: Culture and identity in the 21st century*. London: Routledge.

Blevins, S. (2017). From Corporeality to Virtual Reality: Theorizing Literacy, Bodies, and Technology in the Emerging Media of Virtual. PhD Thesis. University of New Carolina. Available from: https://libres.uncg.edu/ir/uncg/f/Blevins_uncg_0154D_12201.pdf

Butler, A. (2021). *Key scholarship in media literacy: David Buckingham*. Leiden: Brill.

Chalmers, D. (2022). *Reality+: Virtual worlds and the problems of philosophy*. London: Penguin.

Couldry, N. (2019). *Media: Why it matters*. Cambridge: Polity Press.

Freebody, P. (2006). *Constructing Critical Literacies*. New York: Hampton Press.

Gee, J.P. (2015). *Literacy and education*. London: Routledge.

Hayes, S. (2021). *Postdigital positionality: Developing powerful inclusive narratives for learning, teaching, research and policy in higher education*. Leiden: Brill.

Hayes, N. (2021). *The book of trespass: Crossing the lines that divide us*. London: Bloomsbury.

Hendry, S. (2016). 'Reading Text'. Bennett, P. and McDougall, J. (eds.). *Doing text: Teaching media after the subject*. Columbia: Columbia University Press.

Jenkins, H., Shresthova, S., Thompson, L., Kligler-Vilenchik, N. and Zimmerman, A. (2016). *By any media necessary: The New Youth Activism*. New York: NYU Press.

Kendall, A (2008). 'Playing and resisting: rethinking young people's reading cultures', *Literacy*, 42(2), 123 – 130/ (2012) Reading, Writing and Technology: A Special Virtual Issue.

Lee, C., Bailey, C., Burnett, C. and Rowsell, J. (eds.). (2022). *Unsettling literacies: Directions for literacy research in precarious times*. Singapore: Springer.

Lyotard, J. (1988). *The differend: Phrases in dispute*. Minnesota: Minnesota University Press.

McGoey, L. (2019). *The unknowers: How strategic ignorance rules the world*. London: Zed Books.

Mills, K. and Brown, A. (2021). 'Immersive Virtual Reality (VR) for Digital Media Making: Transmediation Is Key'. *Learning, Media and Technology*. 10.1080/17439884.2021.1952428

Natale, S. (2021). *Deceitful media: Artificial intelligence and social life after the turing test*. Oxford: Oxford University Press.

O'Brien, W. (2021). Learning to kill? Taking aim with the first-person shooter. Doctoral Thesis (Doctoral). Bournemouth University. Available from: http://eprints.bournemouth.ac.uk/35263/

Oomen, J., Hoffman, J. and Hajer, M. (2021). Techniques of futuring: On how imagined futures become socially performative. *European Journal of Social Theory*, 25(2), 1–19.

Pahl, K., Rowsell, J., with Diane Collier, Steve Pool, Zanib Rasool and Terry Trzecak (2020). *Living literacies: Re-thinking literacy research and practice through the everyday*. Massachusetts: MIT Press.

Pomarentsev, P. (2022). Solving the problem means confronting the psychological grip Putin has on people. *The Observer*, 20 March 2022.

Potter, J. and Cowan, K. (2020). Playground as meaning-making space: Multimodal making and re-making of meaning in the (virtual) playground. *Global Studies of Childhood*. 10.1177/2043610620941527

Sayah, H. (2022). 'Civic intentionality first: a Tunisian attempt at creating social infrastructure for youth representation'. Fowler-Watt, K. and McDougall, J. (eds.). *The Palgrave Handbook of Media Misinformation*. New York: Palgrave.

Street, B. (1995). *Social literacies: Critical approaches to literacy in development, ethnography and education*. London: Longman.

Travis, R. (2017). What homeric epic can teach us about educational affordances of interactive narrative. *Exploding the Castle: Rethinking How Video Games & Game Mechanics Can Shape the Future of Education*, online. Charlotte: Information Age Publishing. 19–37.

13 Into the Metaverse

*Sarah Jones, Steve Dawkins, and
Julian McDougall*

We have seen that there is often a mistaken idea that VR is a new technology. From the moral panics around the technology to news about Big Tech acquisitions of smaller VR companies, there is often a huge amount of attention given to this emerging and developing technology. In reality, though, VR has been around for many years and its development has coincided with other technological advances and a rise in digital, interactive and social media.

As we have journeyed through the VR landscape, we have sought to bring together a collection of voices from experts, researchers, educators, consumers and producers to try to more fully understand the challenges and concerns that arise with the technology's increasing cultural reach.

We started our journey with the warnings of Lanier that we need to think critically about this technology to ensure that, as it infiltrates our lives, we are able to become critically conscious users. Maintaining a critical distance whilst seeking that moment of presence has been a recurring theme of many of this book's contributors.

We explored the notion of audiences in VR and the need to create safe spaces for immersive experiences, ensuring that a VR experience is not just inside a headset but captures the journey to and from as well. We saw how access to VR in education can be hampered by the digital divide but also the possibilities that it provides, opening up learning experiences for all with, for example, virtual field trips and safely learning in what could otherwise be harmful or dangerous environments. Ethics and the sense of being in a virtual environment have been explored and open up further challenges and debates: how does one protect oneself in VR?

Journeying through a visual medium such as VR in book format is a challenge and so the Virtual Encounters chapter seeks to convey first-person accounts of experiences and their contradictory relationship towards these experiences.

This is not a definitive framework for understanding VR through a media literacy lens. It presents a set of issues that are not going away, provides some sense of the importance of these issues and acknowledges that we need to work out what it means to be a critically engaged user of VR, fully

DOI: 10.4324/9780367337032-17

aware of these issues, while still fully enjoying what is a massively important and liberating technology.

It is our hope that you will now seek out a headset – possibly the one you received last Christmas that is now in a cupboard – and immerse yourself whilst having a deeper understanding and criticality of the virtual worlds. The immersive world opens up opportunities for escapism and exploration and by building it with our critical lens, we can hope that the dream-like environment envisaged by the early pioneers of VR won't become a nightmare.

Index

Page numbers in *italic* refer to tables.